WASHINGTON EVERGREEN

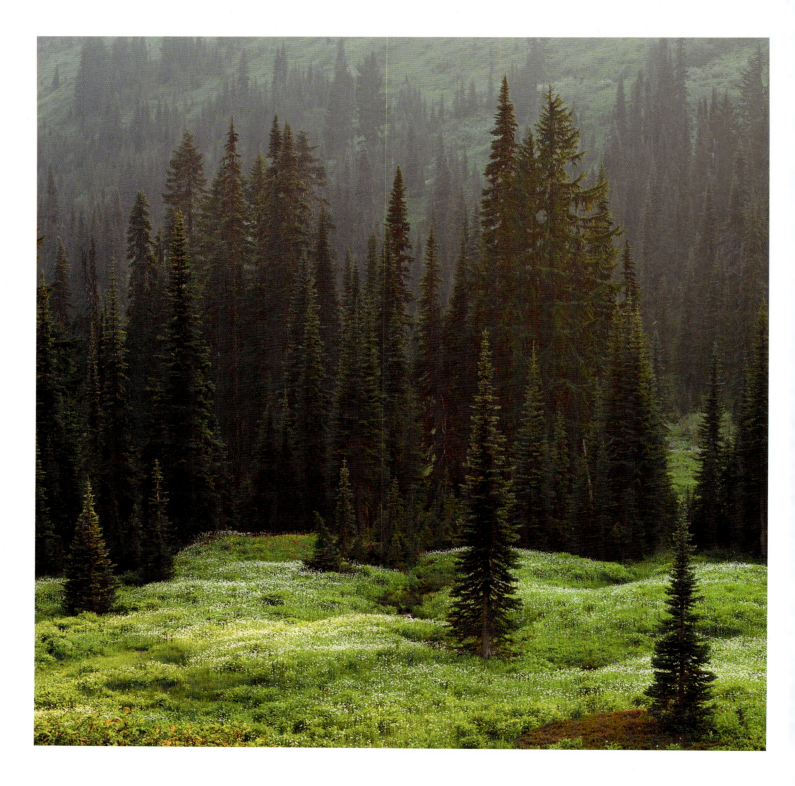

WASHINGTON EVERGREEN

LAND *of* NATURAL WONDERS

PHOTO CASCADIA

foreword by ROBERT MICHAEL PYLE

TIMBER PRESS • PORTLAND, OREGON

FOREWORD

ROBERT MICHAEL PYLE

I n early autumn of 1916, my grandmother Grace Phelps Miller traveled from King Street Station in Seattle north to Everett and then east over (and under) snowy Stevens Pass to Wenatchee, thence north again on the undammed Columbia River by passenger boat to Chelan Falls, and finally around the gorge to Chelan proper by stagecoach. She was arriving for her first teaching job. I now own a big tub of her letters home from that year, and a thick photo album of her small, black-and-white snapshots documenting her adventures with the other teachers during that first exciting year of her long teaching career.

Washington came to me first as pictures. Not so much photographs, except for those black-and-white snaps. But as mental images, colored into my young boy's brain by stories from grandmother Grace, my great-aunt Helen (her sister), and my mother, Helen Lee. We were a Colorado family via Pennsylvania, a family of ranches and railroads back in narrow-gauge and open-range days. Grace and Helen attended the University of Denver. Upon graduation, they took the train to Seattle to visit their favorite cousin, Leila, whose father had started a brick plant on Whidbey Island. So entranced were they by the Pacific Northwest that they enrolled at the University

of Washington (when there were three buildings on campus!), took master's degrees and teaching certificates, and became pioneer teachers in remote villages around the state: Oak Harbor, Sultan, and the aforementioned Chelan, for example. After that, Grace married and bore my mother in Seattle's worst blizzard. Helen Lee then grew up on Naomi Street, alongside wild Ravenna Park, until they all went back to Denver. Mother never got over Washington, and always longed to return.

You can bet that Grace, Helen, and Helen Lee took with them a great store of memories and images from their years in Washington. And it was these misty tales and green pictures, told over and over, that informed my youthful imagination—so much so that half a century after they'd done the same, I hopped a train to come and see it for myself in 1964. A year later I fled hot-cold Denver for green and mild Seattle, entered the University of Washington (now with many more buildings), and that was that. I'm still here.

Since I swapped Colorado for the Evergreen State, I have traveled and worked in every one of the fifty states. And I can honestly say that I believe Washington to be the most physically diverse, visually arresting, and picturesque of all.

So, what a pleasure it was to learn that the seven formidable members of Photo Cascadia were bringing their utterly extraordinary photographic skills to bear upon this grand, green land! What an honor and a delight to be asked to craft some words to help welcome this book into existence. I agreed in a heartbeat and could barely wait to see the photographs. When they arrived, I just basked in the beauty and wonder that I have come to treasure over all other places, just as my mother Helen Lee had done. She never did make it back here to live. In a way, I feel I have been living here for her, and these photographs remind me, over and over again, just why.

My own personal romance with Washington State—as it will be for everyone who dives in, I feel sure—is richly rekindled by this stilling assemblage of images. As I leaf through, particular pleasures of the past leap out as if I were there again. For example, the waning afternoon of long shadows when my wandering pal David Branch and I rounded a country bend and chanced upon an utterly unexpected sight: there, beneath the canyon rimrock, a red, dilapidated bridge spanned the little Palouse River—a covered bridge! I've lived for forty-two years beside the only historic covered bridge in Washington that still carries a public roadway, in Gray's River, Wahkiakum County, in the southwest corner of the state. Now here, near the opposite, southeast corner, was another that I didn't even know about. Like "my" bridge, it had tall, straight walls. But it had no roof—rather, the walls were double, sandwiching the truss beams between them for protection from the weather, instead of covering them from above. It was built as a railroad bridge and, the line long gone, now served as a driveway to a farm. David and I settled onto its deck, popped an ale, and watched the purple sunset compete with a slow moonrise as its glade rode along the river and three different species of herons flew up from the banks toward their evening roosts. Then, as the riotous colors faded from the sky, those herons were matched by three kinds of owls heralding the oncoming night: a barn owl from the bridge timbers, a great horned from a streamside cottonwood, and a screech owl from the rimrock firs. One long series of magic moments—but long lost, until I came to the photo of it by Adrian Klein. This image brought a treasured experience back intimately for me, just one of many such gifts throughout this splendid book.

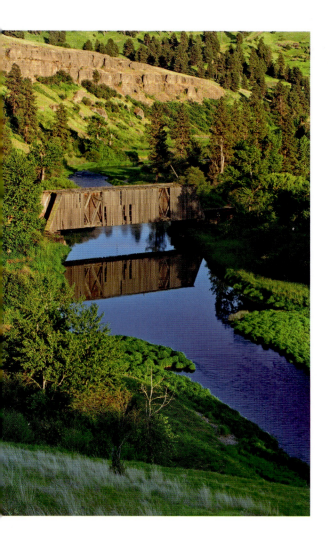

The Manning-Rye Covered Bridge stood for more than 100 years over the Palouse River until it fell victim to a 2020 wildfire.

Had I the room, I could limn many such. Instead, allow me to sketch a broad mosaic of some of the things, places, and artifacts of the people and the rest of nature that have drawn me back again, through this unmatched celebration of color and form in our beloved land. We see many faces of the Columbia River and its basin, all the great, long Bretz Flood country, which forms and waters the heart of the whole place. Walk wilderness beaches, headlands, and sea stacks, to lighthouses, pilings, and piers, then back to ferries, fireworks, fish bars, and boats. Bounce incongruously but with great refreshment and renewal from sage steppe to Olympic rainforest, from club moss to balsamroot, and back again, accompanied over the crest by red heather, snow gnomes, and mauve mushrooms.

We track the wilderness of Goat Rocks and Indian Heaven, Hanford Reach and Juniper Dunes, accept a welcome home from Baker and Adams, Rainier and Saint Helens. We stoop to greet wildflowers in every setting, alpine meadow asters and camas under oaks, then wend beneath cedar, spruce, aspen, and alder, and on down into fields of tulips and poppies, gardens of grace and Japanese maples, moon bridges, lanterns, and doors. All this in the company of rabbit and rail, marmot and mule deer. Now we find ourselves among barns, farms, orchards, and vineyards; windmills and cranes, skyscrapers and cabins, churches and lodges. The silos, towers, elevators, and (still more) lighthouses—all the structures we aim toward the blue and leaden sky.

And we reach all these via bridges and backroads, over passes and dams, wave-struck jetties and aspen-clad lanes, past masts and madronas, columns of basalt and towers of andesite. Watching windmills in the mists, rainbows in the gorge, sun stars in the peaks, sunsets and sunrises all over the whole blessed place. Until finally we fetch up among the soft geometry and every-tint color box of the Palouse, and just want to fall into those hills forever. And everywhere, in Washington, we travel with water flowing, in every form: waterfalls, creeks, lakes, rivers, and tides, and all its other secret places. For what else, besides the many expressions of water, is this one particular state of being, with its faces too many to count, or ever photograph in their entirety? But these seven have tried, and in so doing, they have taken me back through a lifetime of places I love. And what may be just as valuable, to places I've not managed to reach, but have always wished to—chief among them (and it's not looking like I'll make it at this late date, so I'll settle for this amazing array of views) the stunning high Enchantments in October larch-light.

And that's a good place to wrap up this collage, because if there is one word to describe what the book means to me, it is that: enchantment. It was sheer enchantment that brought my family and me here, and enchanted I remain. A few years ago, I felt a need to get back out there and rediscover some of that witchery. For decades I had plumbed and prowled all the larger and many of the smaller and near-nonexistent roads of Washington, as well as an infinitude of trails and animal runs, for classes (first taking, then teaching), research, recreation, delight, curiosity, work, play, whim, adventure, meditation, solitude, sharing, and any other reason or rationale you might suppose. But since losing my boon companion Thea in 2013, friends aging, busy, or gone, and my own writer's life more complex and committed, my wanderings had fallen off. So I resolved to take much of a year and dedicate it to rediscovering this state to which I had chosen to cleave most of my life ago. I did it through the medium of butterflies, a special study of mine and subject of several of my books and part of my professional life as a conservation biologist.

Birdwatchers have a thing they call the Big Year, whereby they try to see as many species in a single calendar year, in a single area (usually the US and Canada), as they can. So in

2017–2018, I decided to celebrate my seventieth birthday by launching the first Washington Butterfly Big Year: July 19–July 19, no one said it had to be January to January (not good butterfly seasons!)—and I had a ball, racking up some 130 of Washington's 150+ species. But I also became reacquainted with many beloved spots, and first-time acquainted with many others: from Slate Peak to Obstruction Point, Moses Meadows to Steptoe Butte, the Pend Oreille to the Grand Ronde, Blue Mountain to the Blue Mountains; through fritillaries and swallowtails, blues and coppers, arctics and alpines, wood nymphs and mourning cloaks. It was Big Year as Grand Tour, reminding me of just how many faces of this state I'd come to love. It was a lot of work, fun, and travel. I don't intend to quit anytime soon, but I doubt I'll essay quite such a far-flung look-see again. But, lo! Now with these images I will be able anytime to revisit many of the landscapes, lightscapes, and colorscapes I have come to adore about Washington. Maybe especially the color: for if there is one quality that stands out even above form and texture in this collection, it is our state's phantasmagorical palette—and these photographers have managed, against all natural odds, to get it.

I've no doubt the way Photo Cascadia has used their astonishing artistry to capture nature's artistry will awaken in the breast of every reader care, concern, and commitment for the long-term task of conserving all we have left of this great green treasure. How lucky for Washington, this book; how lucky for us! I only wish I could send copies of it to Grace, Helen, and Helen Lee, who ignited my enduring infatuation.

WASHINGTON'S

SEVEN REGIONS

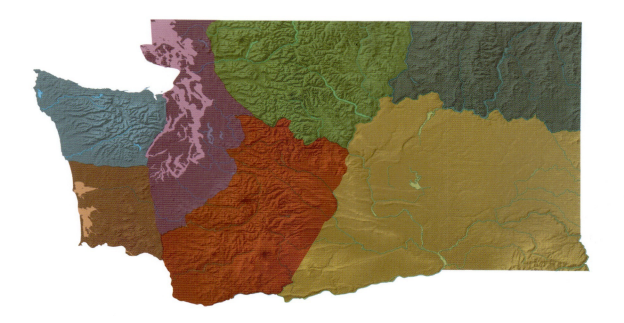

- OLYMPIC PENINSULA
- PUGET SOUND
- NORTH CASCADES
- OKANOGAN HIGHLANDS
- WILLAPA HILLS
- SOUTH CASCADES
- COLUMBIA BASIN

The colored dots next to the captions that
follow coordinate with the region of the featured image.

A long exposure at low tide showcases Rialto Beach in Olympic National Park. ●

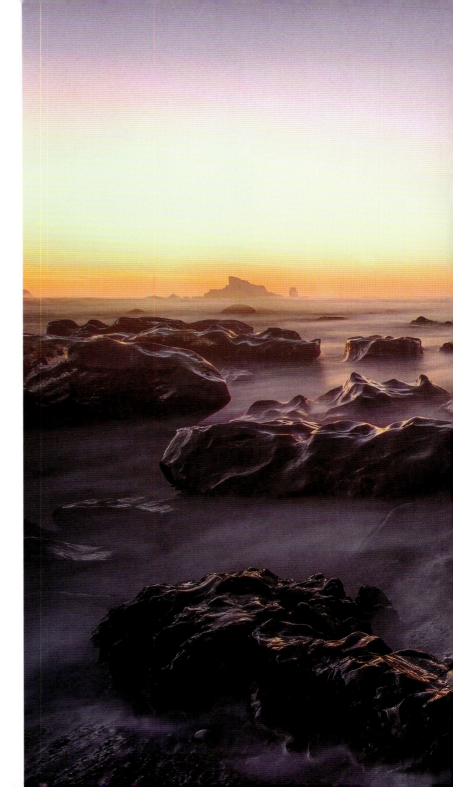

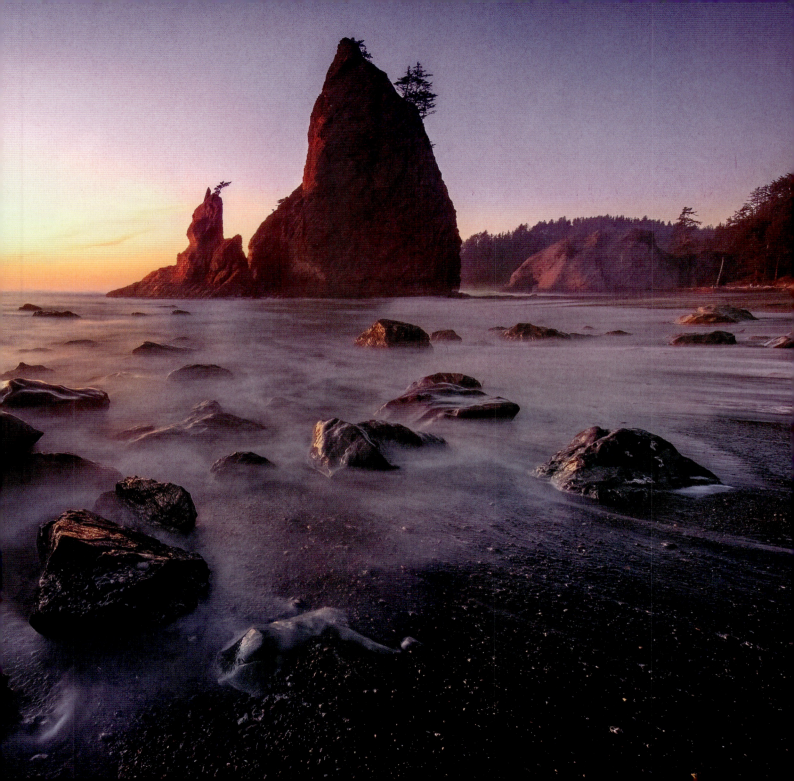

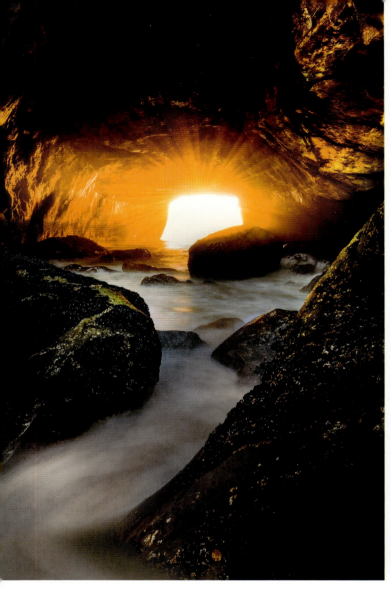

ABOVE A sunburst glows through a
sea cave at low tide in Grays Harbor on
the western coastline of the Olympic
Peninsula. •

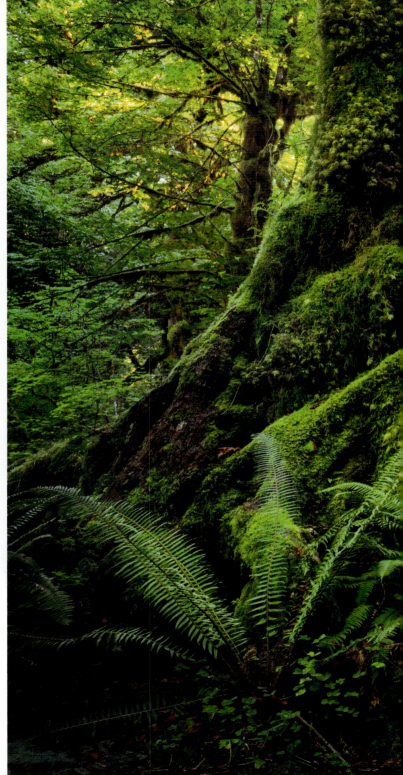

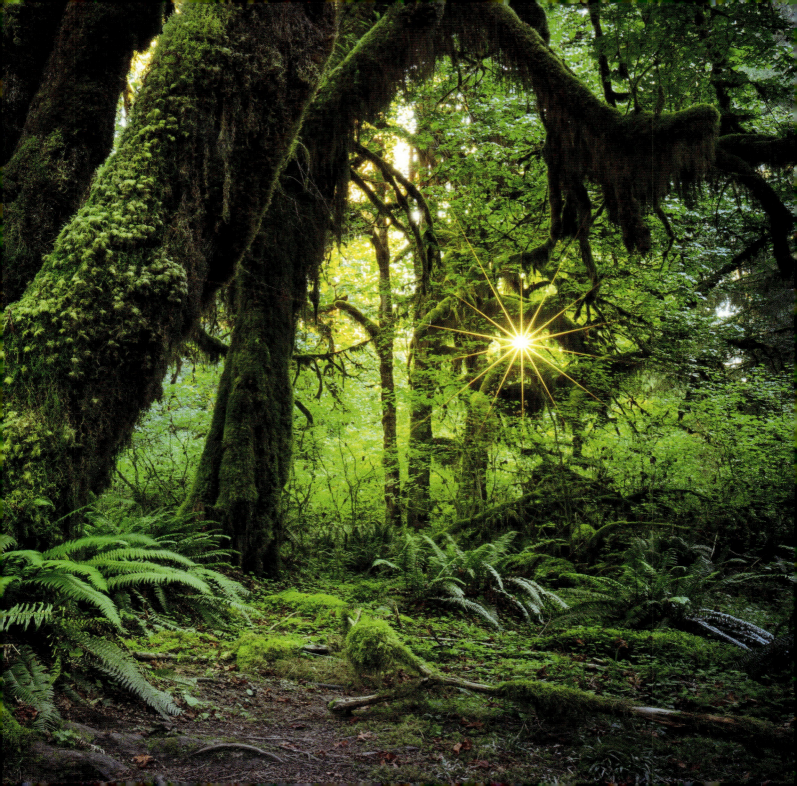

PREVIOUS PAGE Early sun shining through
the Hoh Rainforest canopy illuminates
bigleaf maple trunks (*Acer macrophyllum*),
sword ferns (*Polystichum munitum*),
and several varieties of lichens and
mosses. •

RIGHT Bigleaf maple trees are draped in
moss in the Hoh Rainforest of Olympic
National Park. •

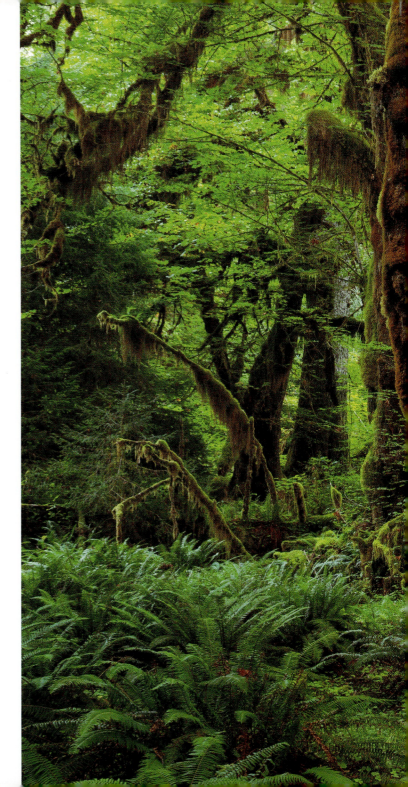

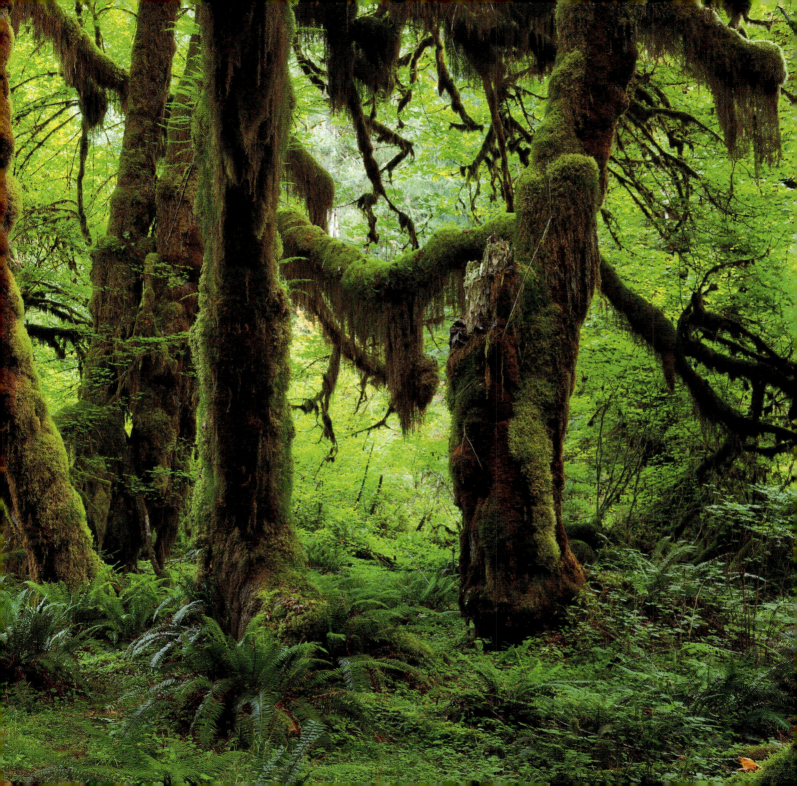

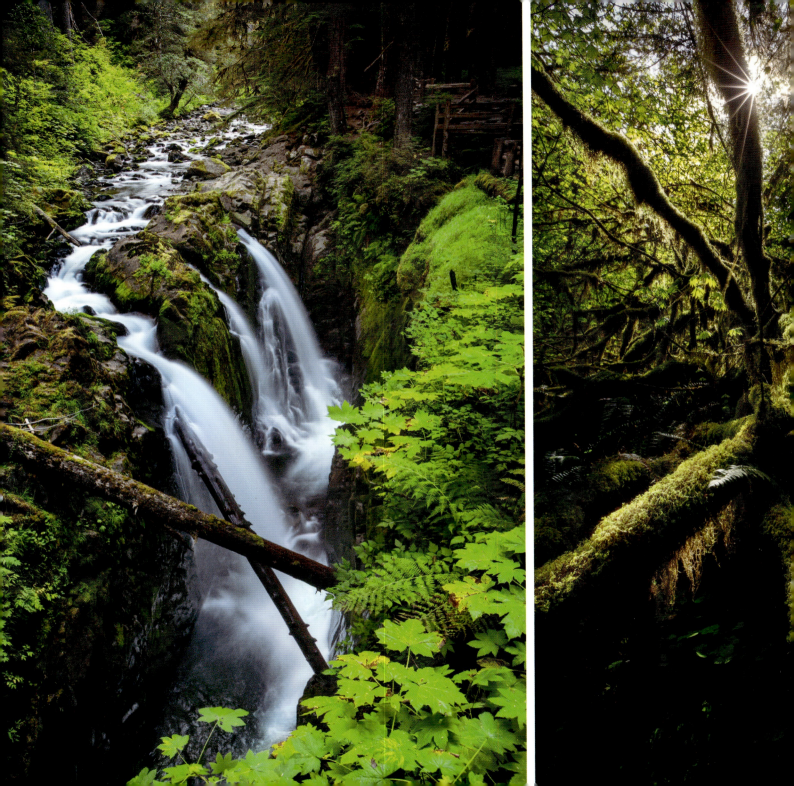

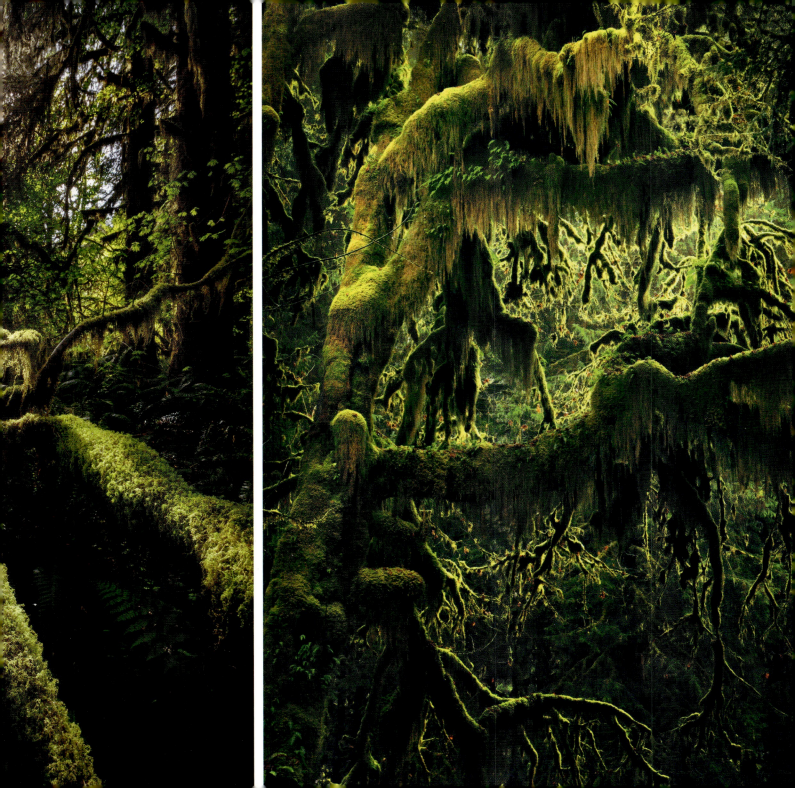

PREVIOUS PAGES, LEFT TO RIGHT
Sol Duc Falls is one of Olympic National Park's most beloved attractions. Depending on water flow, it splits into as many as four channels and cascades 48 feet into a narrow, rocky canyon. ● The branches of a vine maple tree reach out across the lush rainforest floor in Olympic National Park. ● Dense layers of trees within the rainforest of Olympic National Park. ●

RIGHT Ferns, Sitka spruce, and bigleaf maple make up a large part of the Hoh Rainforest. ●

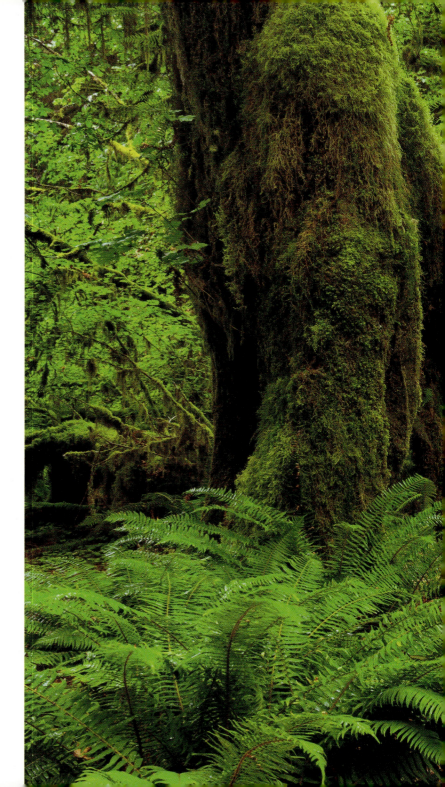

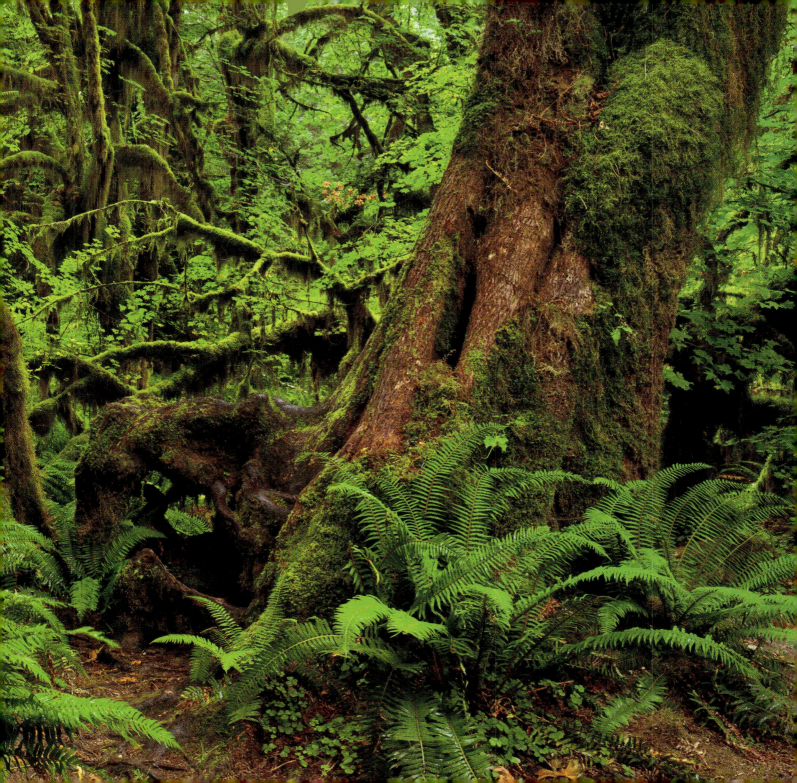

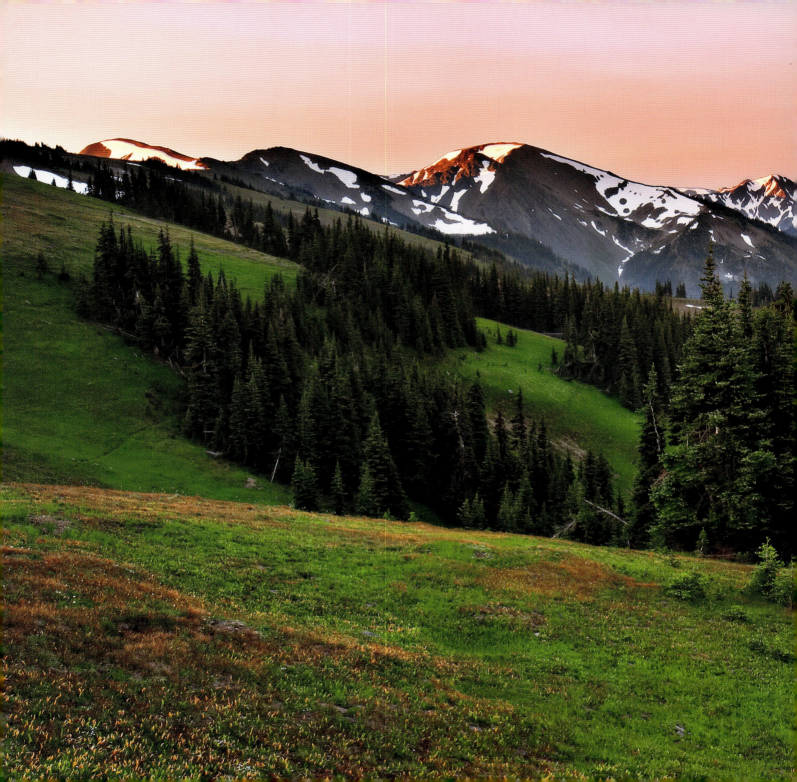

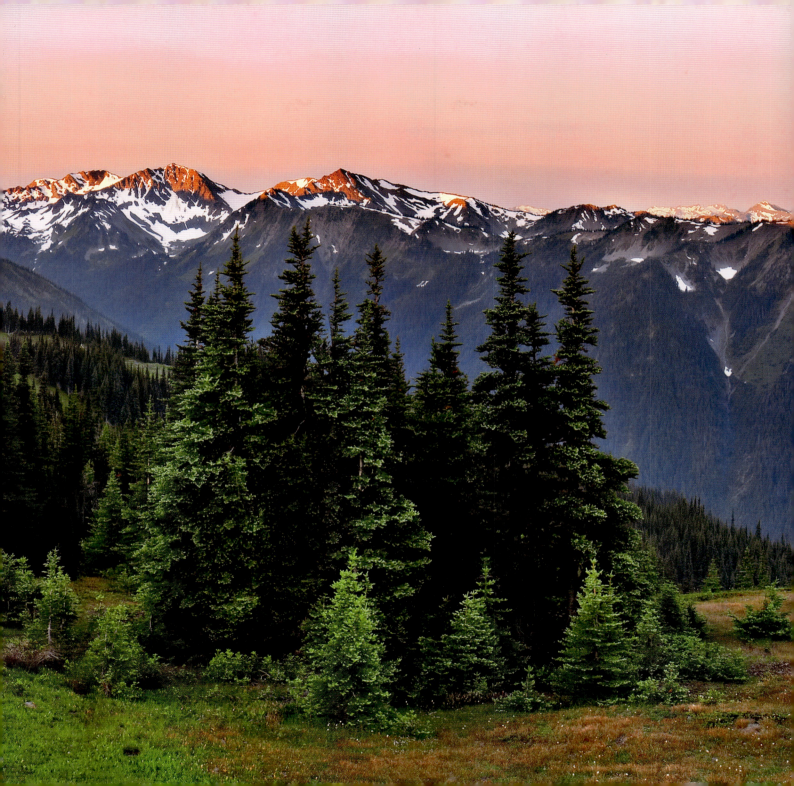

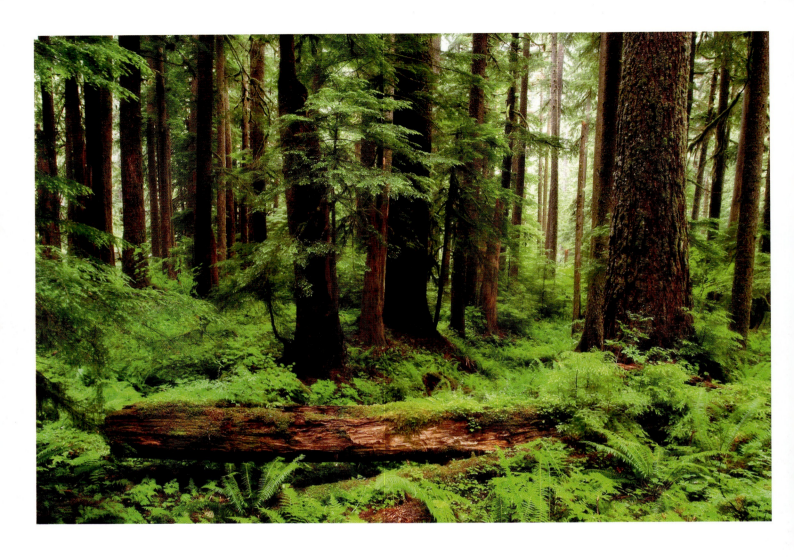

PREVIOUS PAGES Sunrise over the
Olympic Mountain Range from
Hurricane Ridge. •

ABOVE Early spring vibrant greens in the
Sol Duc Rainforest. •

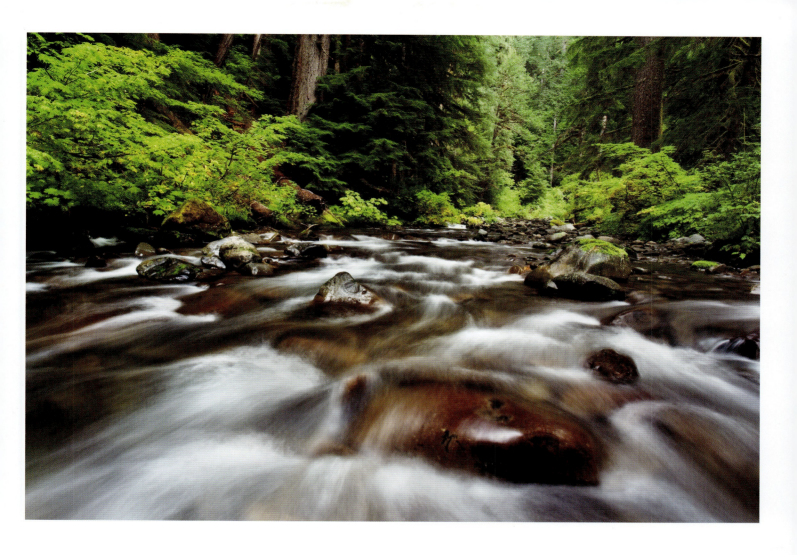

Sol Duc River flows through the dense
evergreen rainforest of Olympic National
Park. •

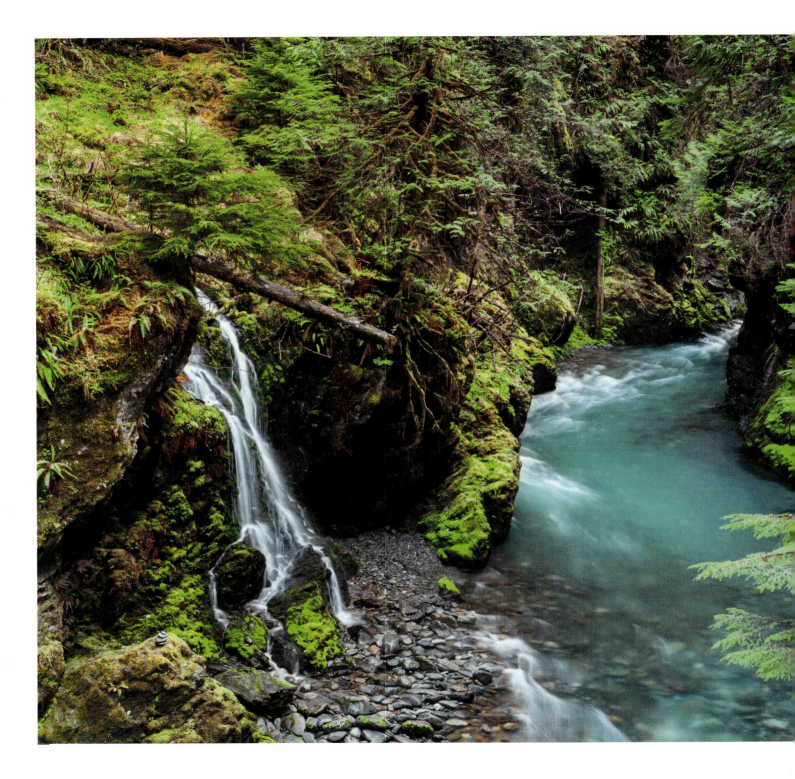

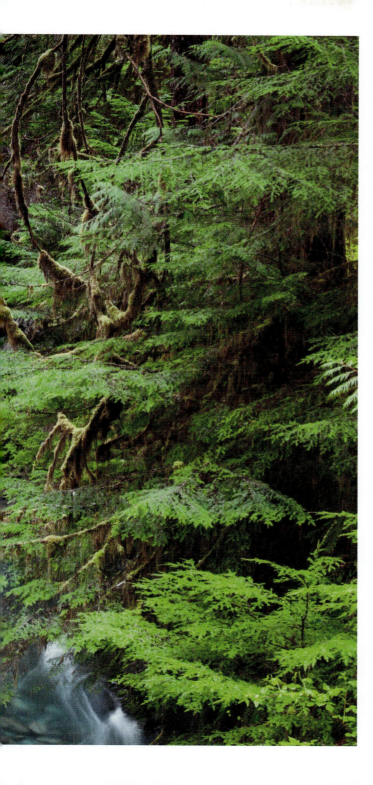

A seasonal waterfall along the east fork of the Quinault River near Lake Quinault. •

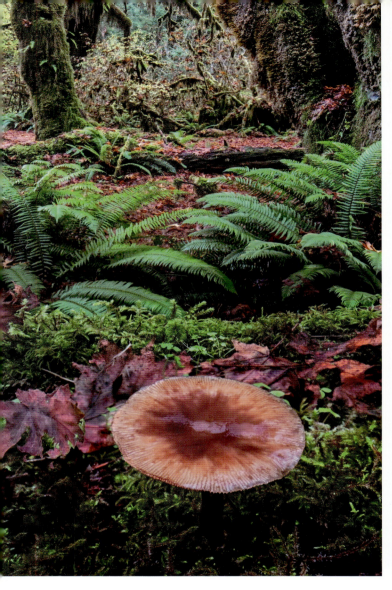

ABOVE A mushroom looms in the foreground during the vibrancy of springtime in the Hoh Rainforest. •

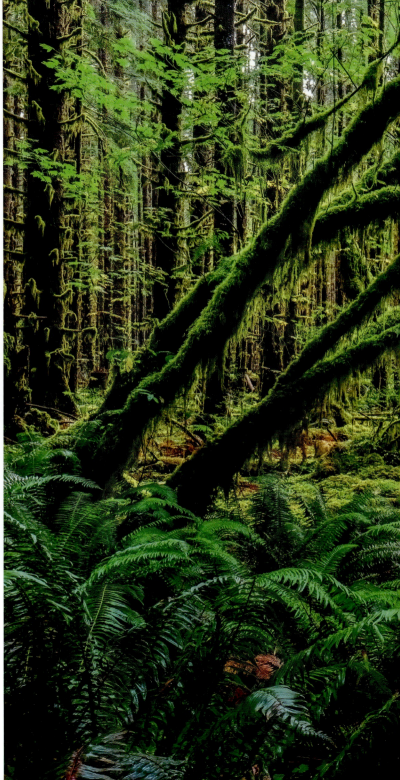

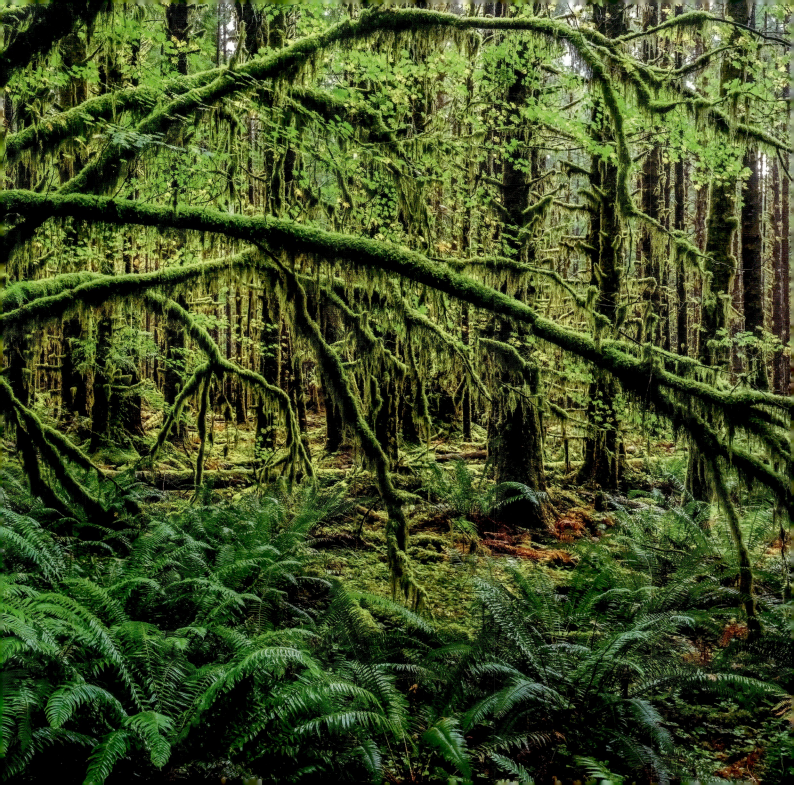

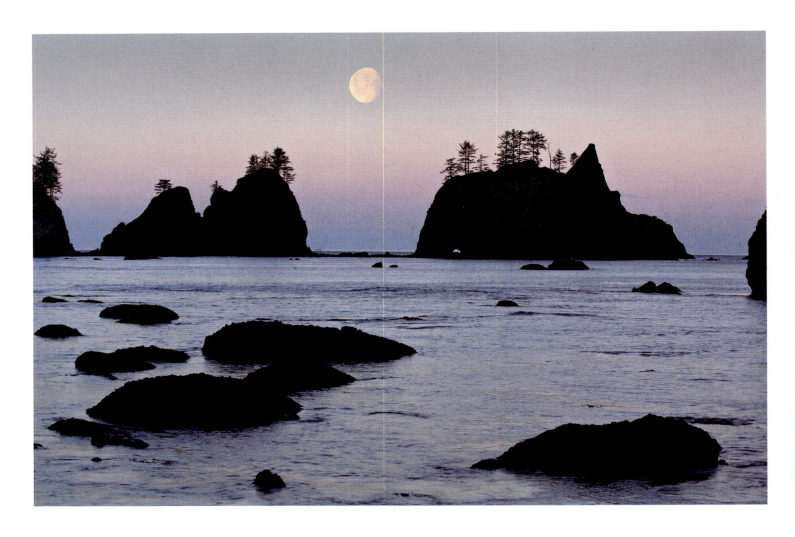

PREVIOUS PAGE Brilliant green colors illuminate the Hoh Rainforest during the peak of spring. •

ABOVE The moon setting at sunrise over the sea stacks of the remote Shi Shi Beach in Olympic National Park. •

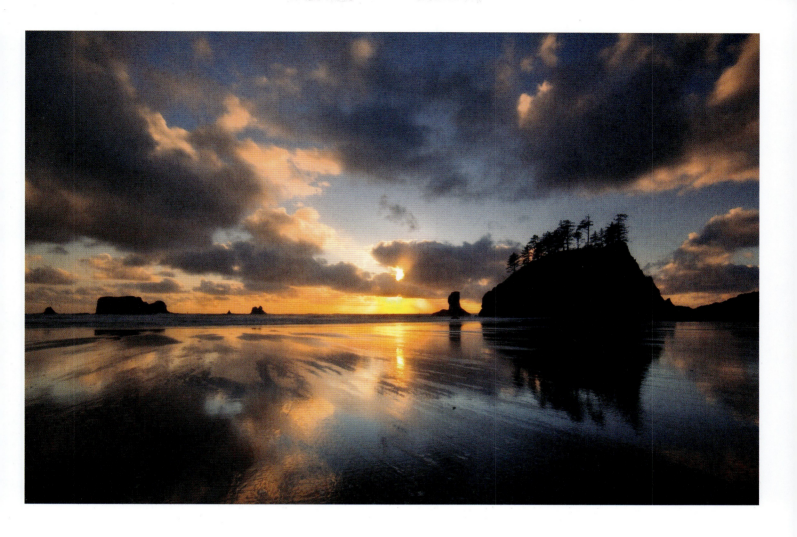

Cold unstable air moves inland as the
sun sets over Second Beach in Olympic
National Park. •

Lupine fills the meadow below the Olympics on Hurricane Ridge during summer season. •

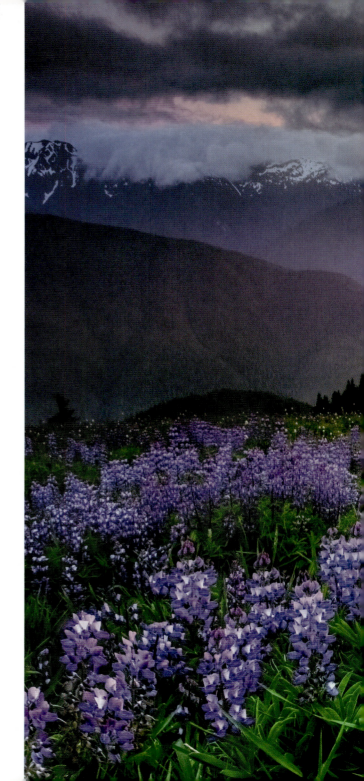

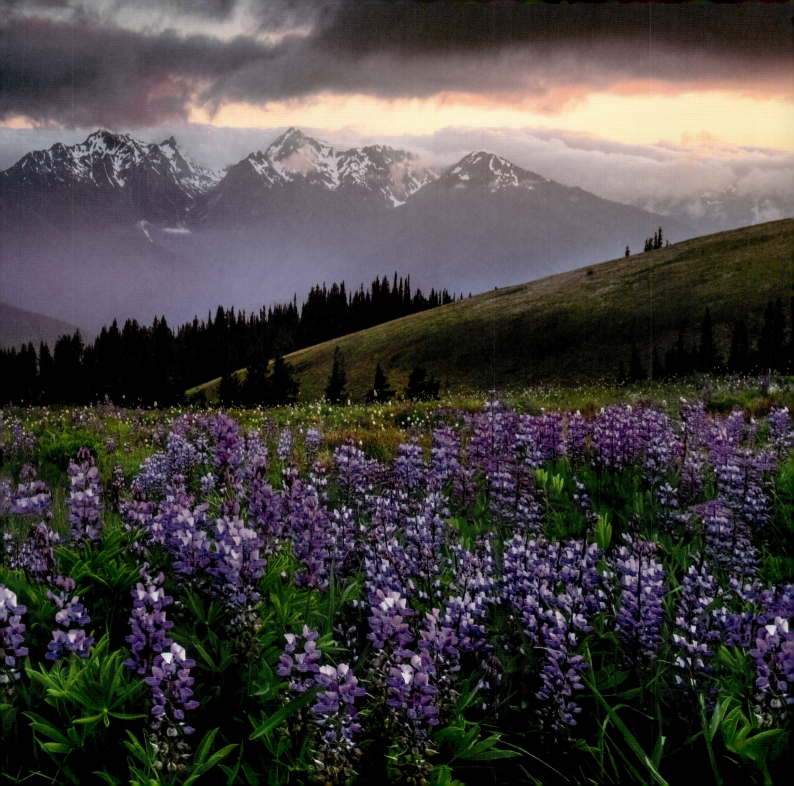

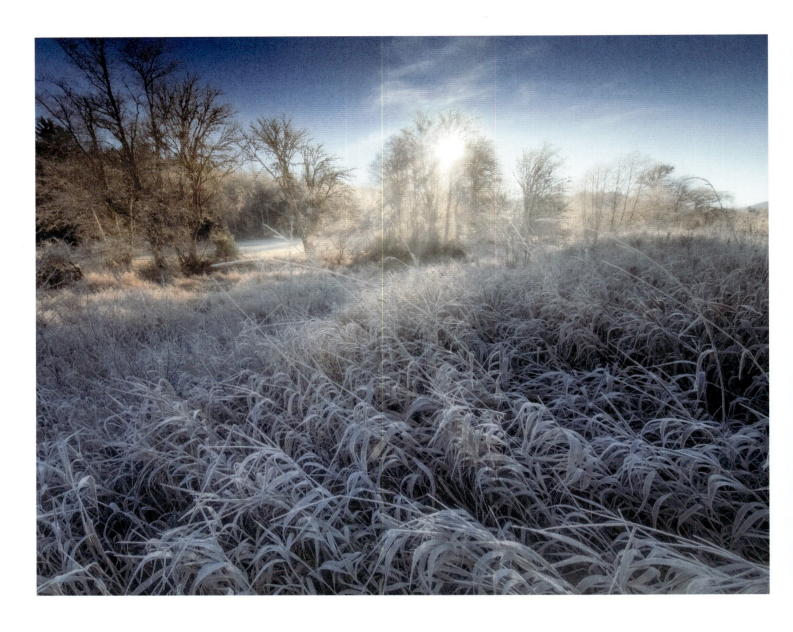

Morning frost covers the foliage in a fresh
white blanket during the start of winter in
the Olympics. •

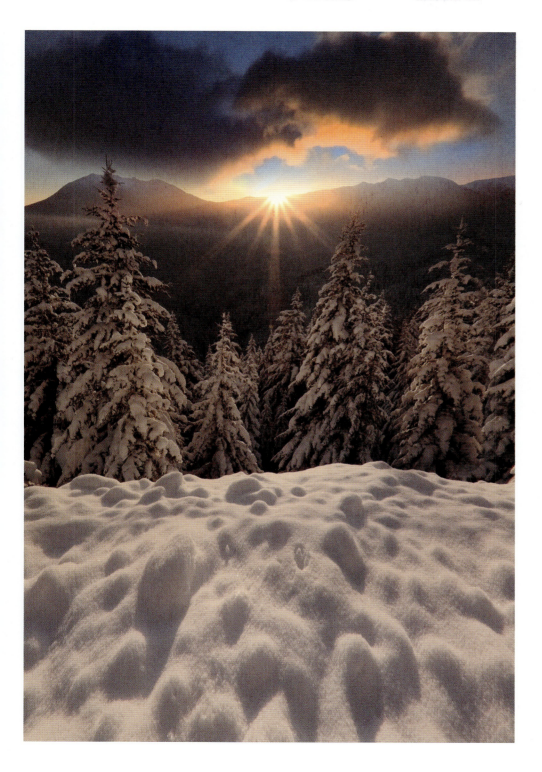

Snow pillows cover the foreground during a winter sunrise on Hurricane Ridge in Olympic National Park. ●

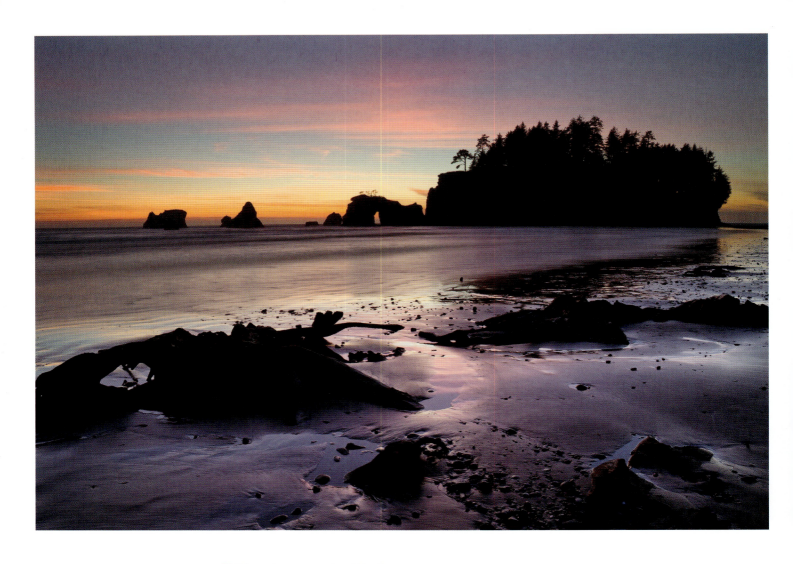

Twilight settles over an arch and island.
An American Indian guide is required
to travel to this remote section of the
Washington coast. •

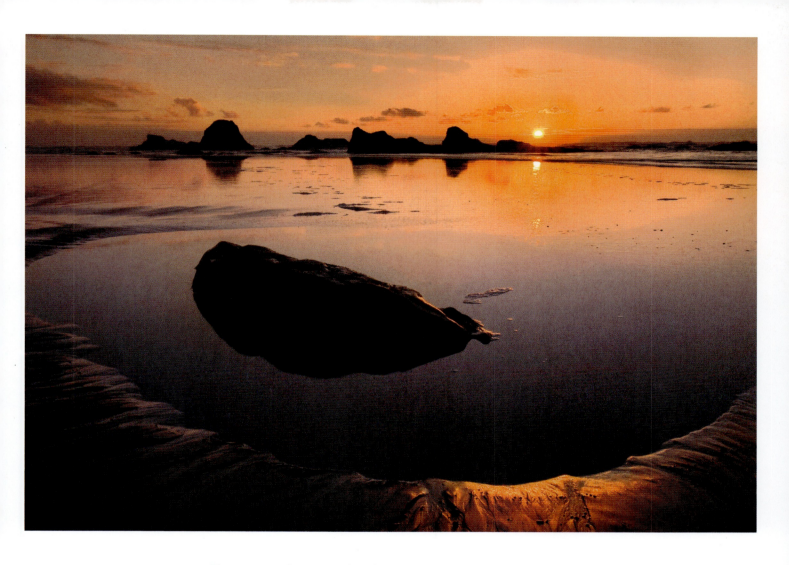

The sun sets over distant sea stacks as the beach and tide pool capture reflections on Ruby Beach. •

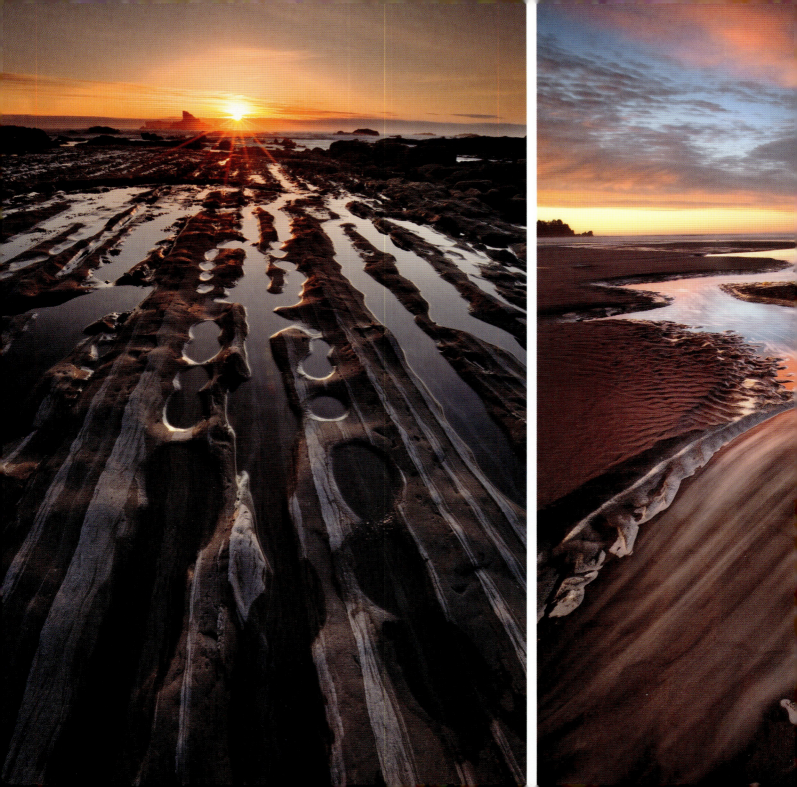

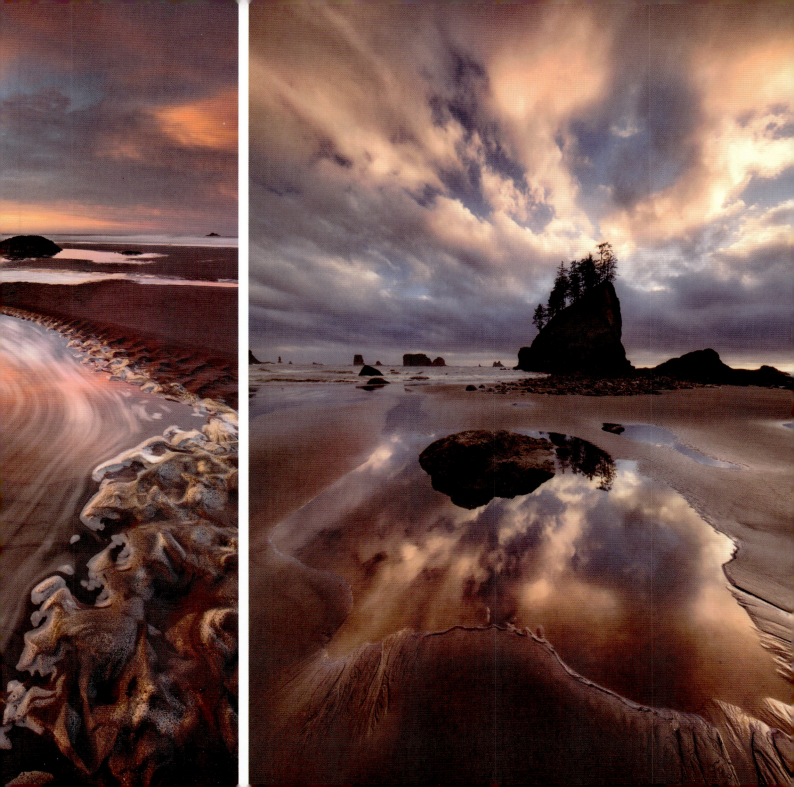

The sun sets over rows of rocks at low tide on a remote beach in Olympic National Park. • A very slow shutter speed creates motion in the tidal water on Second Beach in Olympic National Park. • Cloud reflections in the sand at Second Beach in Olympic National Park. •

RIGHT A pair of sea stacks at sunset on Rialto Beach in Olympic National Park. •

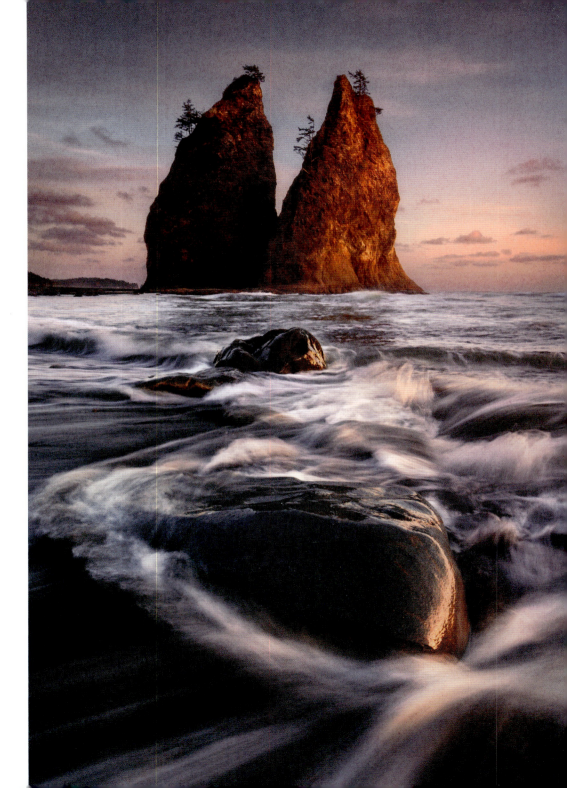

A wide array of colorful rocks found along the Olympic Peninsula at Shi Shi Beach. •

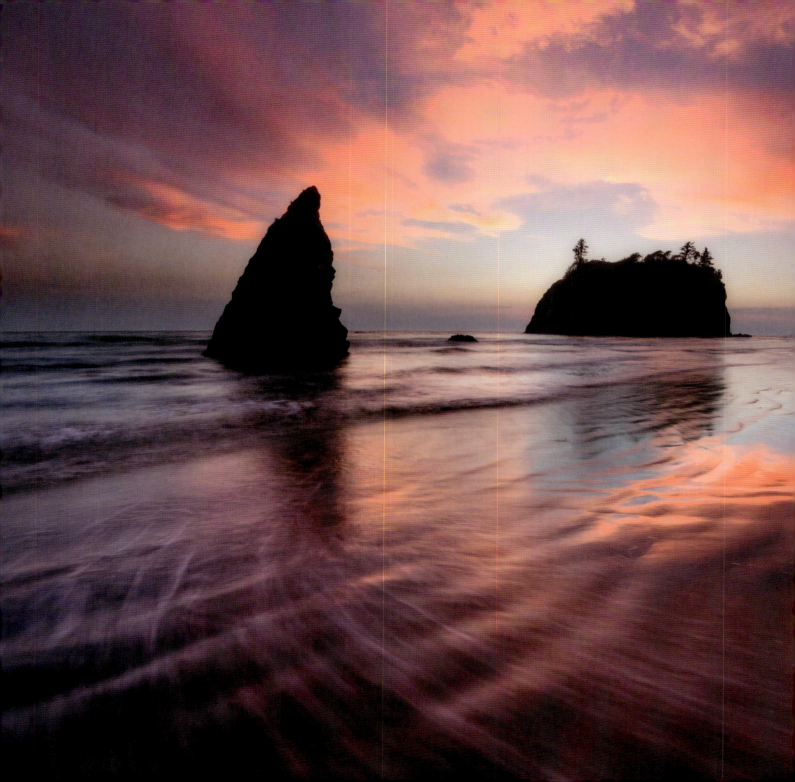

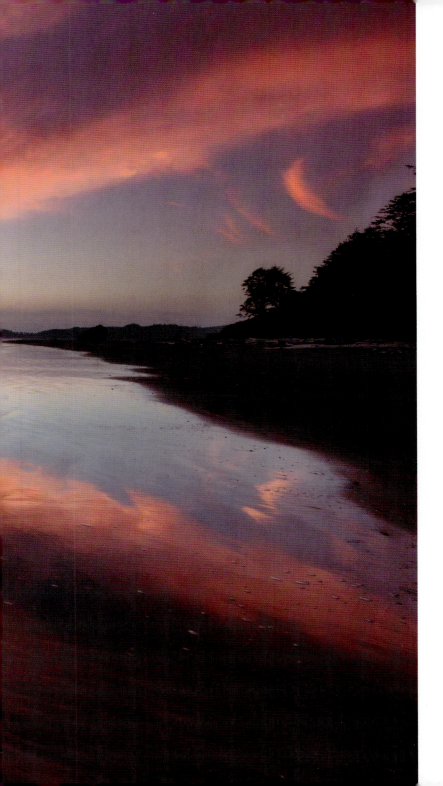

A beautiful summer sunset over Ruby Beach in Olympic National Park. •

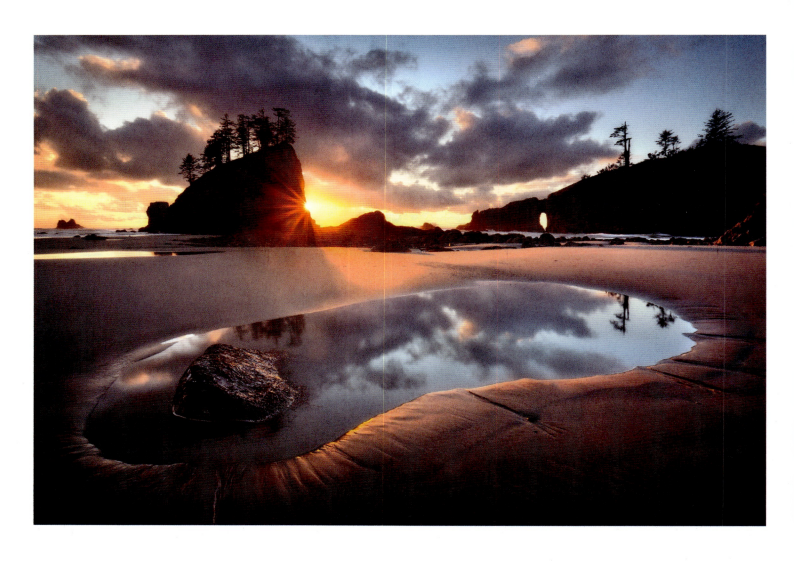

Tide pool catching the light of sunset
at Second Beach in Olympic National
Park. •

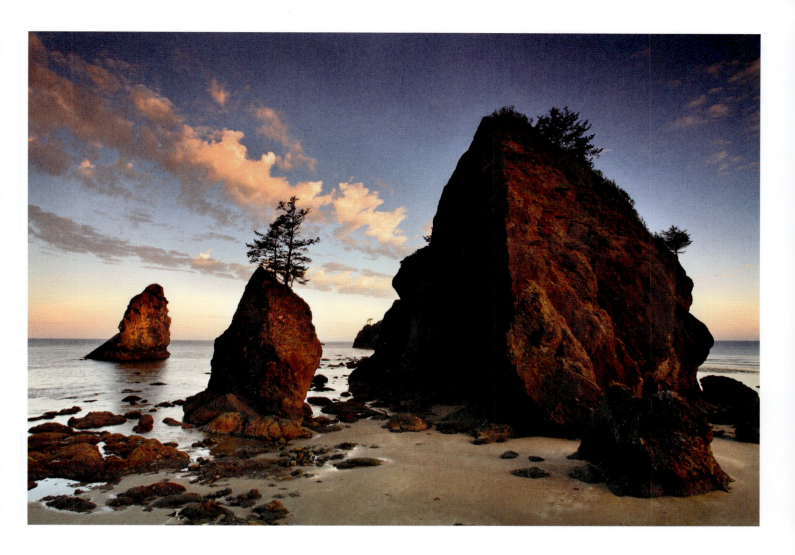

Pastel colors of sunrise illuminate a collection of sea stacks on Shi Shi Beach, Olympic National Park. •

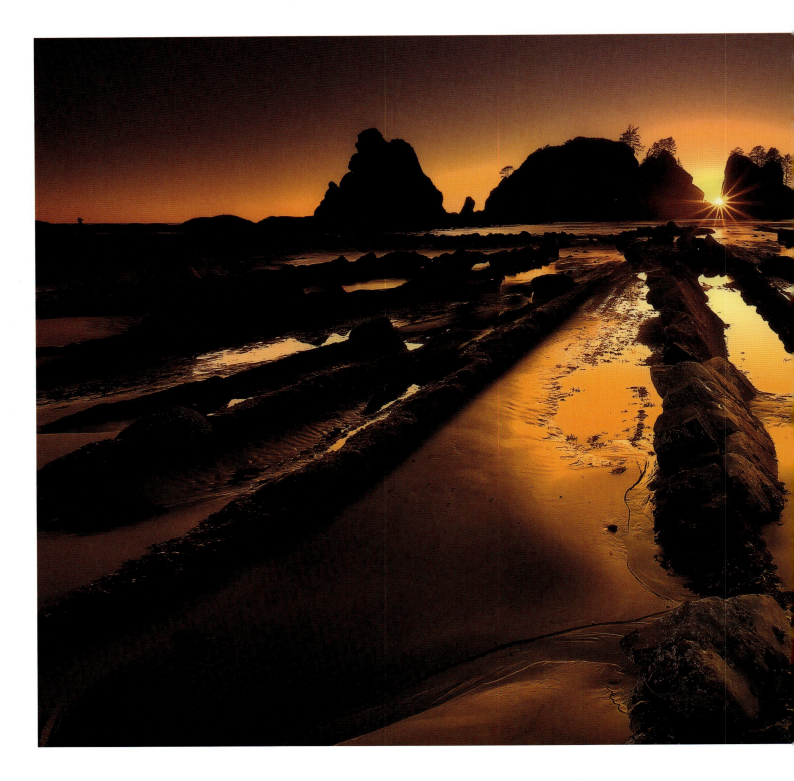

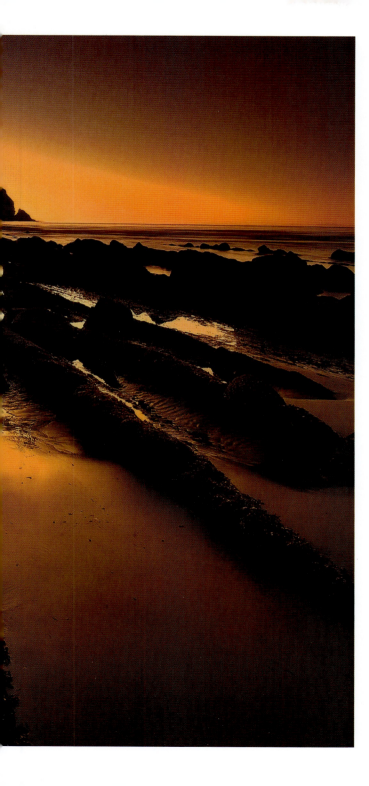

Sun dips below the sea stacks on Shi Shi Beach at the Point of Arches. Shi Shi Beach is the northernmost beach in Olympic National Park. •

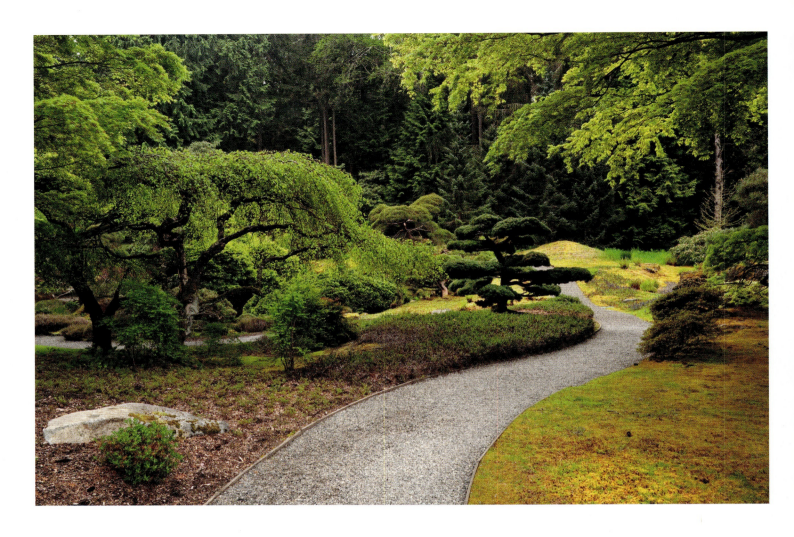

A garden path at the formal Japanese
Garden in the Bloedel Reserve on
Bainbridge Island. •

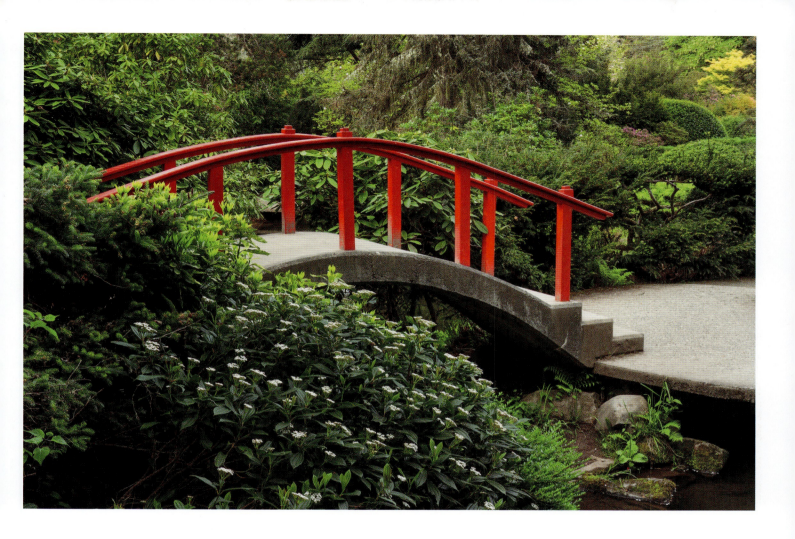

Viburnum blooms alongside the
Moonbridge at Seattle's Kubota
Garden in spring. ●

Bellingham's Whatcom Falls during a dry spring. •

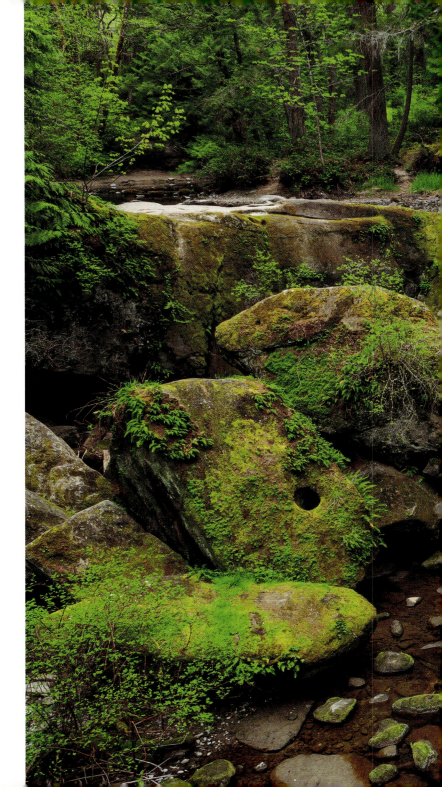

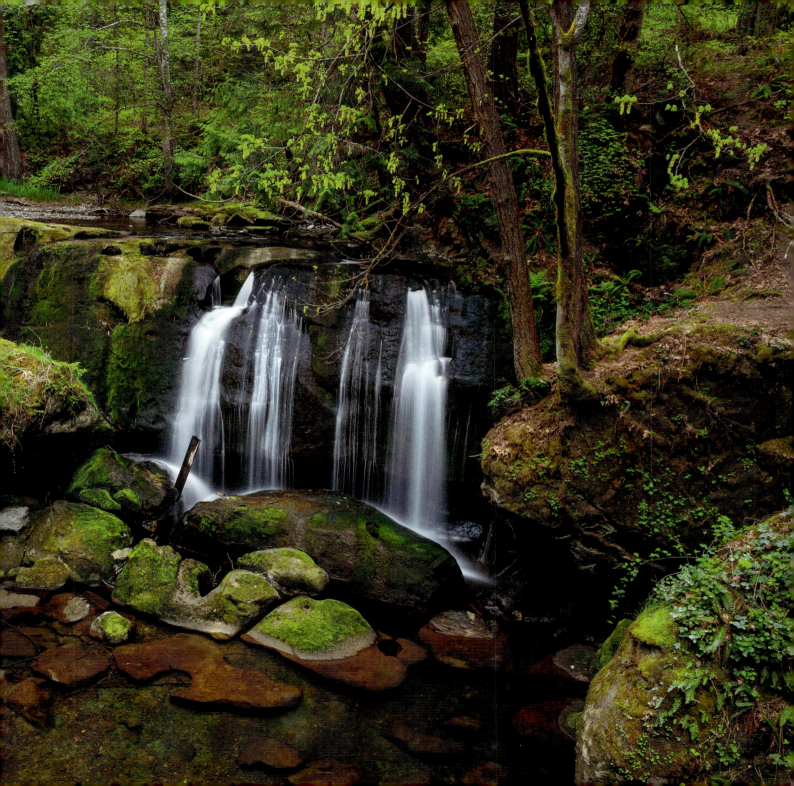

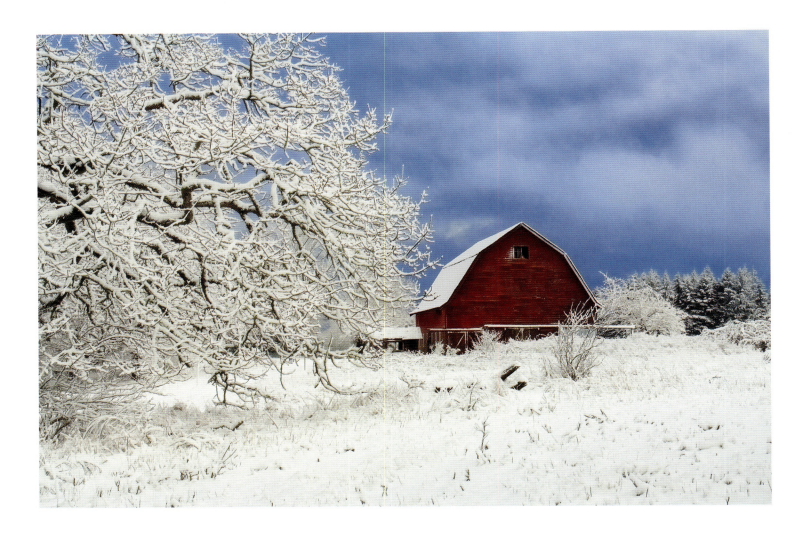

A fresh snowfall covers the rural farm area
of Scatter Creek just south of Olympia. •

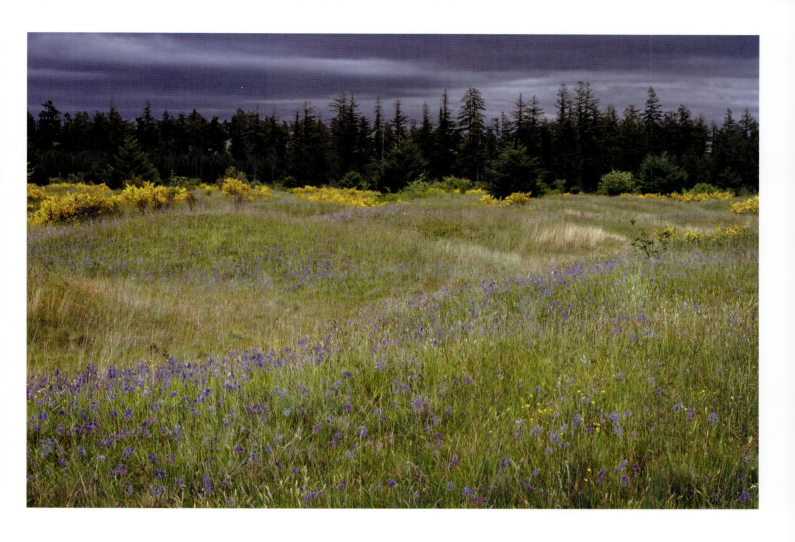

Mima Mounds Natural Area Preserve
south of Olympia contains hundreds of
acres of mima mounds—low, domelike,
naturally formed soil structures. The
mounds are blanketed in wildflowers
in spring. •

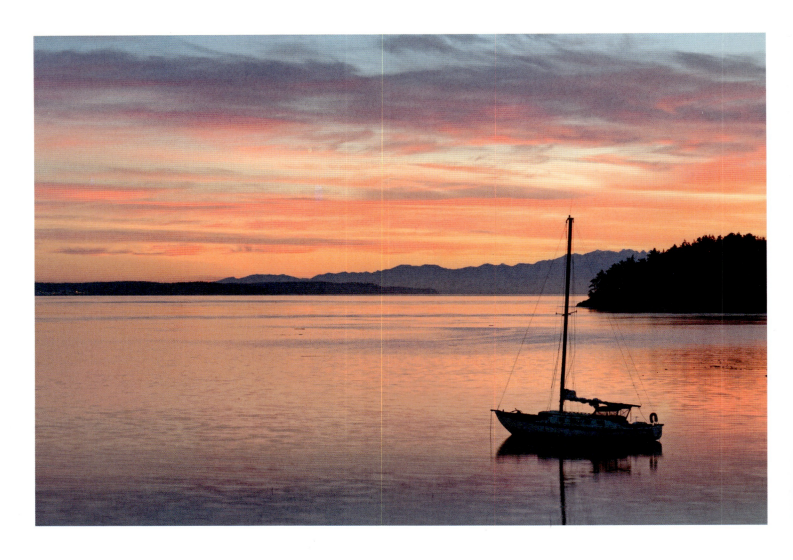

A sailboat is in safe harbor at Bowman
Bay on Fidalgo Island at sunset. •

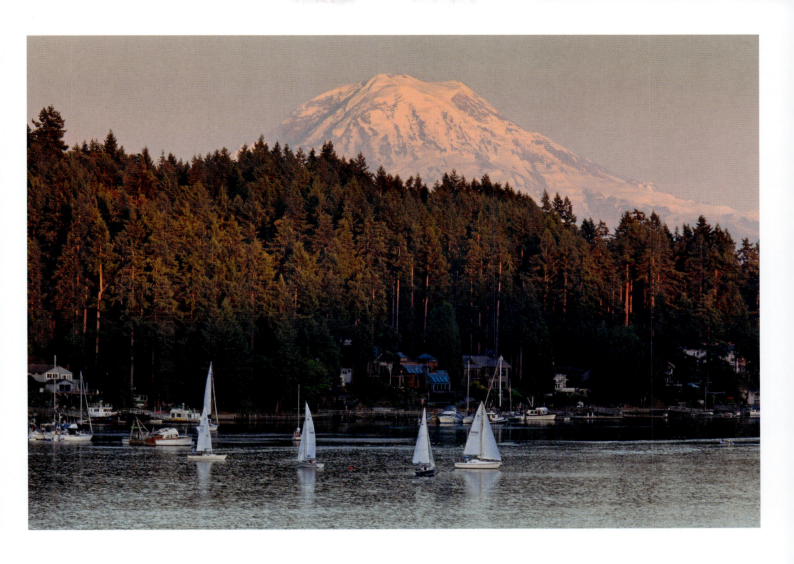

The picturesque Gig Harbor below the majestic Mount Rainier during a stormy sunset. •

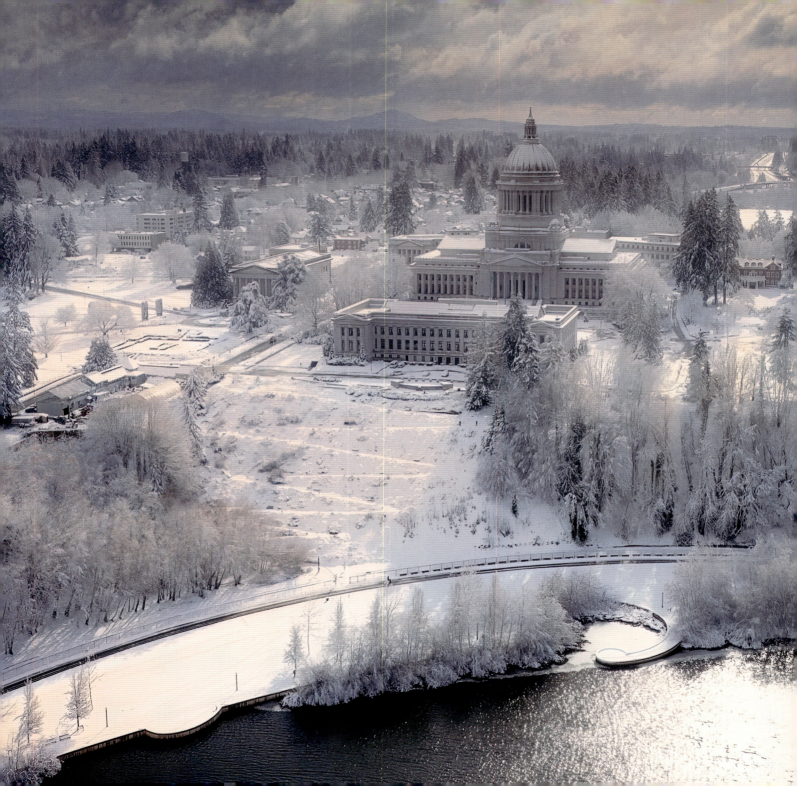

An aerial view of the capitol building of Olympia and grounds with fresh snow. Capitol Lake can be seen in the foreground. •

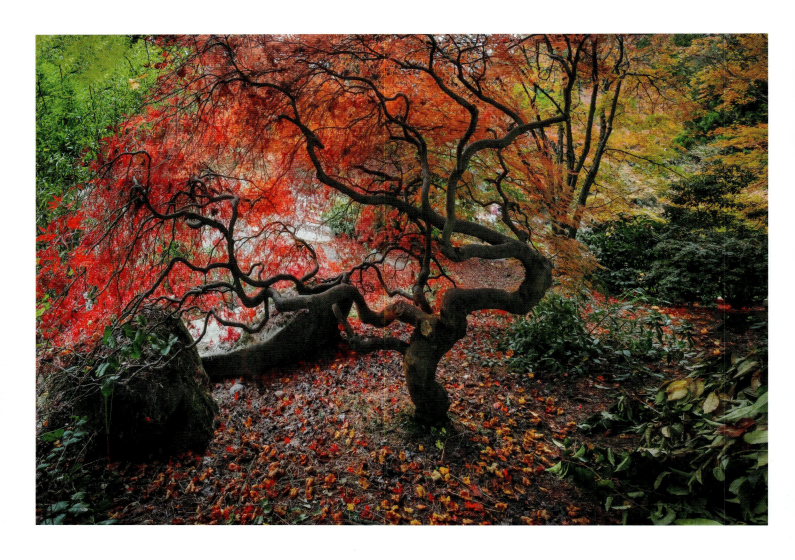

A Japanese maple tree at its autumnal peak in Olympia's Yashiro Japanese Garden. ●

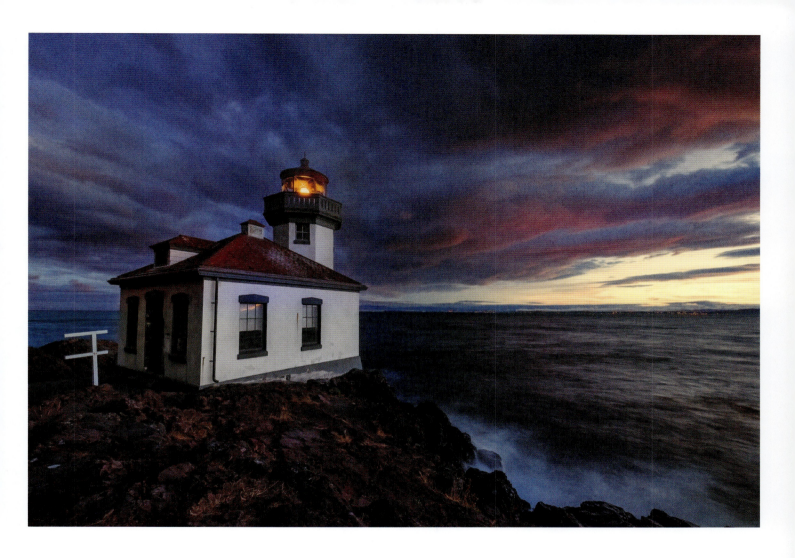

Lime Kiln Lighthouse stands strong during a summer storm. The lighthouse overlooks Dead Man's Bay on the western side of San Juan Island. •

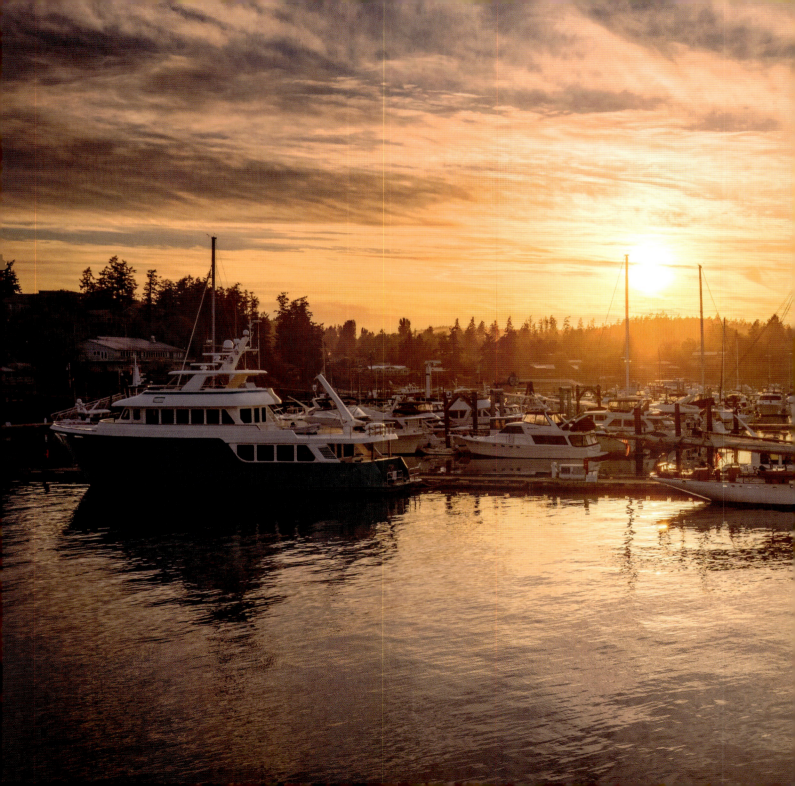

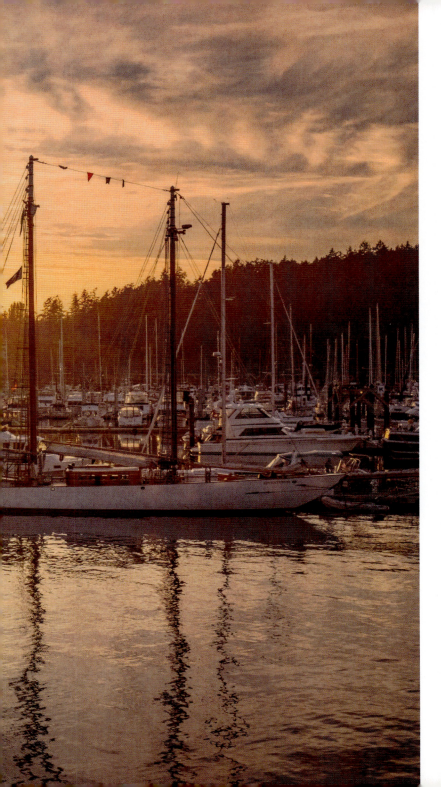

Sunset from the ferry in Friday Harbor on San Juan Island is a beautiful sight. Friday Harbor is the only incorporated town in the San Juan Islands. In the early 1900s it was a busy working seaport but today it is a popular tourism and sailing destination. •

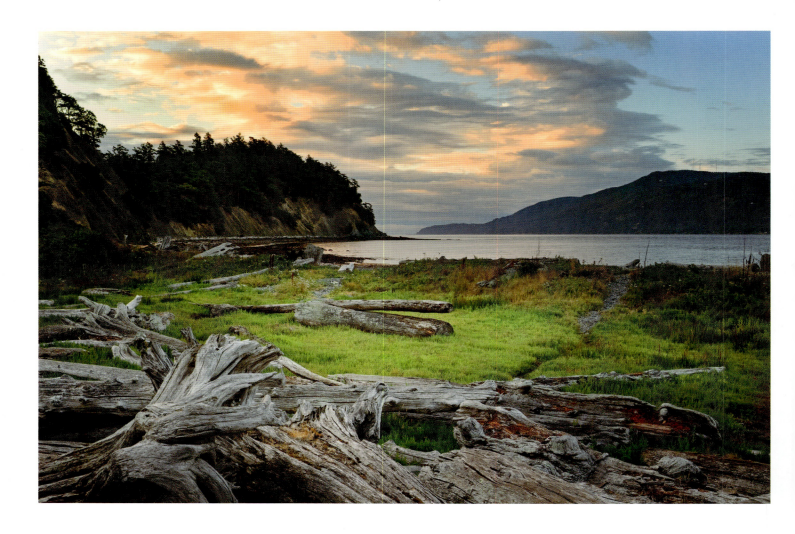

Piles of driftwood jumbled up along
the shore as the morning sun lights up the
clouds on Sucia in the San Juan Islands. •

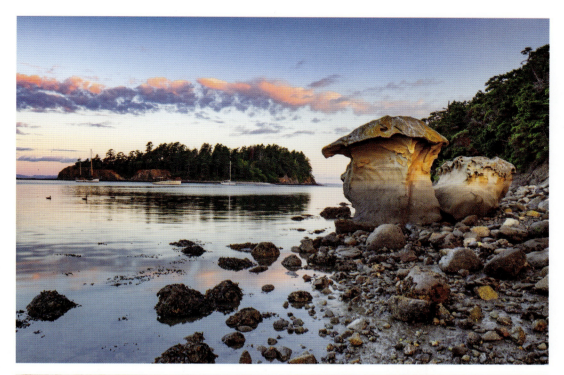

A minus tide along the shore at sunrise exposes a lesser-seen area of Sucia in the San Juan Islands. •

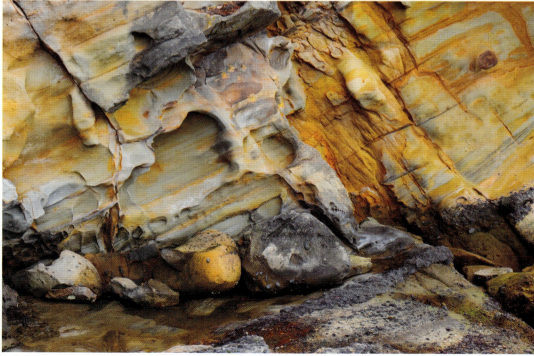

Unique and colorful sandstone formations dot the landscape at Sucia in the San Juan Islands. •

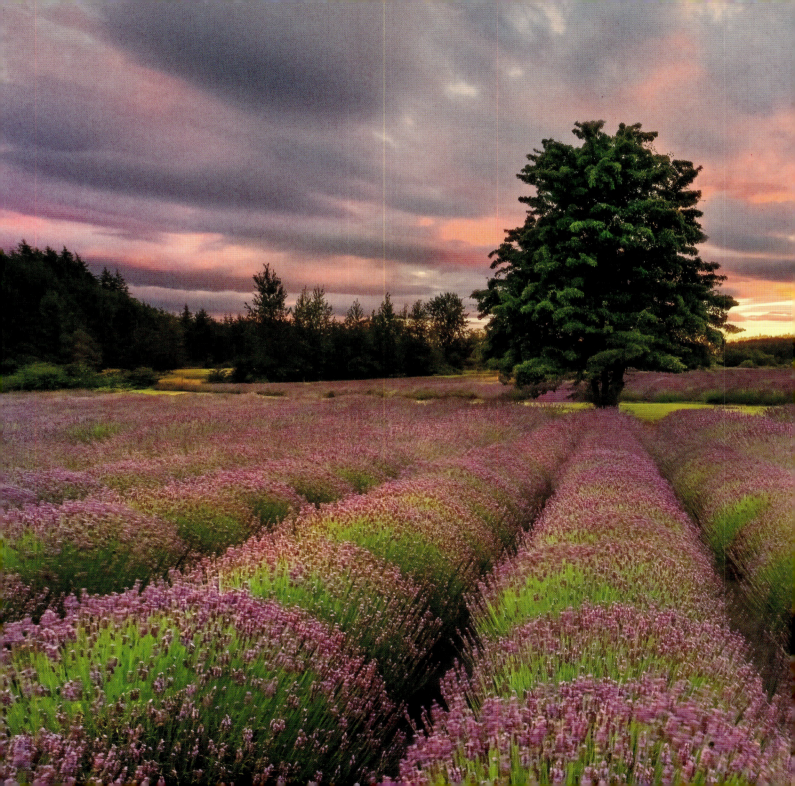

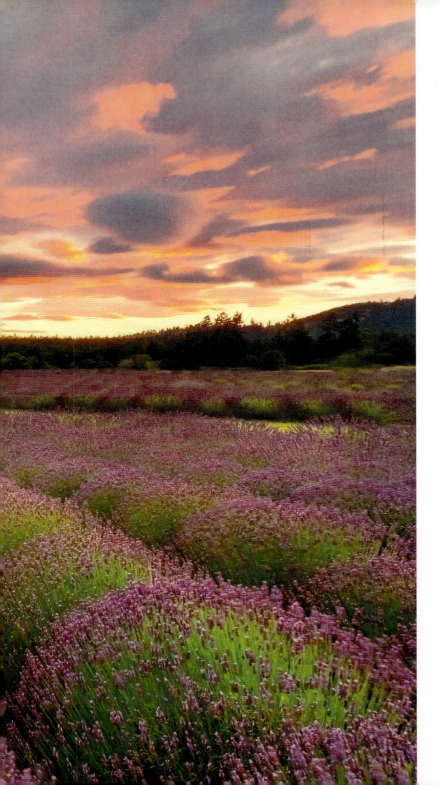

Pink pastel sunset above a lavender farm on Friday Harbor in the San Juan Islands. •

A lamp lights the way by a stone bridge and path. The filtered sun provides backlighting to the fall leaves of Seattle's Japanese Garden. ●

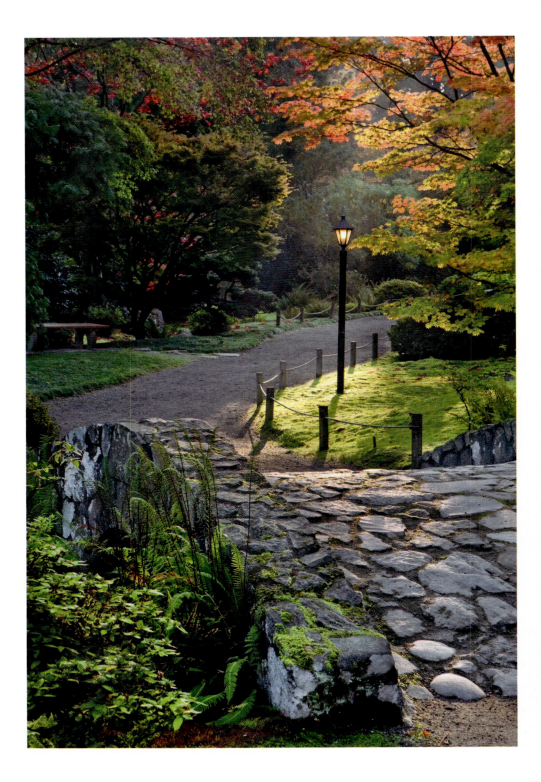

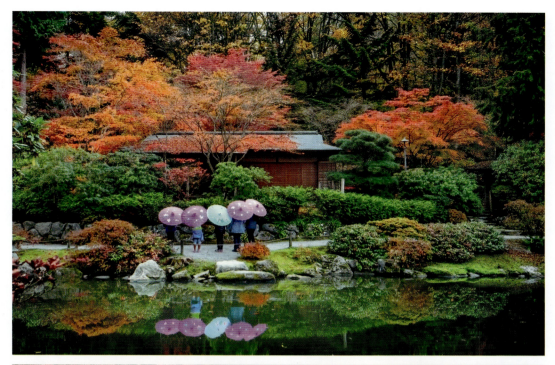

A set of colorful umbrellas and bystanders take in the sights of the Seattle Japanese Garden during fall season. ●

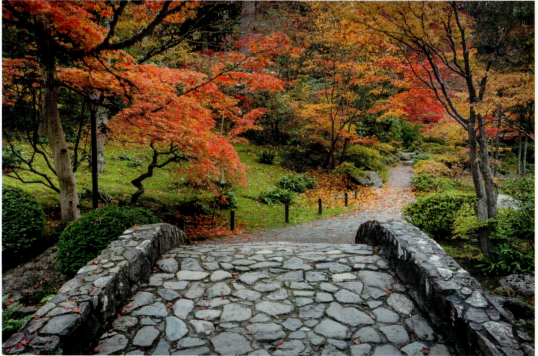

A pathway bridge takes visitors into the stunning autumn colors of the Seattle Japanese Garden. ●

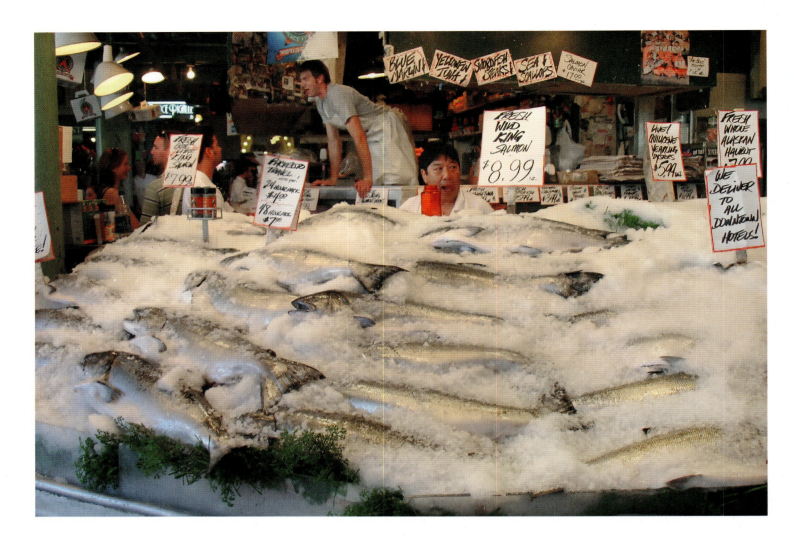

Seattle's world-famous Pike Place Fish Market. Tourists from all over the world come to see and taste the seafood. •

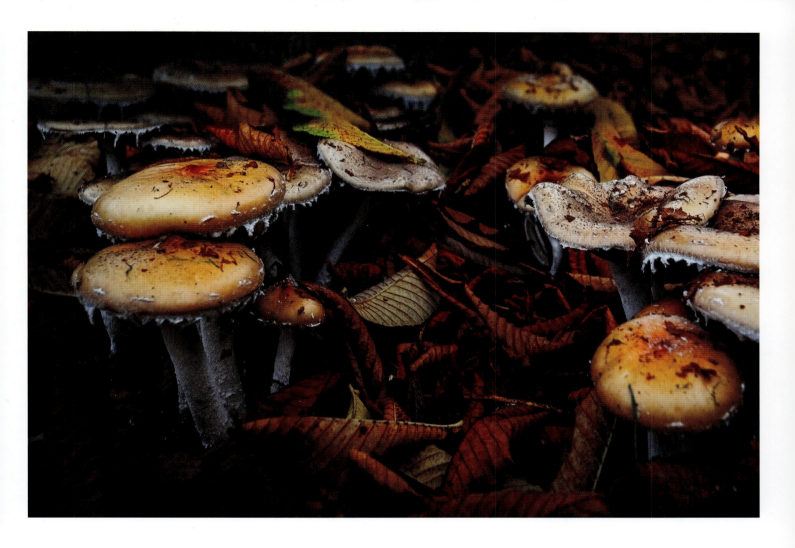

A view from the forest floor of mushrooms and autumn foliage in Seattle's Washington Park Arboretum. •

OVERLEAF From an overlook in the Queen Anne neighborhood, you take in a view of downtown Seattle and Mount Rainier. •

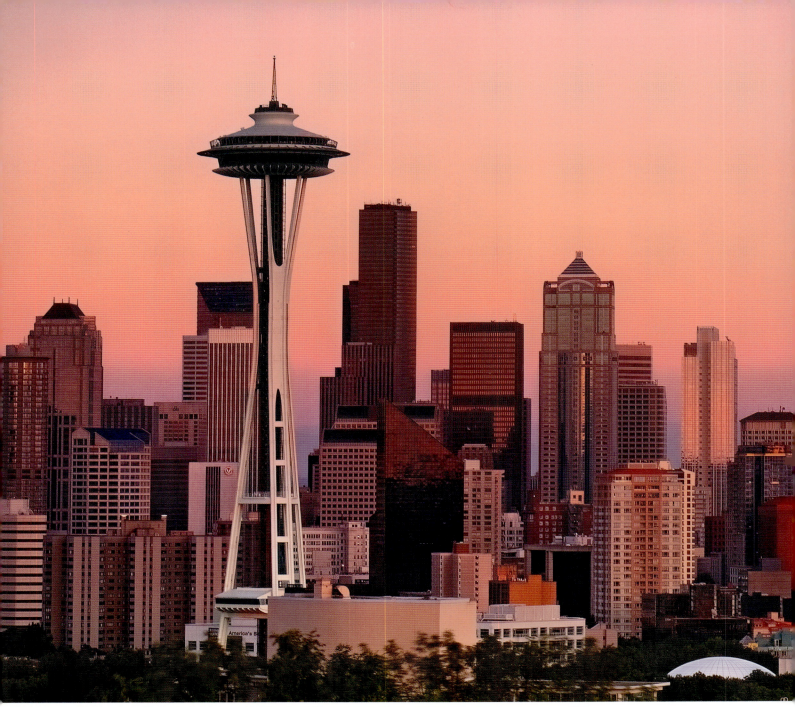

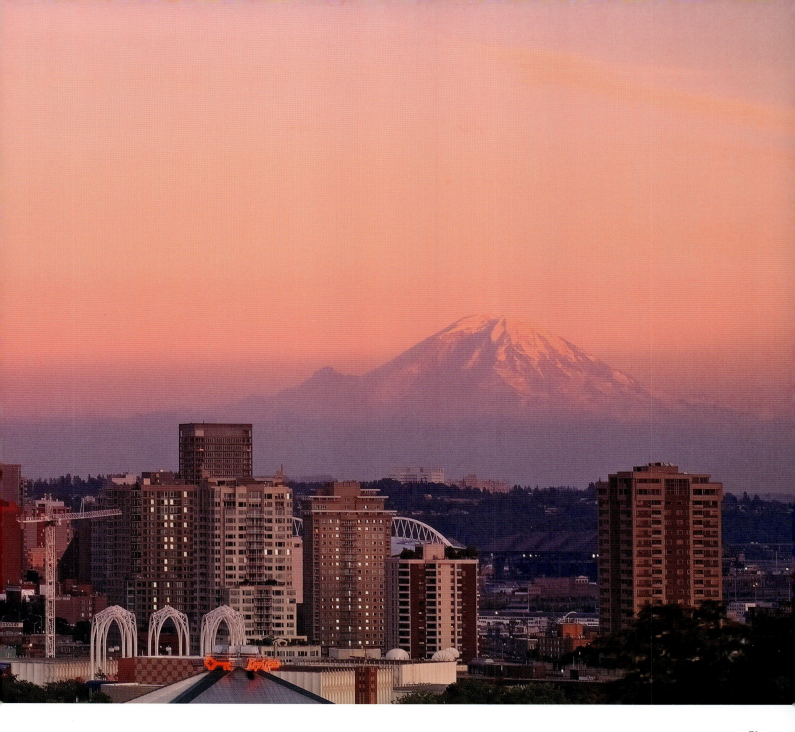

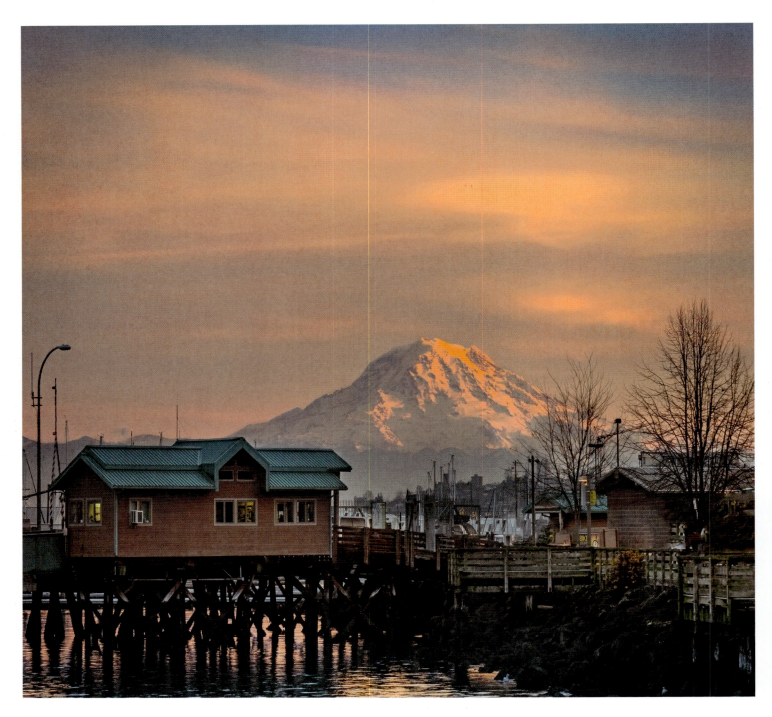

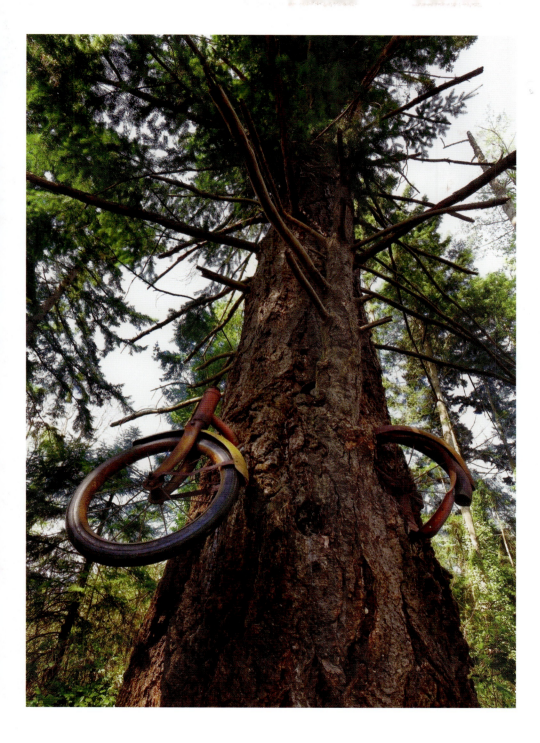

OPPOSITE A waterfront view of Mount Rainier and Point Defiance Marina in Tacoma during a sunset. •

LEFT On Vashon Island, an old, rusted bicycle is being consumed by a tree and pushed nearly 7 feet from the ground. •

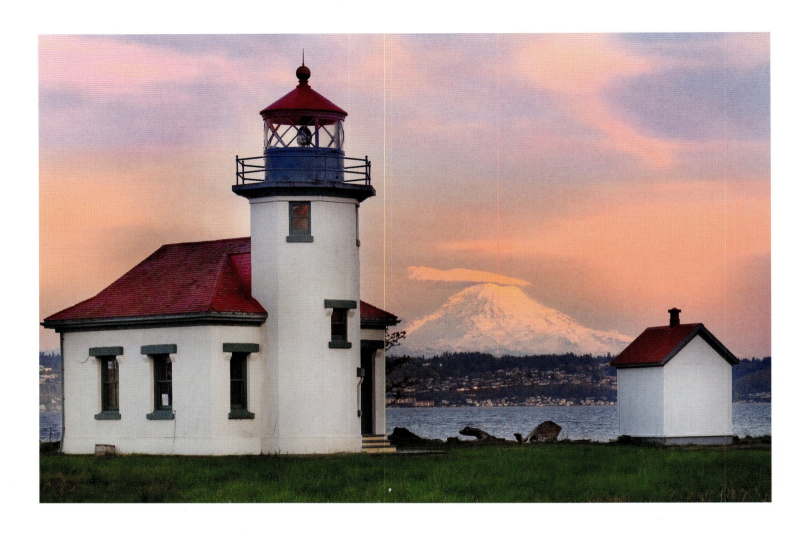

ABOVE Mount Rainier framed at sunset at Vashon Island's Point Robinson Lighthouse overlooking the Puget Sound. •

OPPOSITE An old tractor sits on the front lawn of a Vashon Island farm property. •

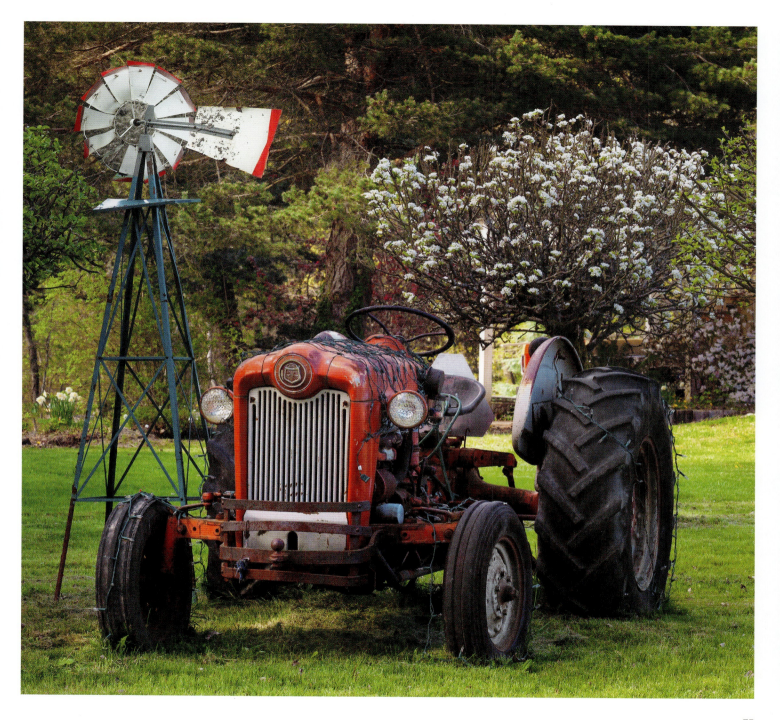

Barnacles and mussels cling to the posts of a pier on Coupeville Wharf on Whidbey Island. •

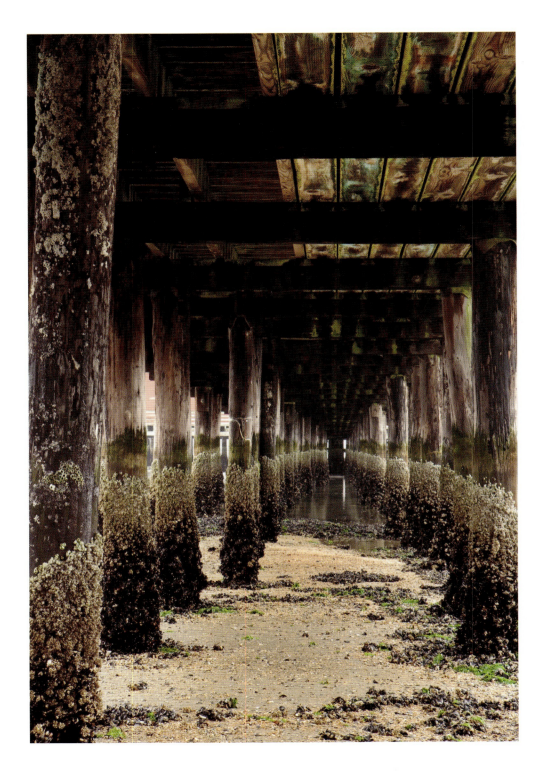

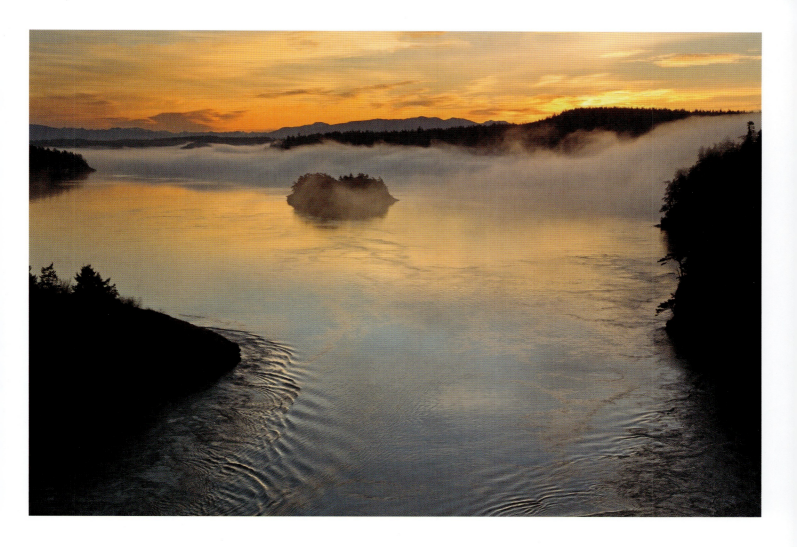

ABOVE Sunrise and fog with Strawberry Island in the distance at Deception Pass State Park on Whidbey Island. •

OVERLEAF Three boats anchor on a calm morning in Penn Cove near Coupeville Wharf on Whidbey Island. •

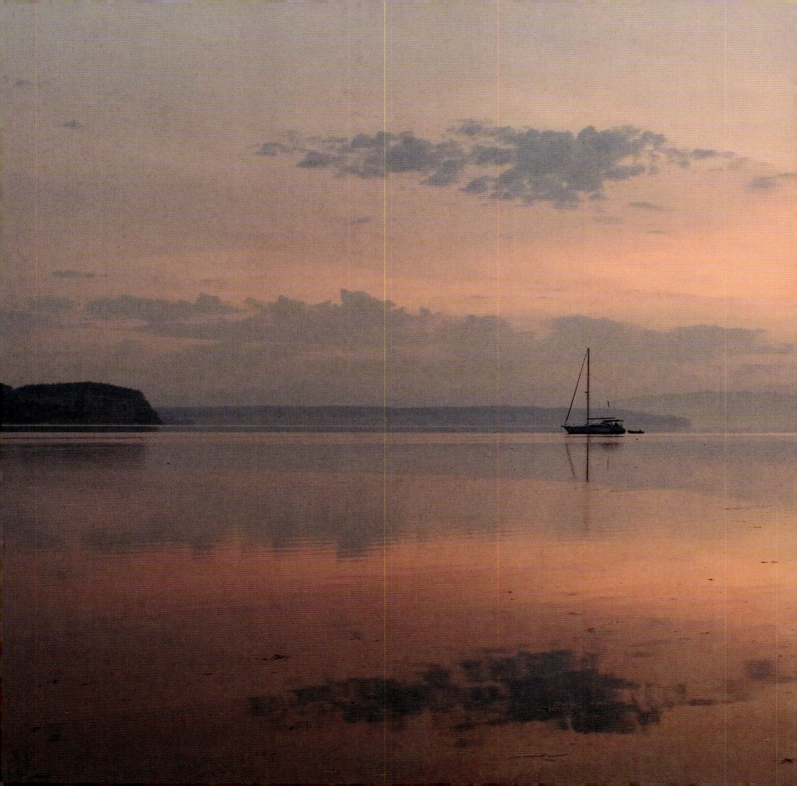

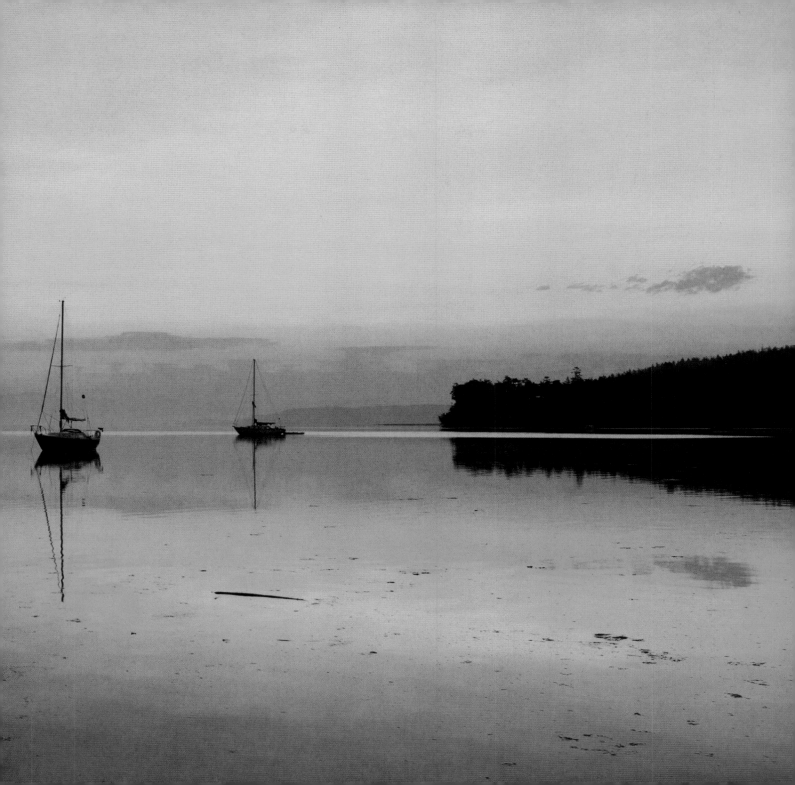

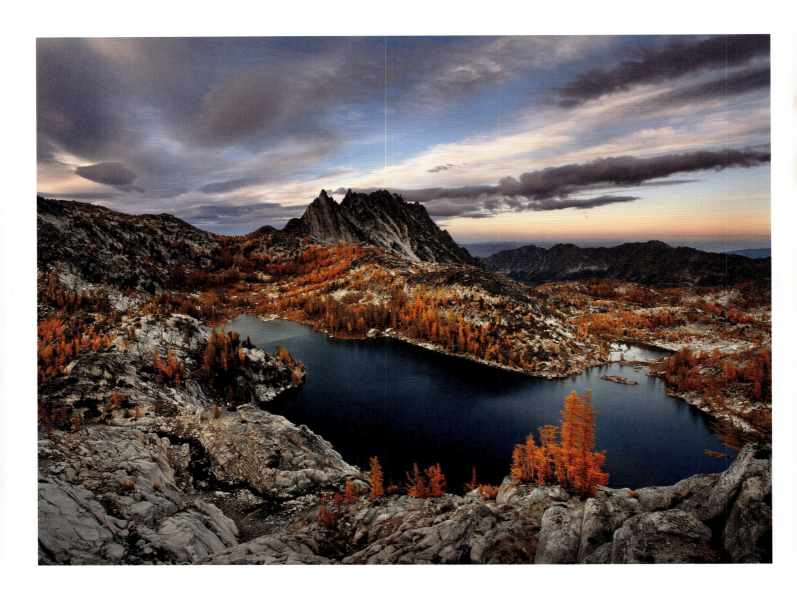

Storm clouds gather over Perfection Lake
and Prusik Peak in the Enchantments in
the Alpine Lakes Wilderness. •

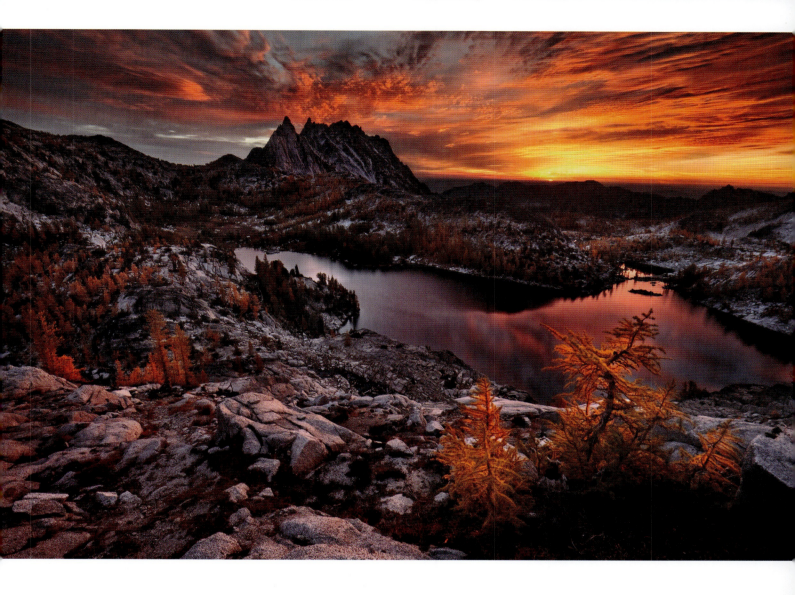

ABOVE A fiery sunrise bathes the beautiful Enchantments in red light. •

OVERLEAF, LEFT TO RIGHT
The Milky Way floats above Prusik Peak and Gnome Tarn on a cold autumn night high in the Enchantments. • Fall larch reflecting in an Enchantments pond. •

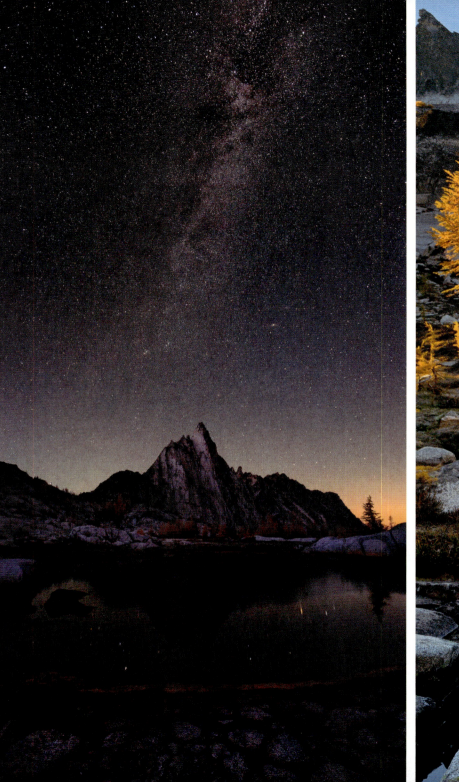
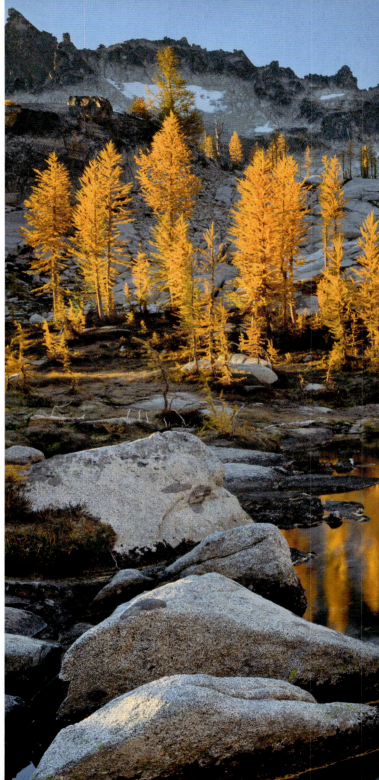

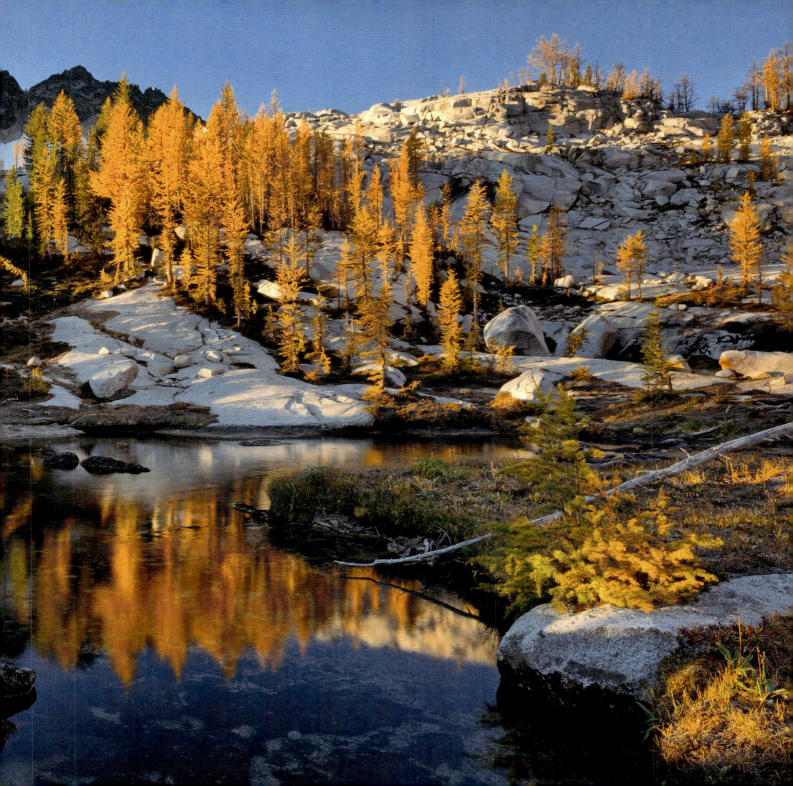

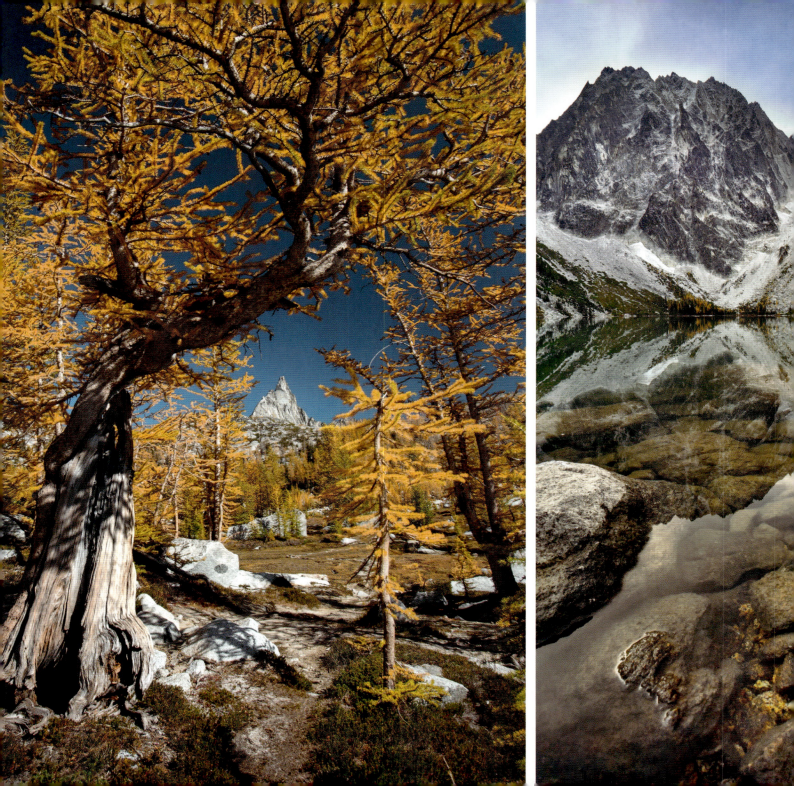

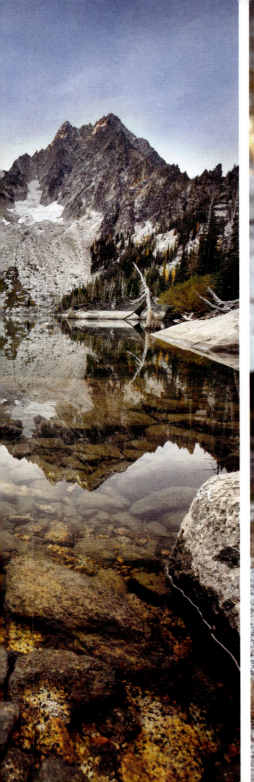
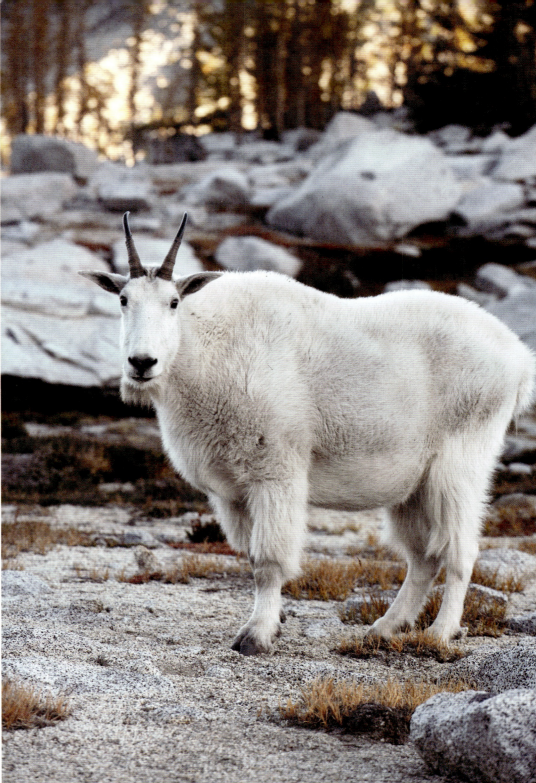

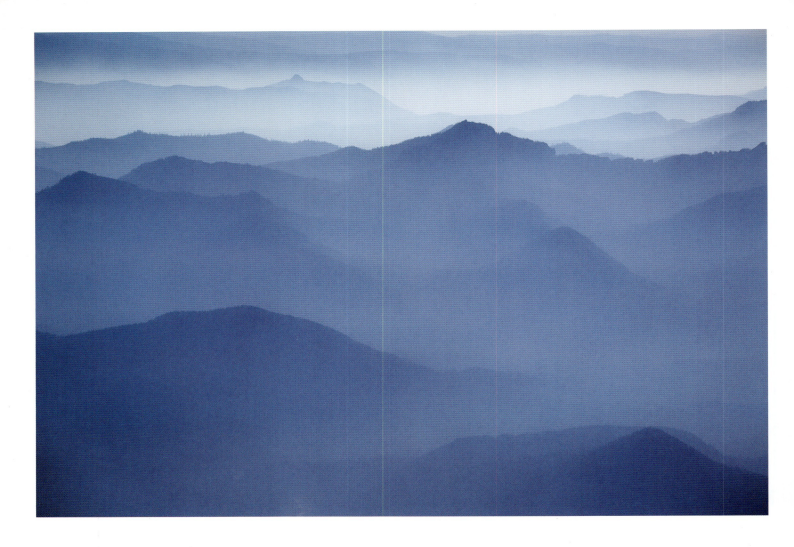

PREVIOUS PAGES, LEFT TO RIGHT
In October in the Enchantments, the autumn foliage of western larch trees (*Larix occidentalis*) blaze against a cobalt sky. • A mirror-like reflection at Colchuck Lake with Colchuck and Dragon Tail Mountains in the background during the colorful fall season in the Alpine Lakes Wilderness. • A wild mountain goat greets hikers in the Enchantments. •

ABOVE High up on Mount Rainier near Camp Muir, the Cascades seem to stretch on forever. •

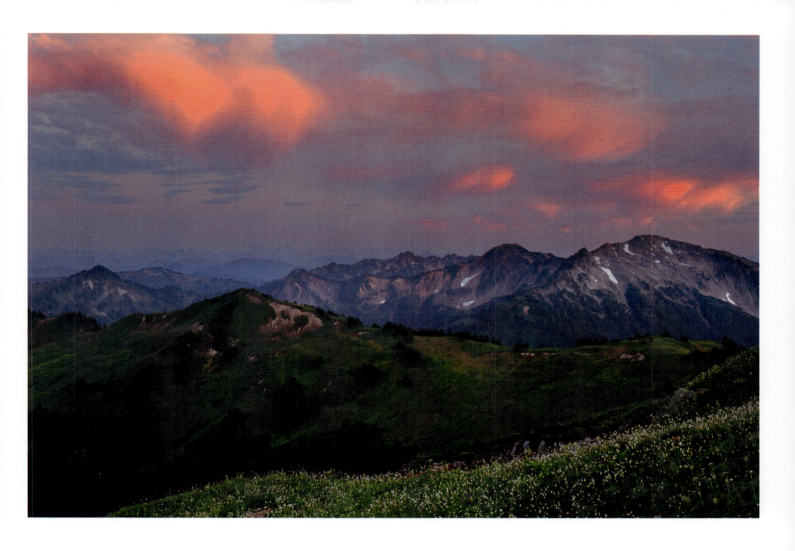

Cloud wisps catch the last rays of sunlight over the peaks and valleys of the Glacier Peak Wilderness. •

Rainbow Creek drops 392 feet over Rainbow Falls in the Lake Chelan National Recreation Area, part of North Cascades National Park. The falls can only be reached by hiking over the mountains or by a 50-mile boat ride up Lake Chelan. •

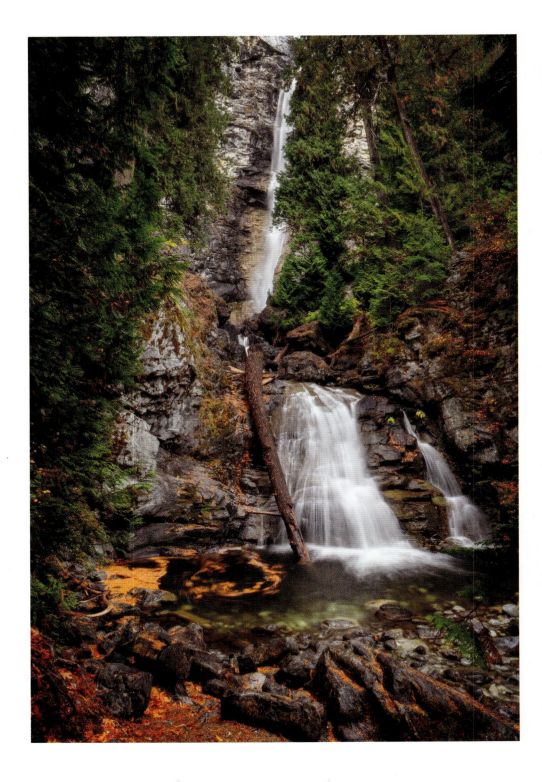

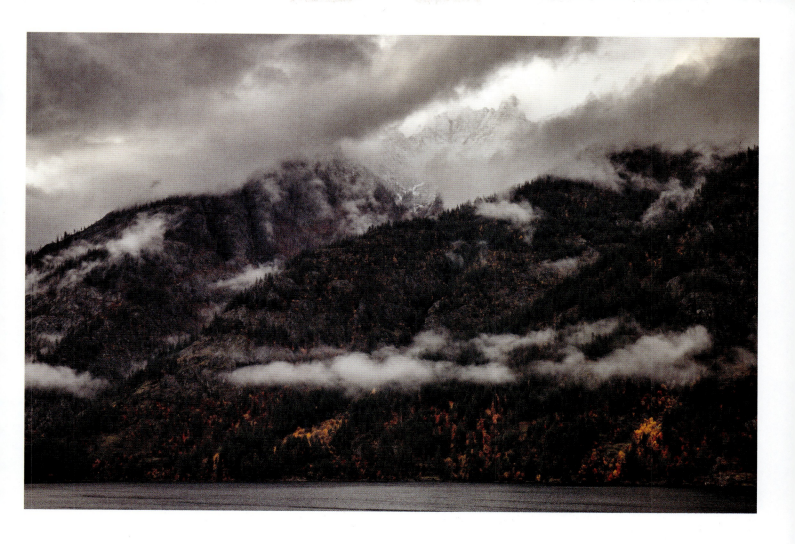

Late autumn storms bring low clouds
and mountain snows to Lake Chelan, the
third deepest lake in the United States.
Stehekin, a small community with no road
access, lies at the north end of the lake. ●

Stones and boulders break up the fall
color reflections of the Methow River in
the Methow Valley. ●

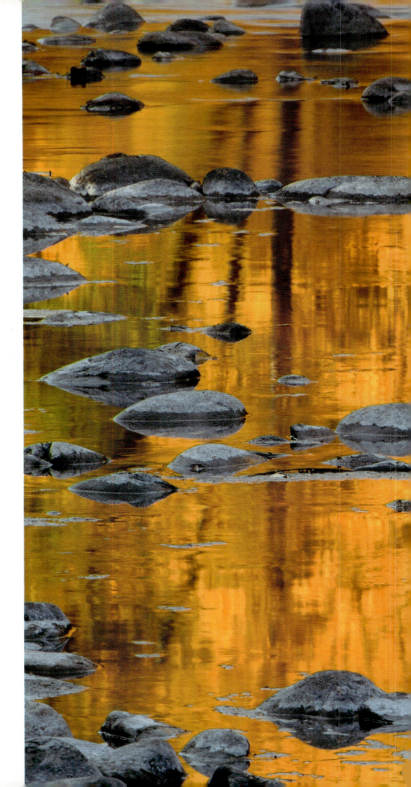

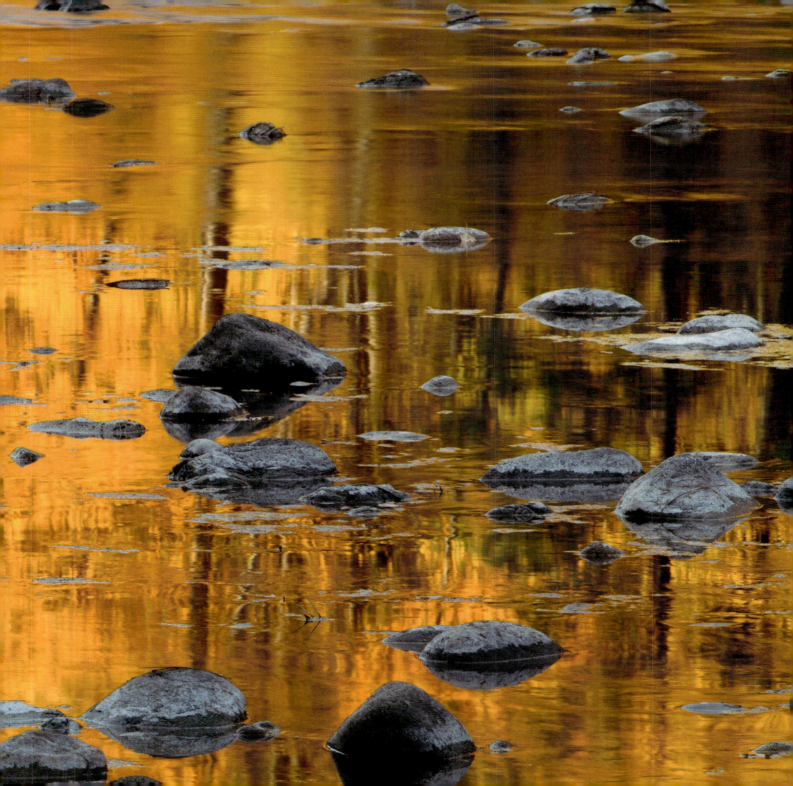

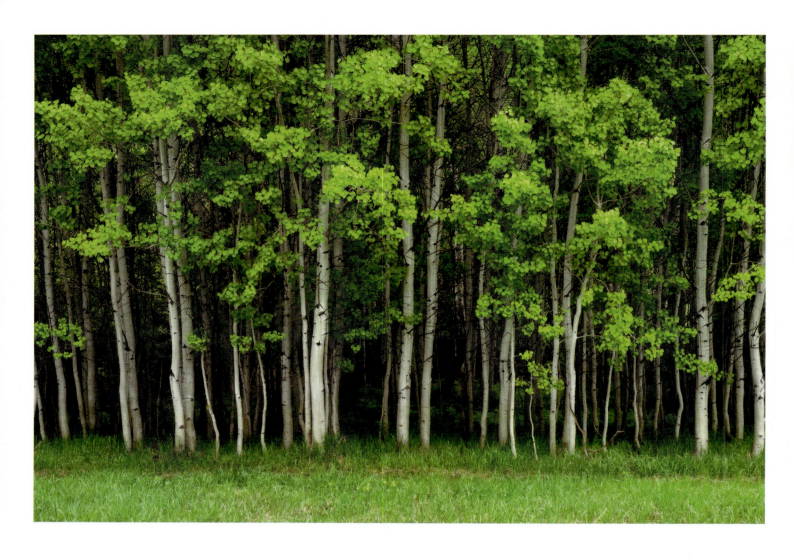

Fresh spring foliage fills a dense aspen grove in the mountains surrounding the Methow Valley. ●

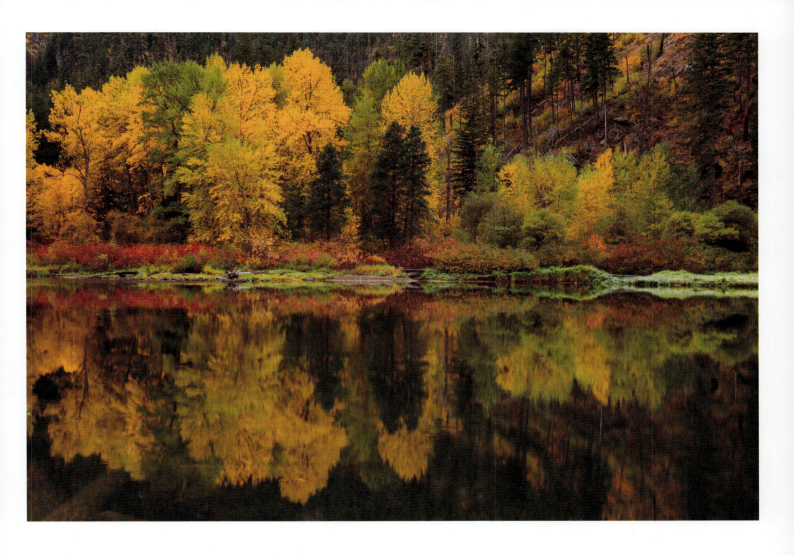

Fall reflections in a calm spot on the
Wenatchee River in the Methow Valley
near Winthrop. •

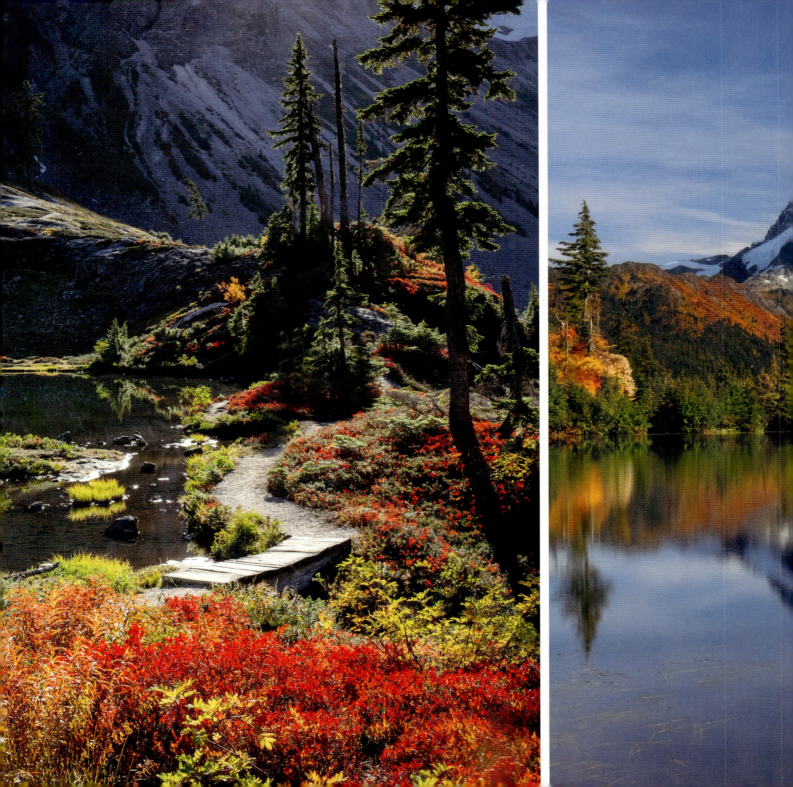

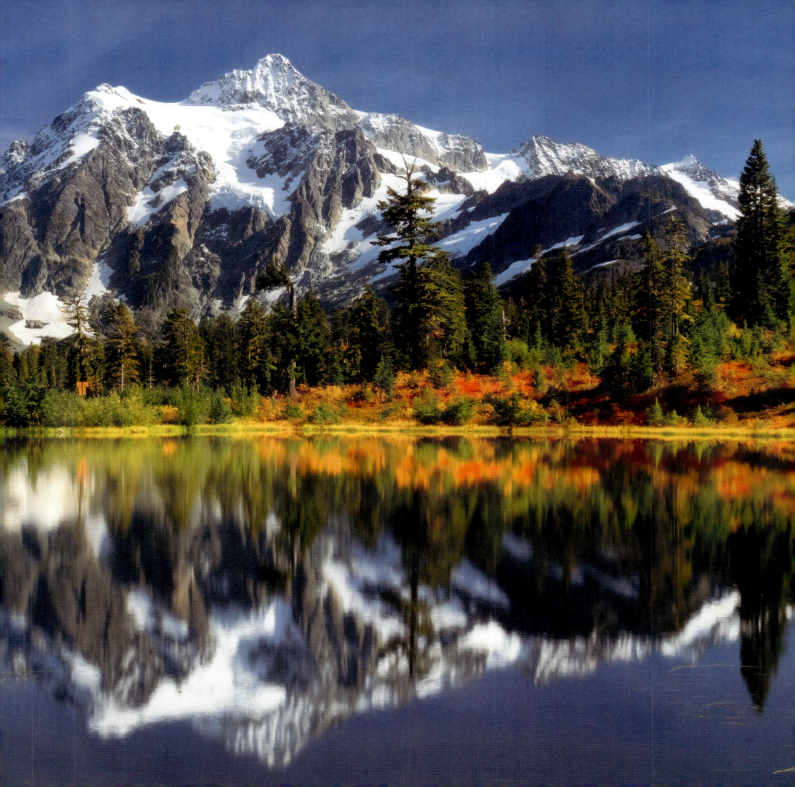

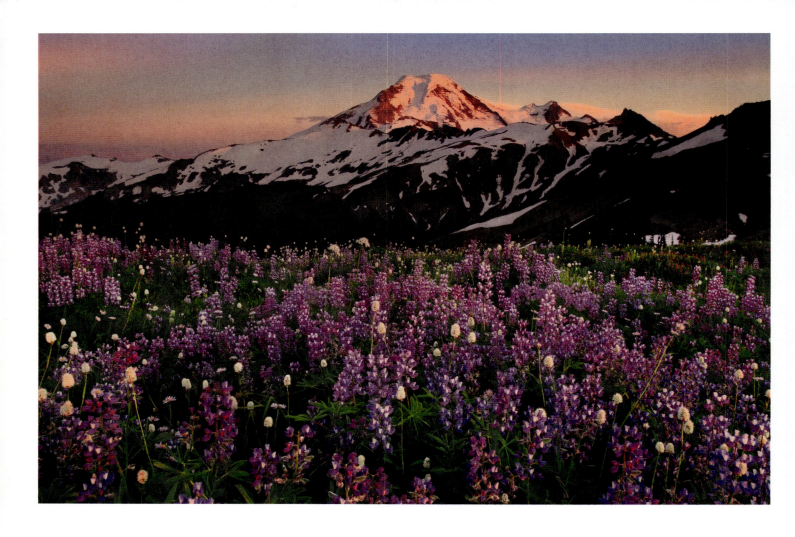

PREVIOUS PAGES, LEFT TO RIGHT
Fall foliage glows in late afternoon
light along the Bagley Lakes Loop trail
in Mt. Baker-Snoqualmie National
Forest. • Fall color lines the banks of
Picture Lake in the North Cascades with
Mount Shuksan in the background. •

ABOVE Wildflower meadows from Skyline
Divide at sunset with Mount Baker in the
background. •

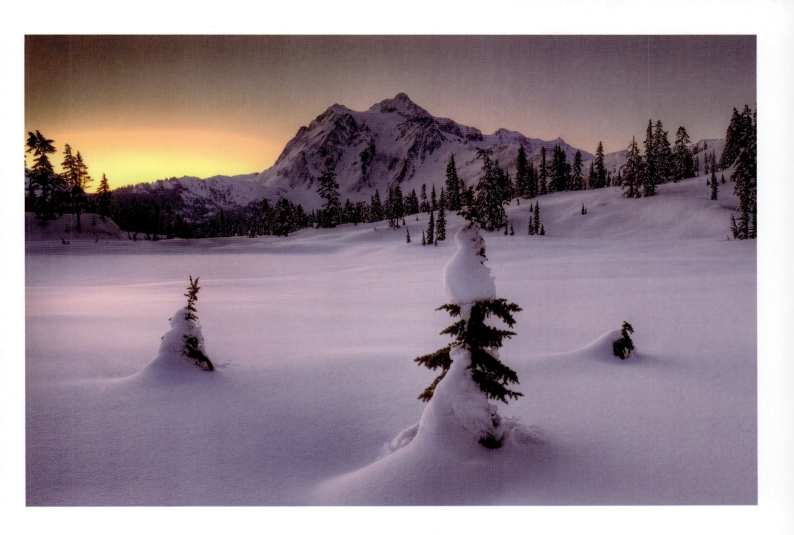

The winter sun glows behind
Mount Shuksan over Picture Lake in
Mt. Baker–Snoqualmie National Forest. •

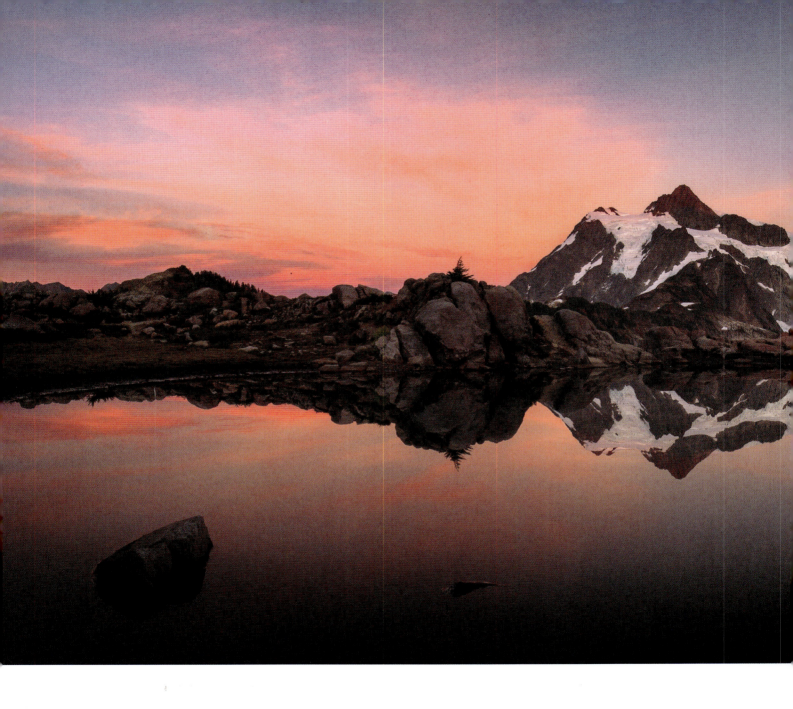

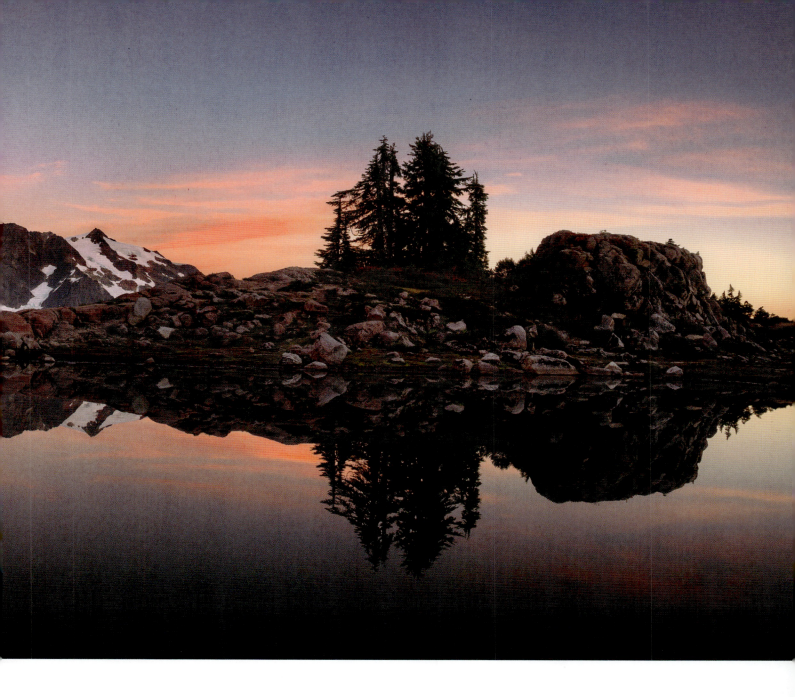

PREVIOUS PAGES Mount Shuksan, one of the crown jewels of the North Cascades, reflecting in the mirror-like surface of an alpine pool at sunset near Artist Point. •

A breathtaking sunrise captured in the Alpine Lakes Wilderness near Mount Stuart. •

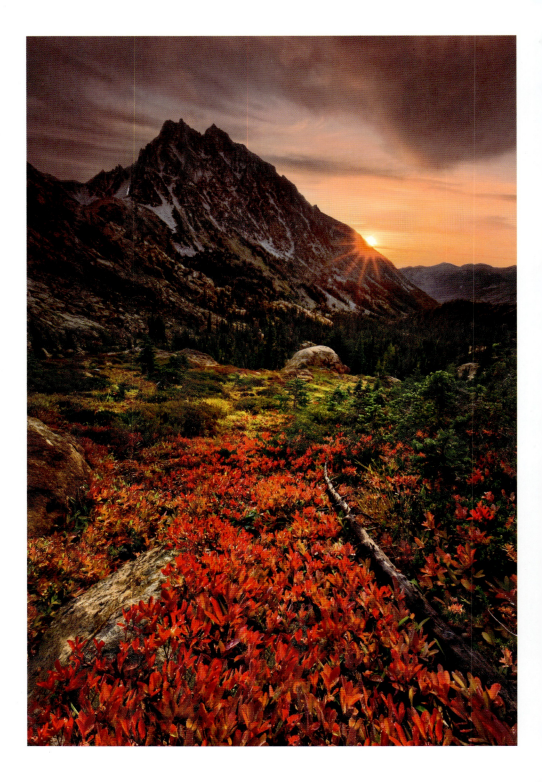

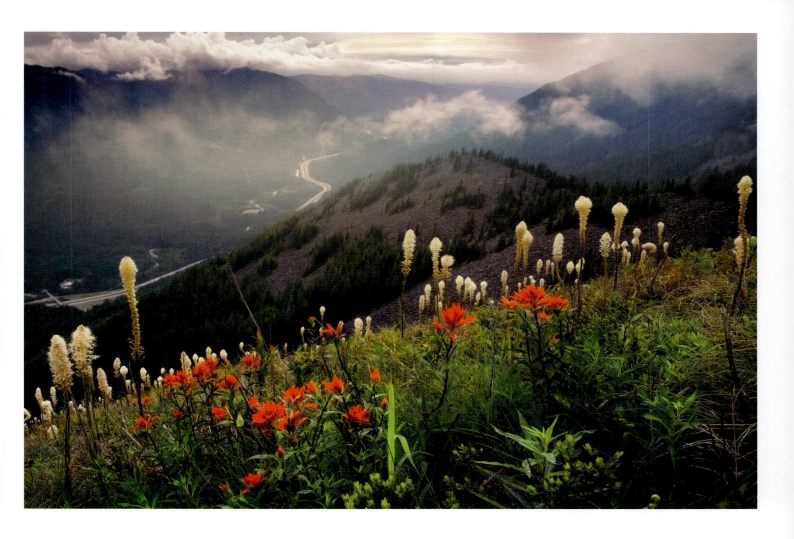

Wildflowers appear in springtime along
the hills of Bandera Mountain near
Snoqualmie Pass. ●

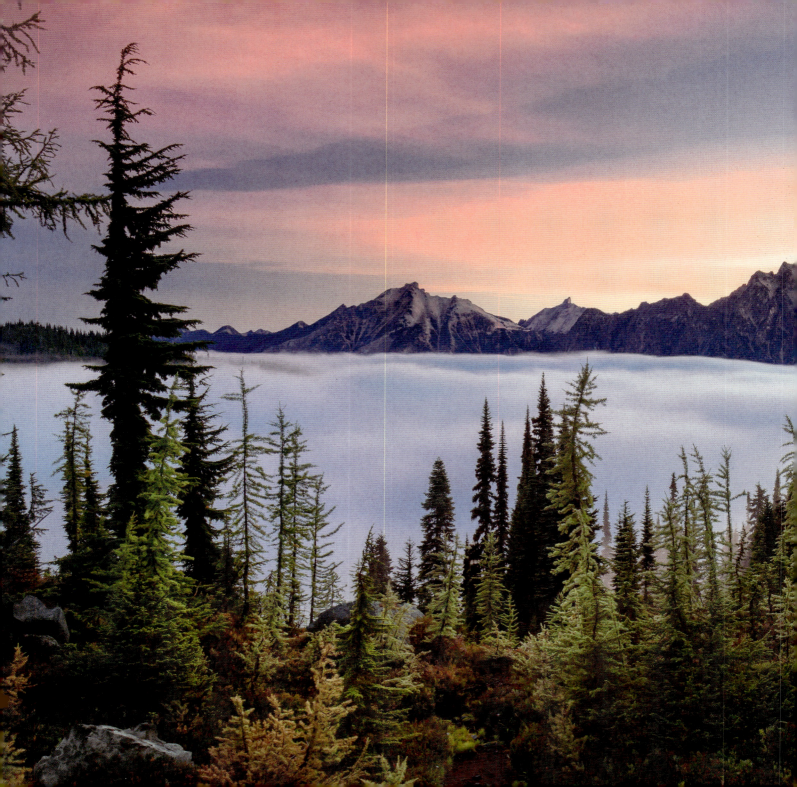

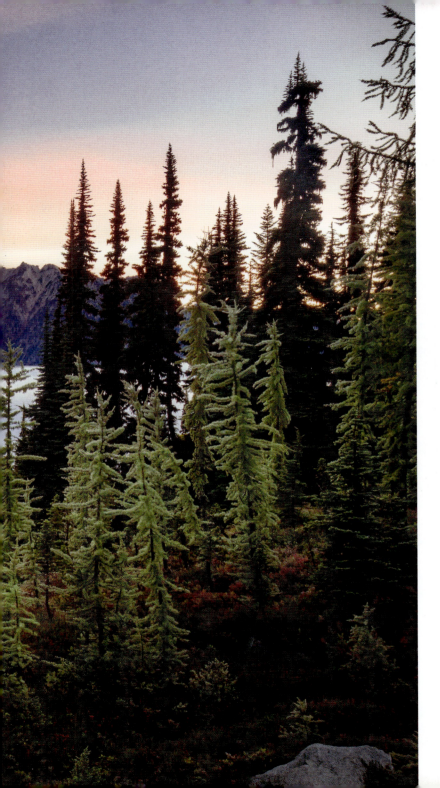

Sunrise adds a blush of color to the sky and illuminates a sea of fog below Heather Pass in the Okanogan-Wenatchee National Forest on the border of North Cascades National Park. •

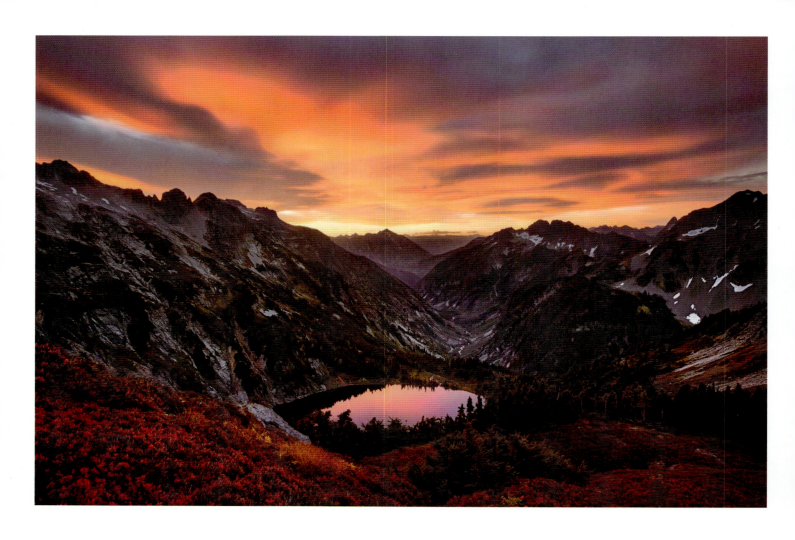

A colorful sunrise captured from Cascade
Pass in North Cascades National Park. •

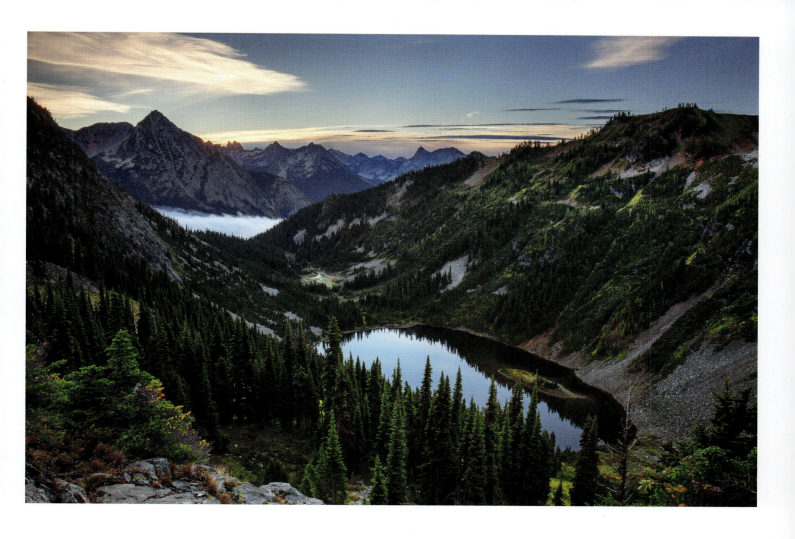

The trail to Maple Pass rewards hikers with stunning views down the glacial carved valley to Ann Lake and Rainy Pass beyond. ●

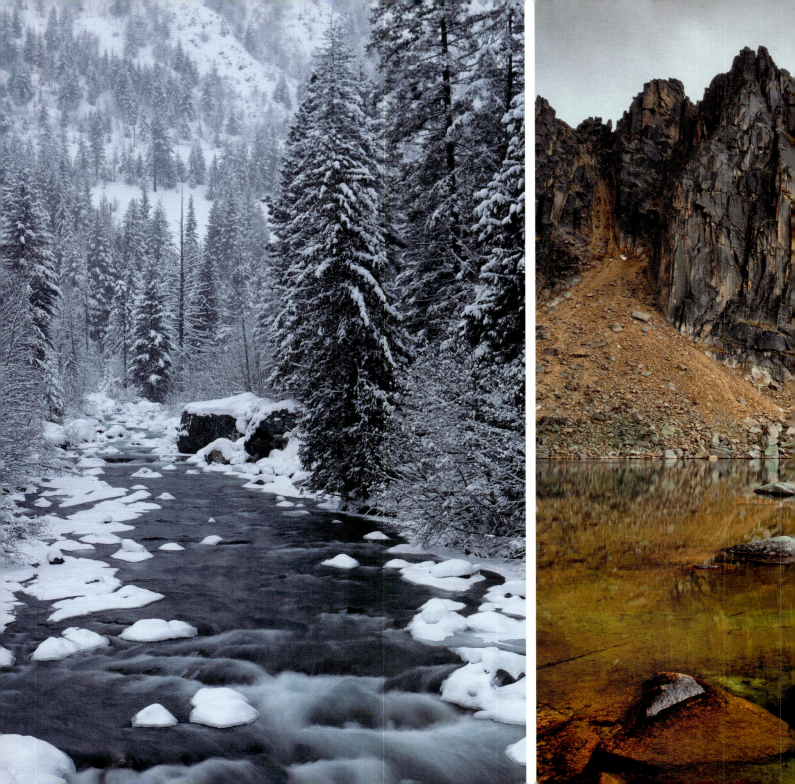

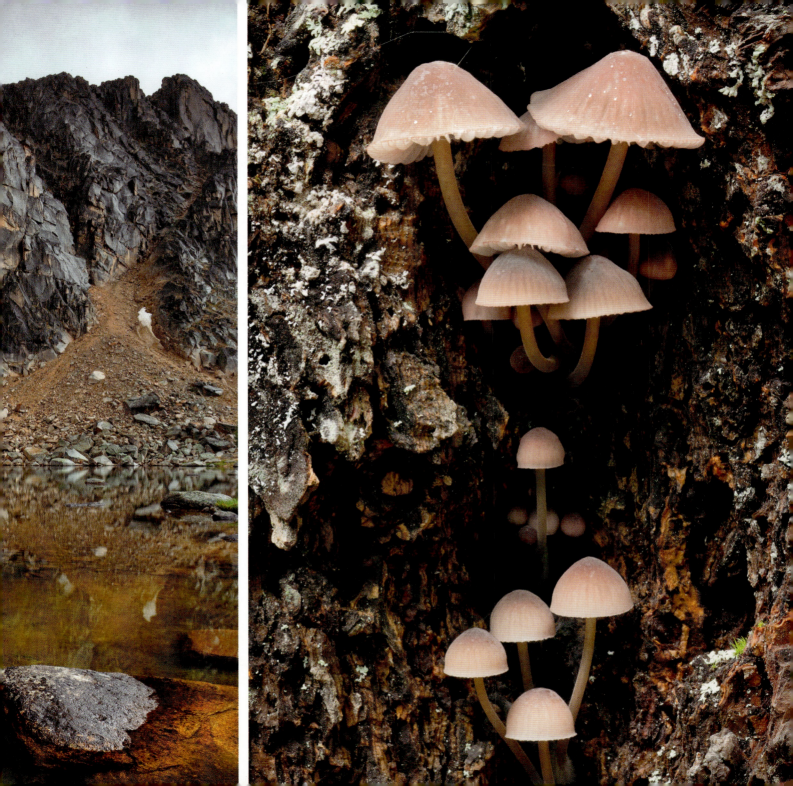

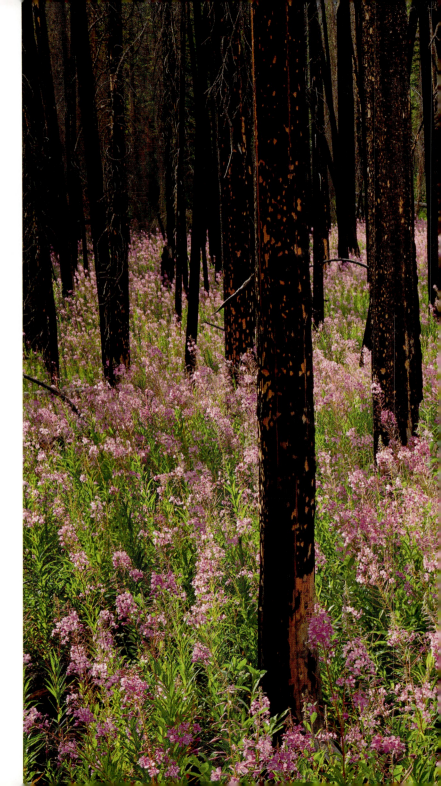

PREVIOUS PAGES, LEFT TO RIGHT
A creek flows through the Baker-Snoqualmie National Forest during a snowstorm. • Near the high point of the Pacific Northwest National Scenic Trail lies Upper Cathedral Lake and Amphitheater Mountain of the Pasayten Wilderness. It's a stormy day in Washington's high country. • Purple edge bonnet (*Mycena purpureofusca*) growing in the cavity of an old tree. •

RIGHT Fireweed (*Chamerion angustifolium*) grows along the Chewuch Trail in a burned area of the Pasayten Wilderness on a summer day. •

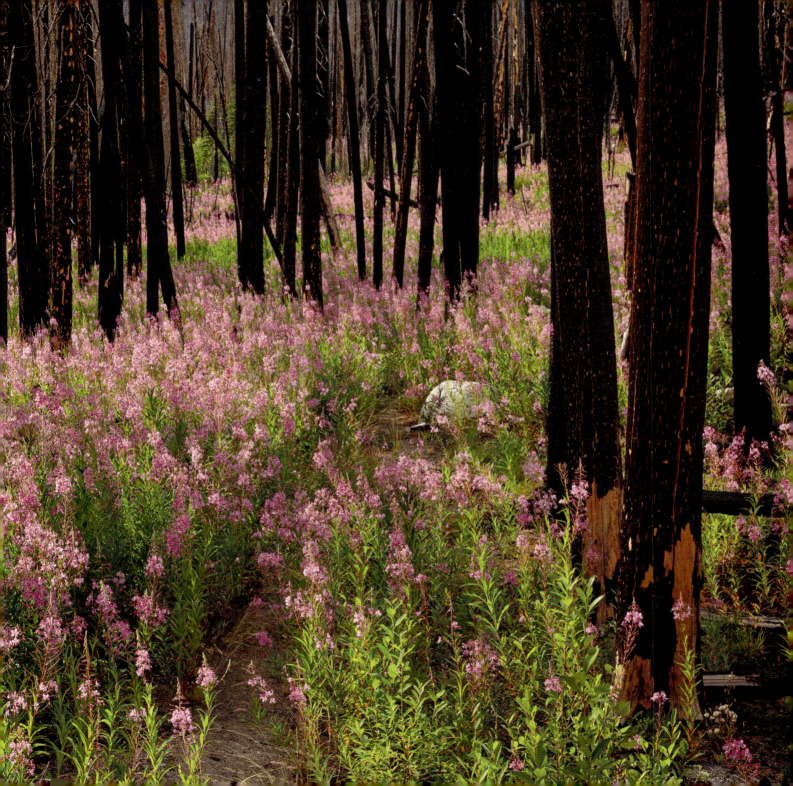

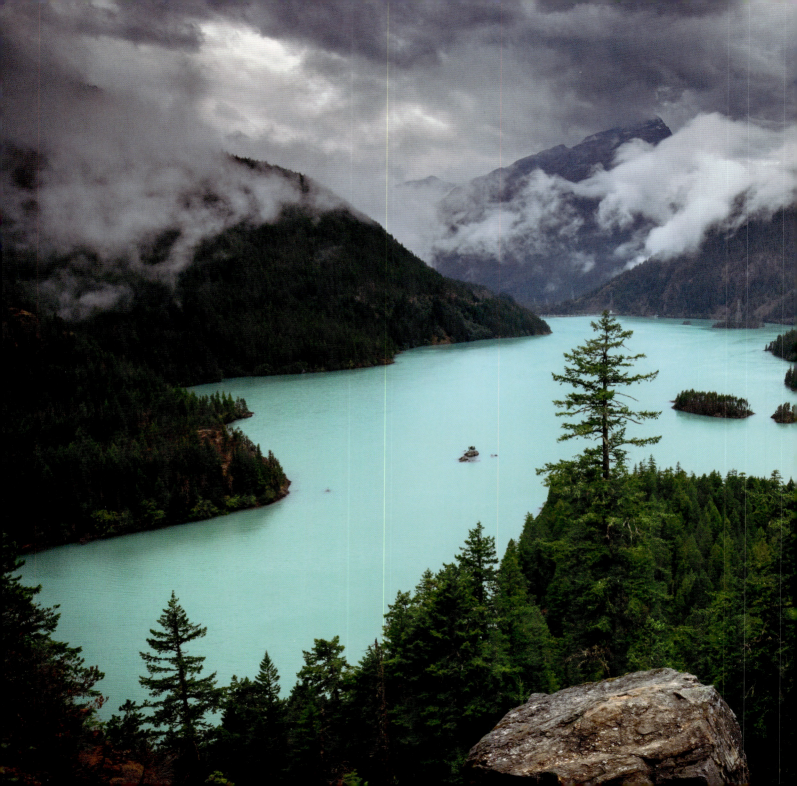

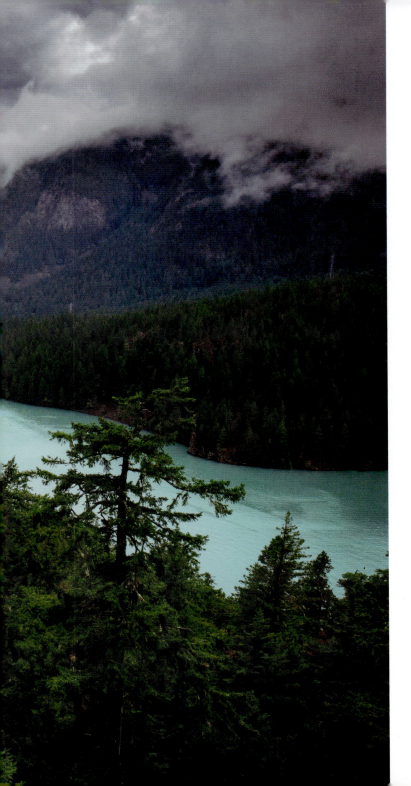

The striking turquoise color of Diablo Lake in the North Cascades is a result of the fine rock powder that is ground by surrounding glaciers and carried to the lake in melt water. ●

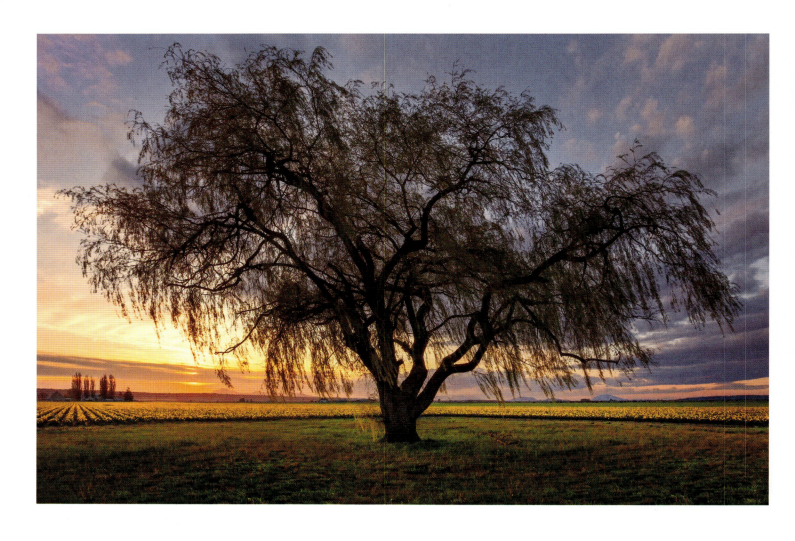

A solo weeping willow tree stands in front of the Skagit Valley tulip fields. •

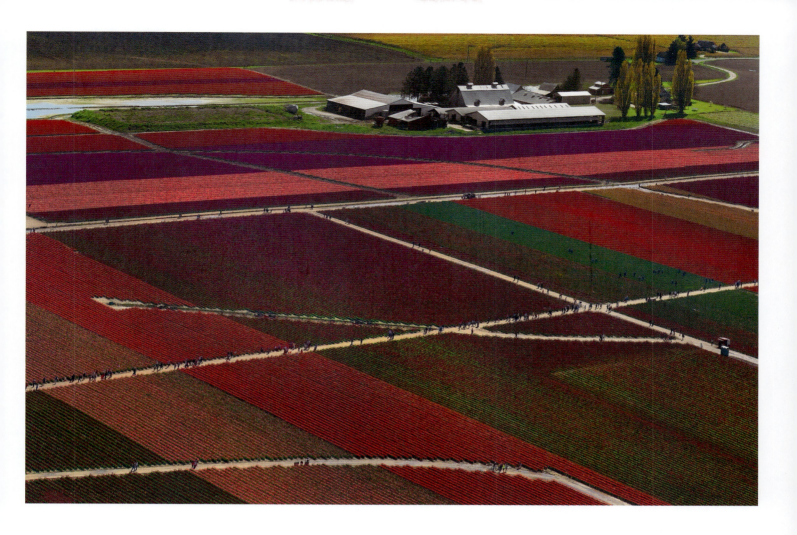

An aerial view of the colorful tulip fields of
Skagit Valley, a popular tourist destination
in springtime. ●

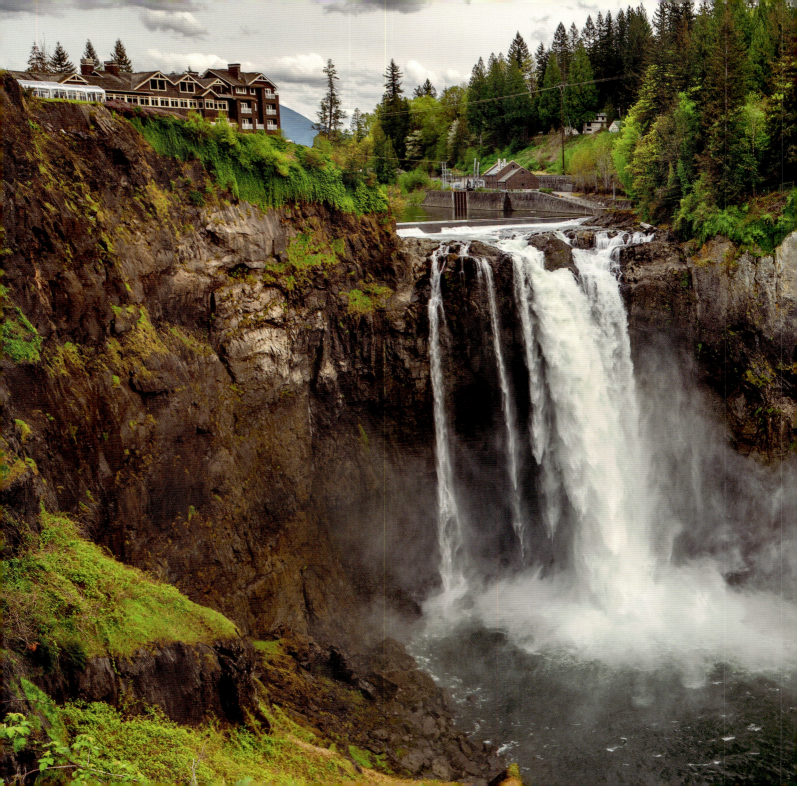

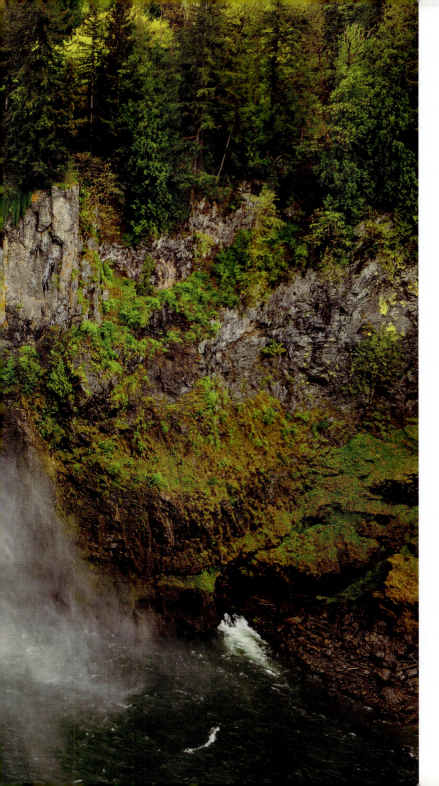

A view of cascading Snoqualmie
Falls and Salish Lodge from the upper
observation deck. ●

Hikers will be rewarded with this view of Middle Wallace Falls in Wallace Falls State Park. •

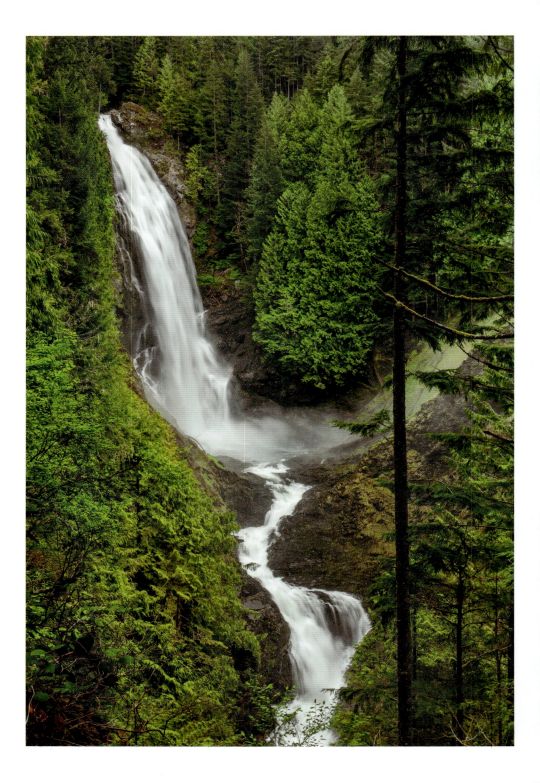

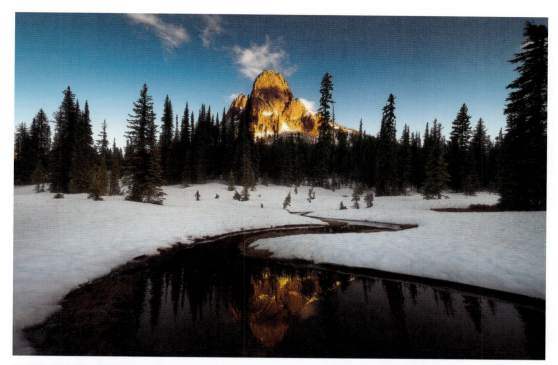

Early snowmelt in the North Cascades showcases creeks reflecting Liberty Bell Mountain. ●

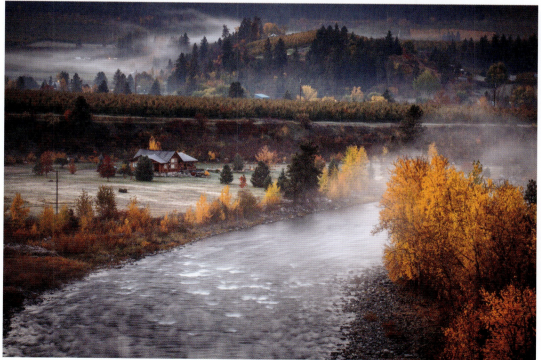

On a misty autumn morning, the Wenatchee River flows through apple, pear, and cherry orchards on its way east from Lake Wenatchee in the Cascade Range to the Columbia River. ●

Frosted fog of winter freezes on larch
trees in the Kettle Mountains. ●

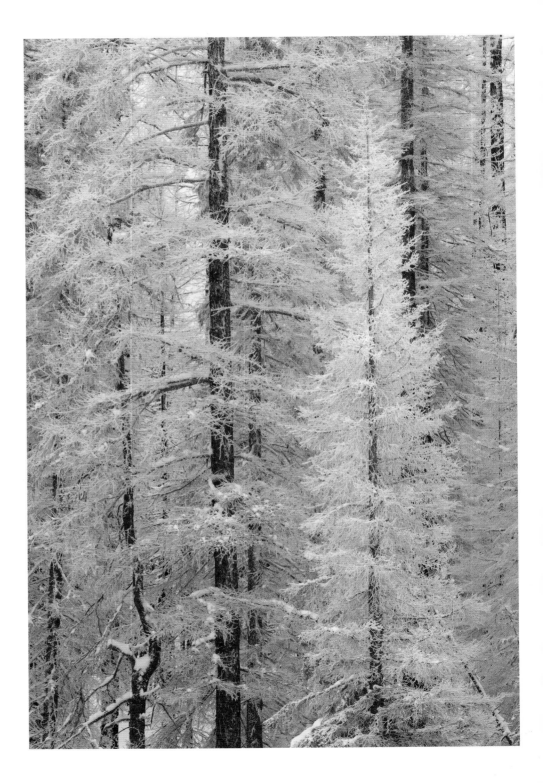

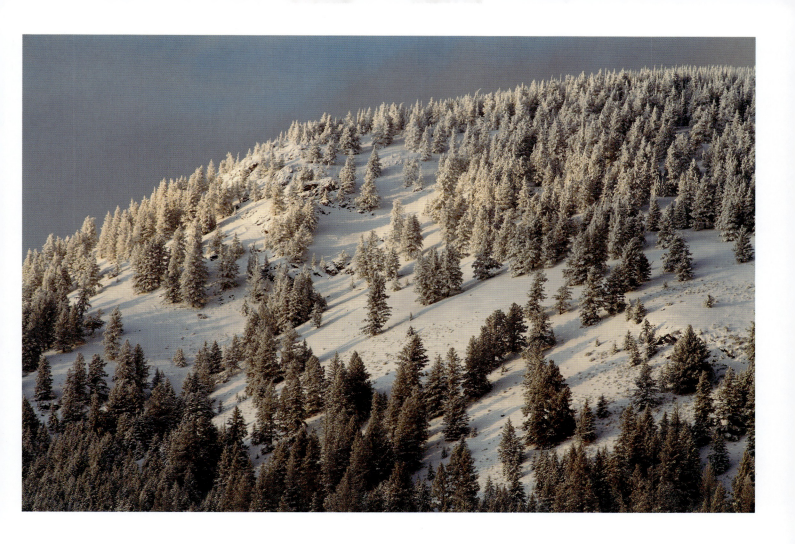

Winter snow and frost drape the trees of
the Kettle Mountains at sunset. ●

Colorful larch trees catch the evening
light from Sherman Pass in eastern
Washington's Kettle Range. •

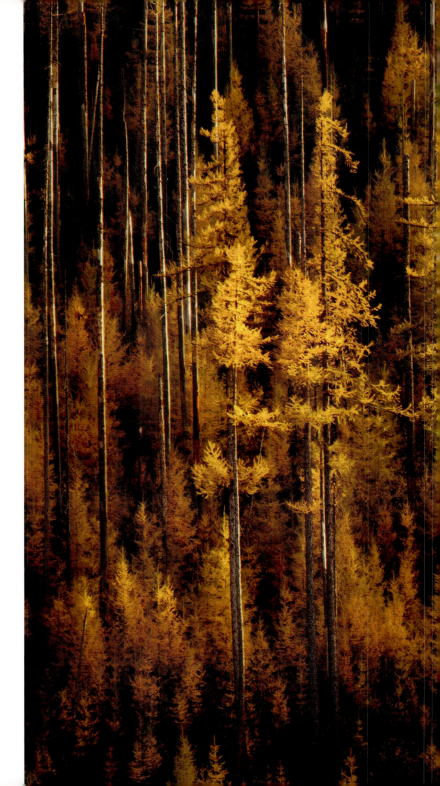

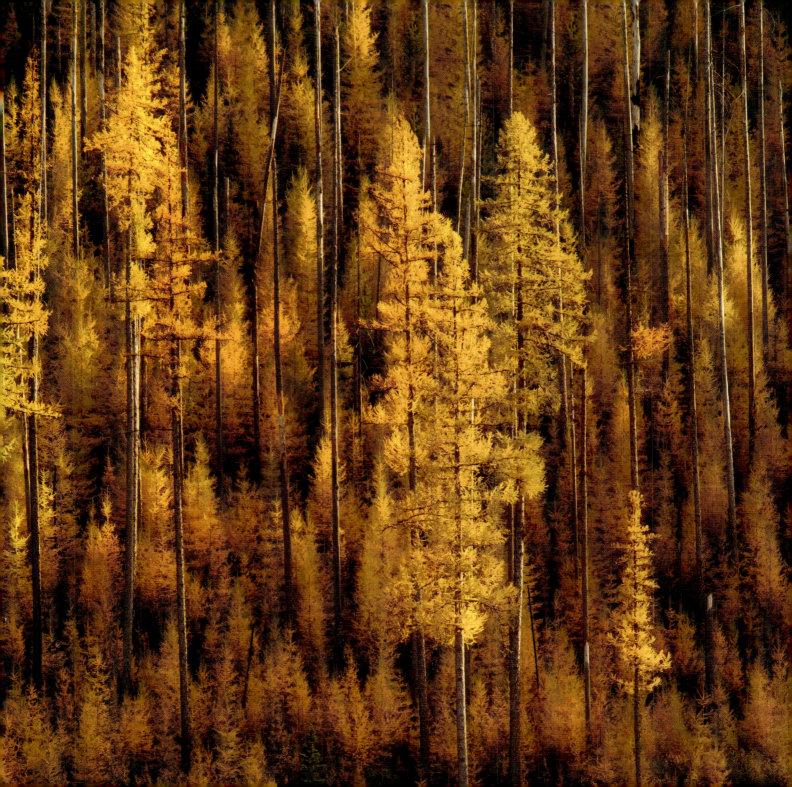

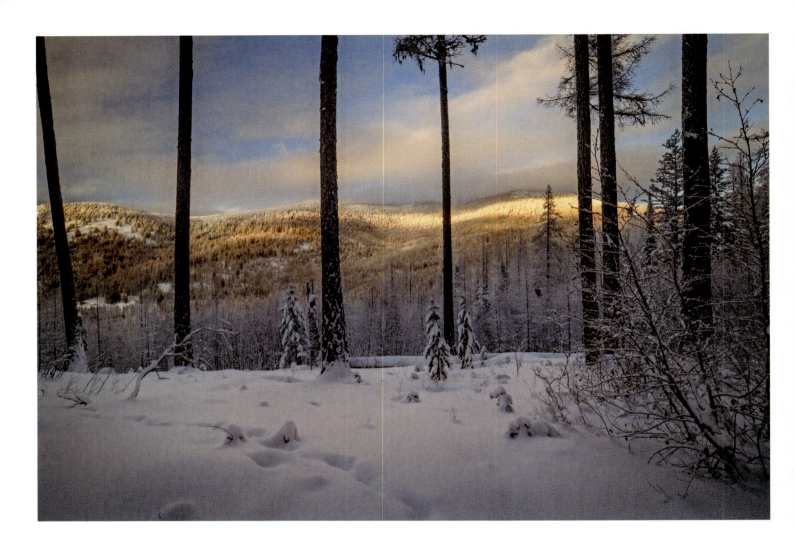

Late evening light touches the crest of
the Kettle Range near Sherman Pass as
a winter storm breaks. •

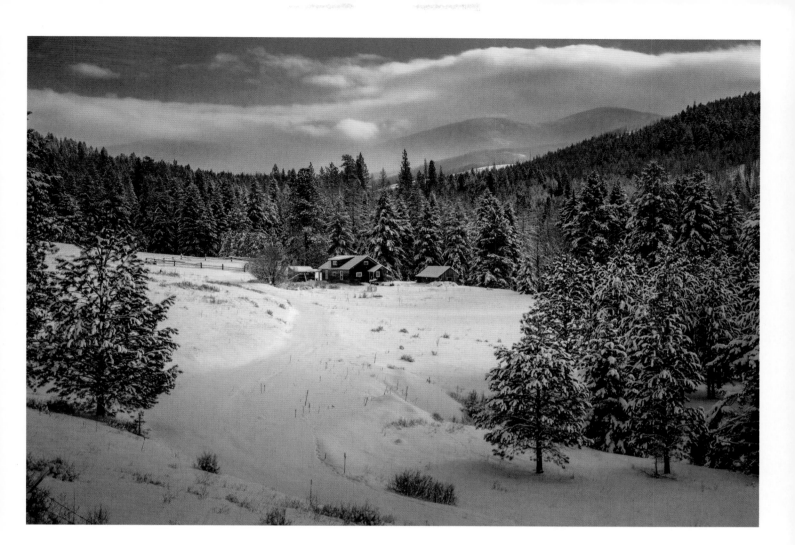

A hardy cabin weathers the grip of
winter in the Kettle Range just south of
Washington's border with Canada. •

RIGHT Water rushing over
Sherman Creek Falls after spring rains
in northeastern Washington. •

OPPOSITE The rolling mountains of
the Kettle Range, seen here in the early
summer blanketed by forests of western
larch, are quite different than their craggy
counterparts in the Cascade Range to
the west. •

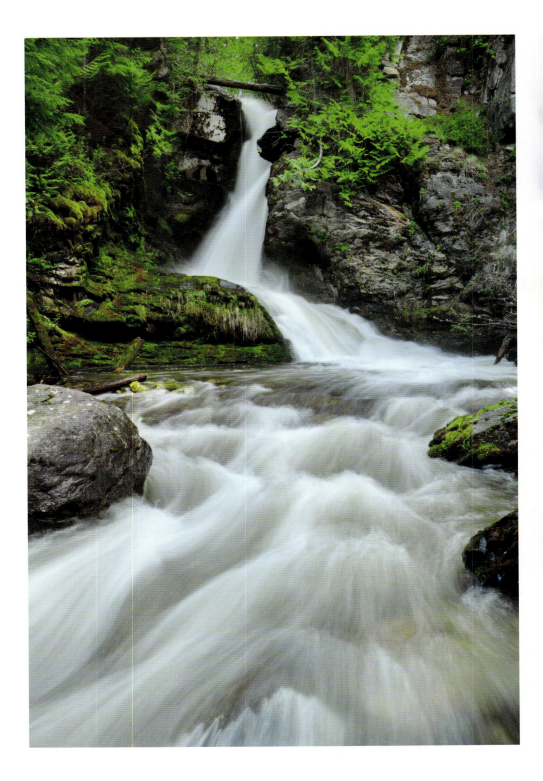

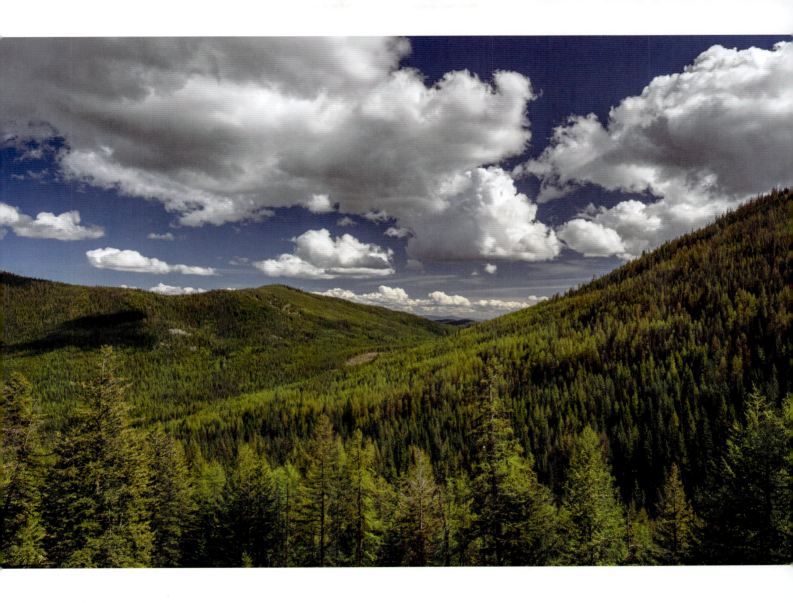

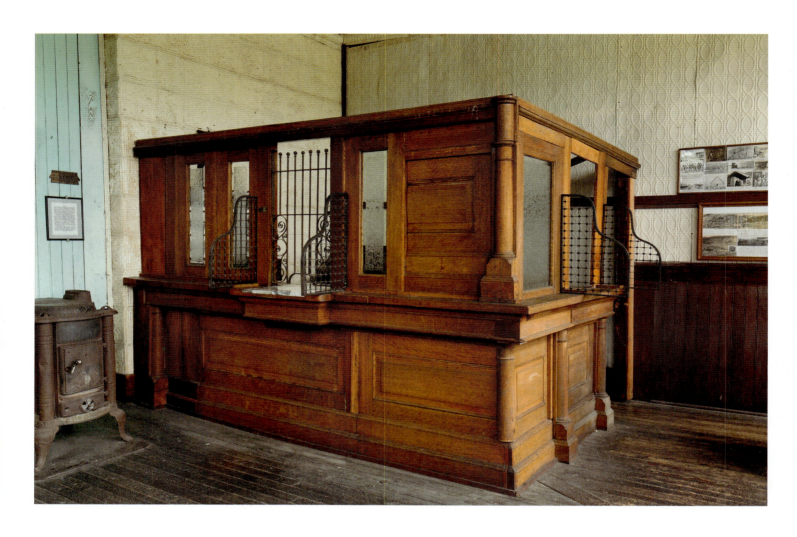

The old bank in the ghost town of Molson near the Canadian border. •

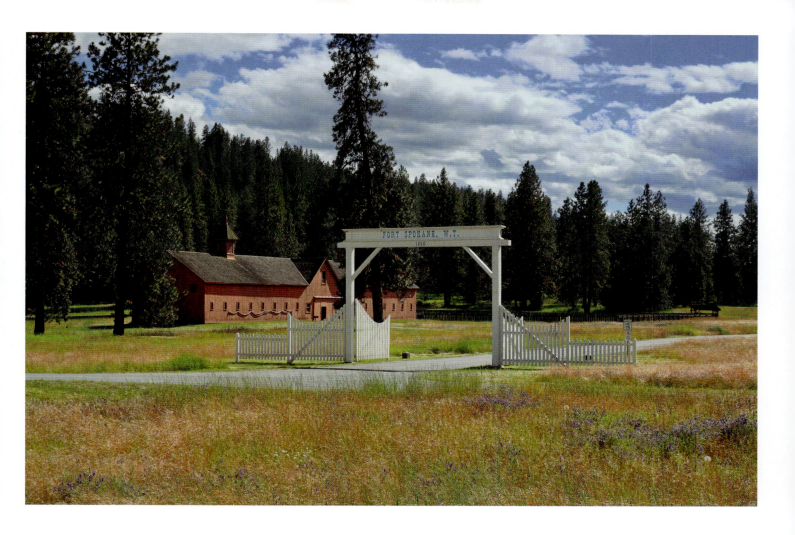

Fort Spokane was built in 1880 at the confluence of the Columbia and Spokane Rivers in what is now the Lake Roosevelt National Recreation Area. •

The last light of the evening fades and fog rolls in from high up on Mount Spokane in eastern Washington. •

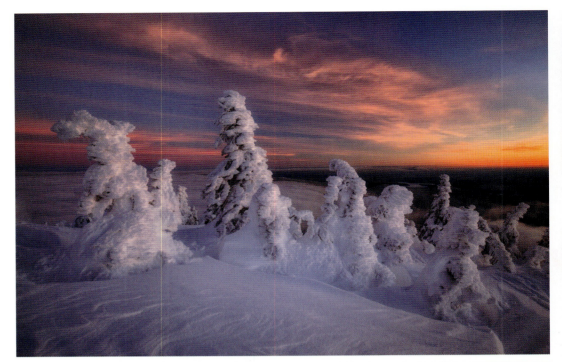

RIGHT Evening light breaks through the fog among the snow ghosts on the summit of Mount Spokane. •

OPPOSITE The sunset from Mount Spokane's summit is brilliant, while down below the city of Spokane is completely shrouded in fog. •

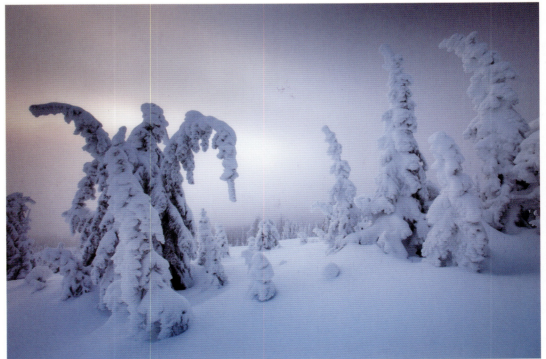

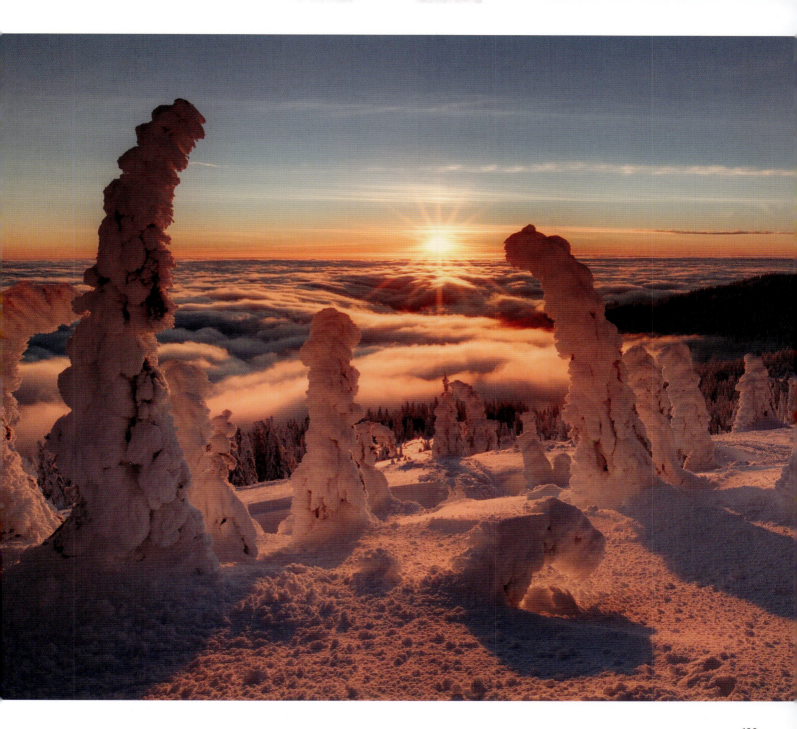

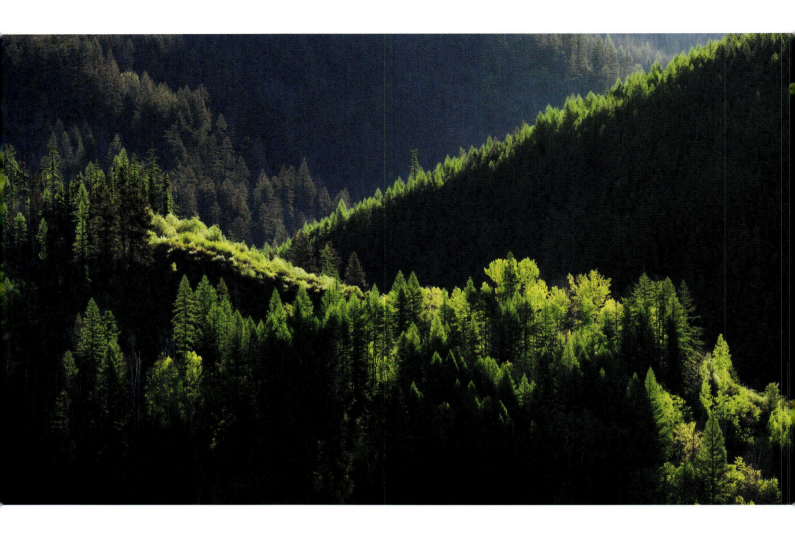

Lush green forest in the mountains
above Sullivan Lake in Colville National
Forest. ●

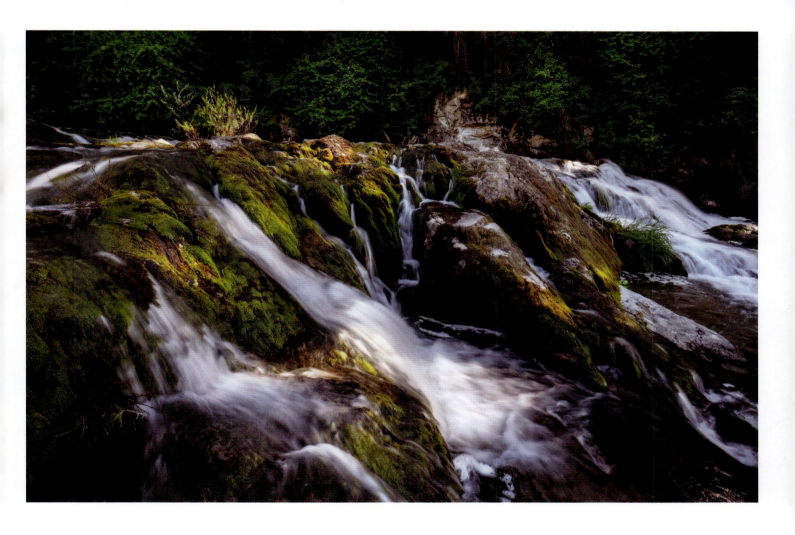

Meyers Falls is a series of cascades near the town of Kettle Falls. At various times since the early 1800s the falls have been used to power a grist mill, a sawmill, a brick factory, and a hydroelectric dam, making it the oldest continually used water power source west of the Mississippi River. •

Sunset on Lake Roosevelt. When the Grand Coulee Dam on the Columbia River was completed in 1941, it created Franklin D. Roosevelt Lake, named after the then president. Stretching 150 miles in length and covering 125 square miles, it is Washington's largest reservoir. ●

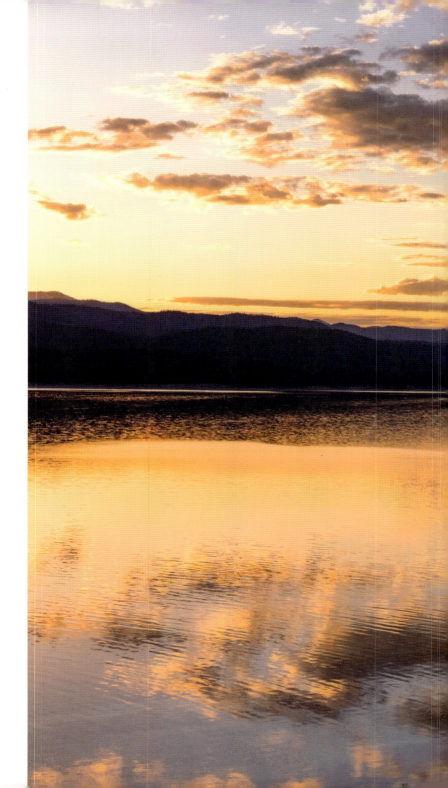

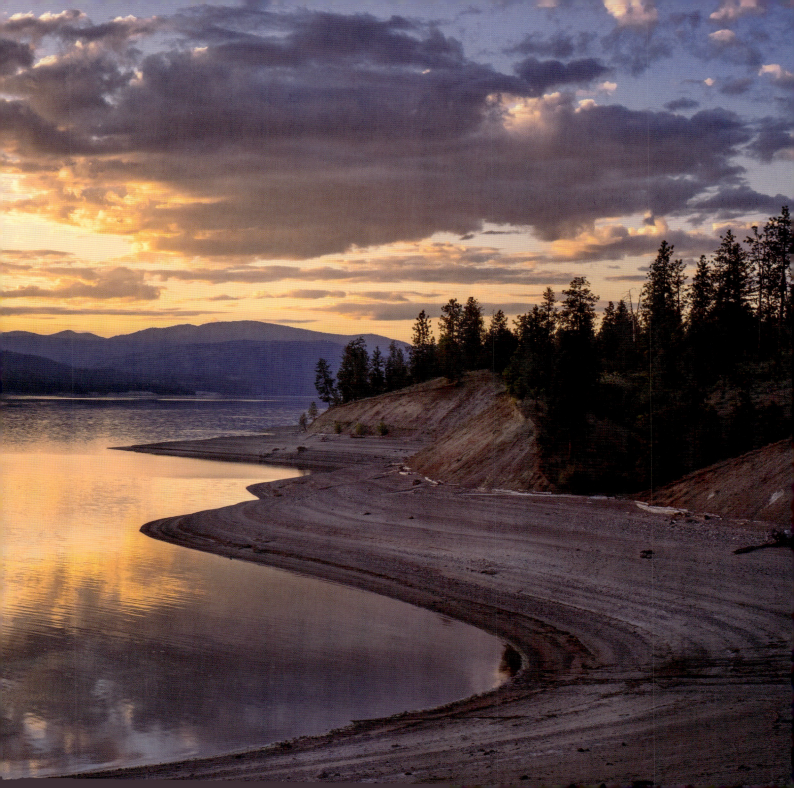

Driftwood grain makes for interesting abstract patterns on Waikiki Beach at Cape Disappointment State Park. •

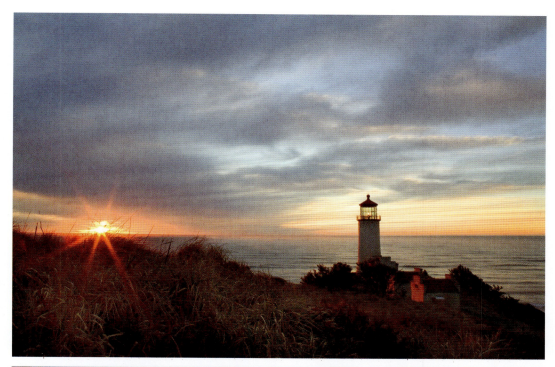

A beacon shines during sunset at Cape Disappointment's North Head Lighthouse. •

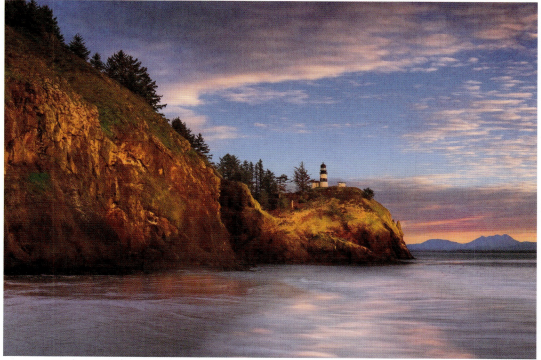

Pink skies light up Cape Disappointment Lighthouse and the incoming tide near the mouth of the Columbia River. •

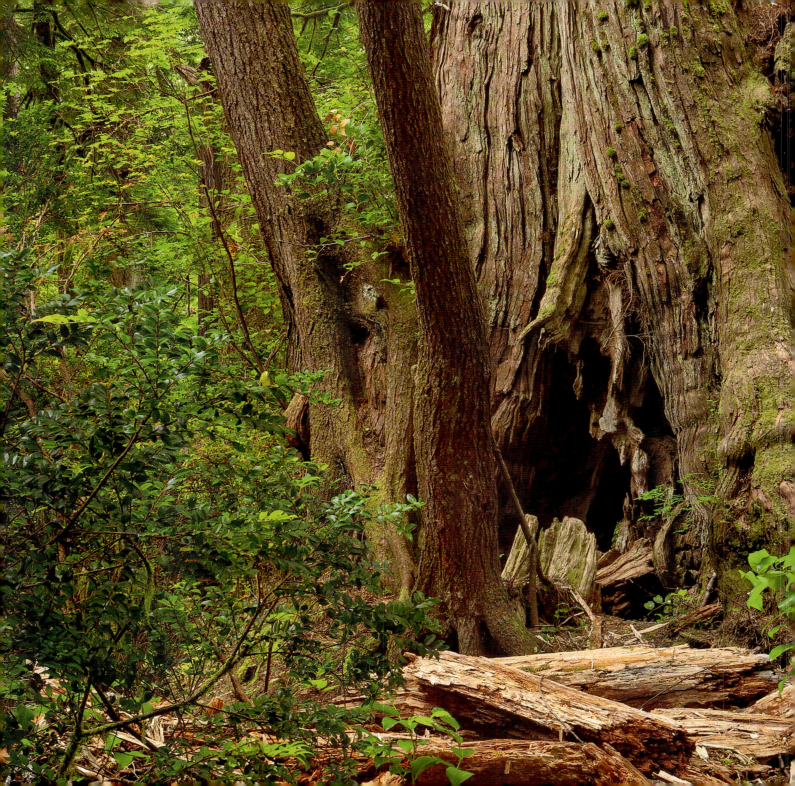

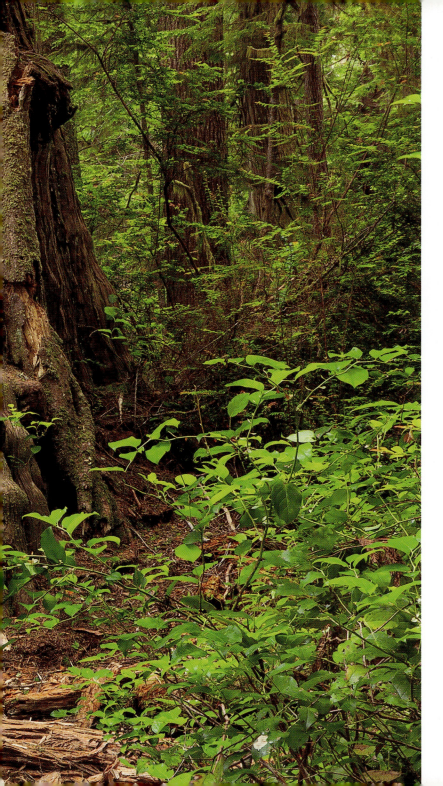

Accessible only by boat or kayak, this western redcedar (*Thuja plicata*) forest on Long Island in Willapa Bay is said to have begun around the time of Julius Caesar. •

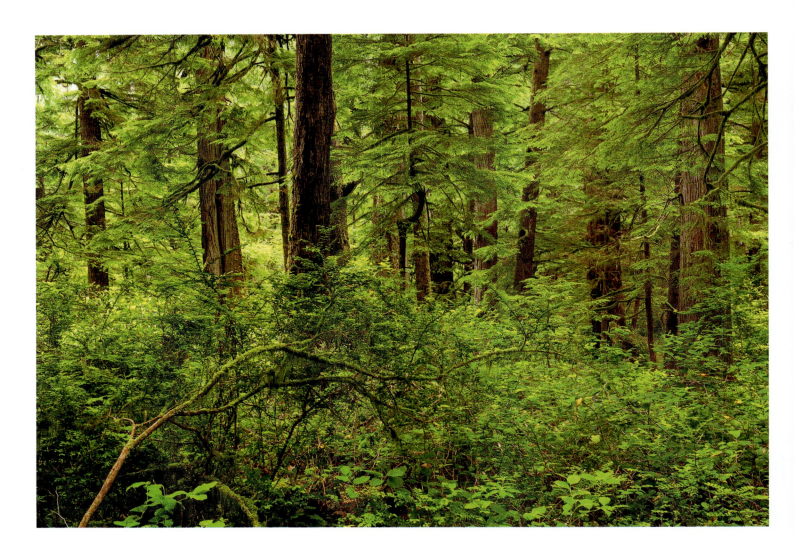

A stand of western redcedar pokes above the tangle of salal and coastal huckleberry in this Long Island old-growth forest. •

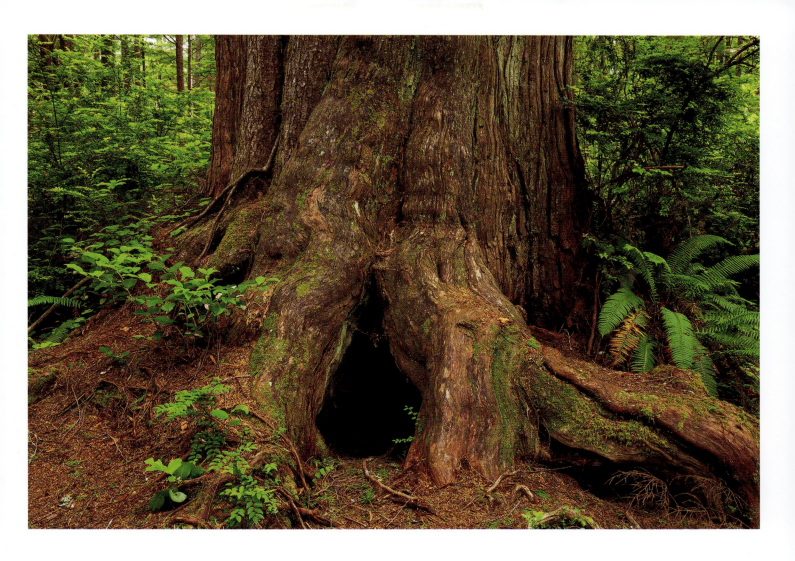

A cavity in the roots of this western
redcedar along the Don Bonker Cedar
Grove Trail provides shelter for animals. ●

A rainbow reflects off the waters of Ilwaco Harbor at sunrise. ●

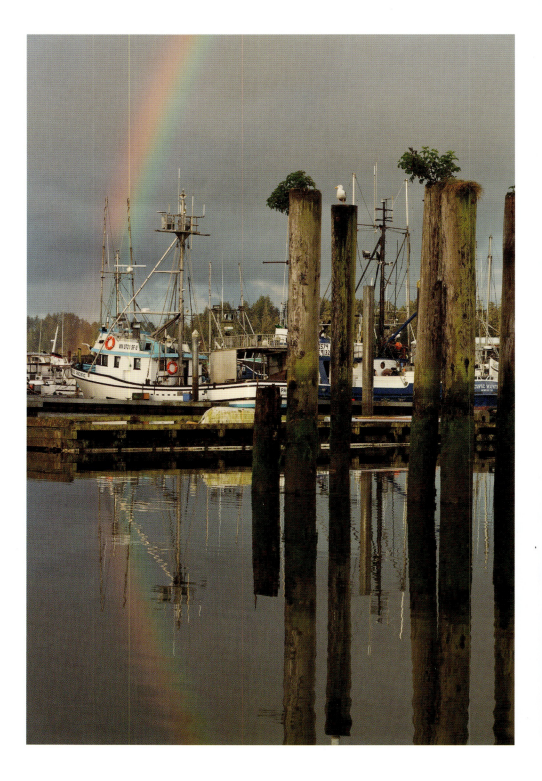

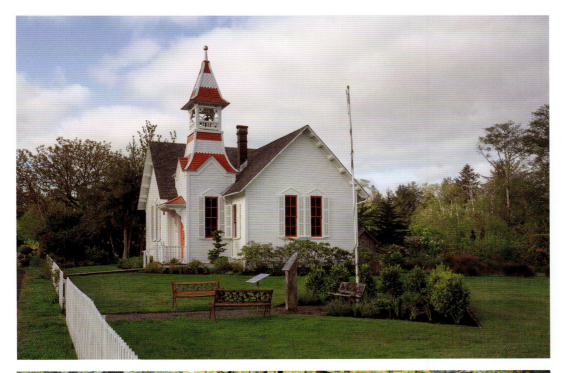

A beautiful spring morning at the historic Oysterville Church, built in 1892. ●

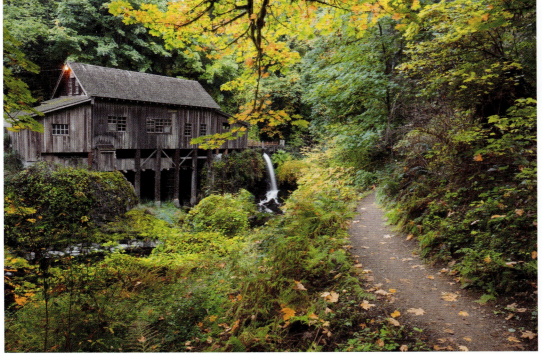

A hiking trail near Ridgefield provides a scenic view of the historic Cedar Creek Grist Mill in fall. ●

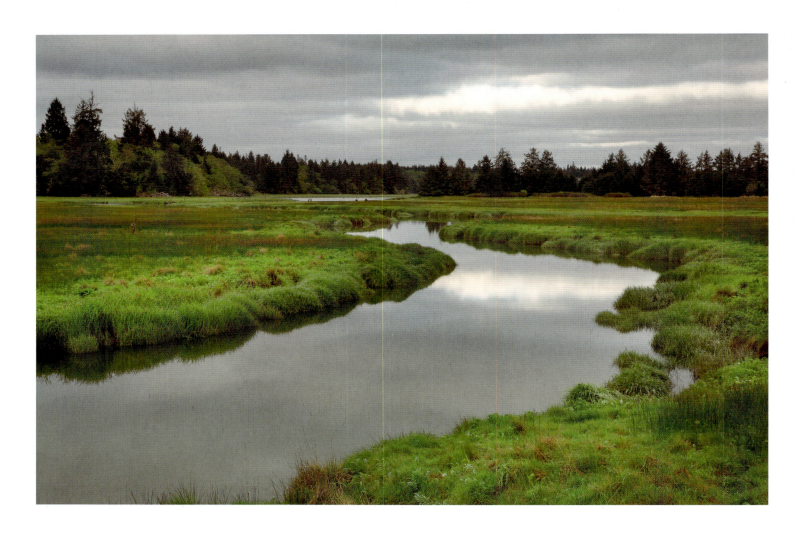

A gray morning along one of the many
tidal sloughs in the Willapa National
Wildlife Refuge. •

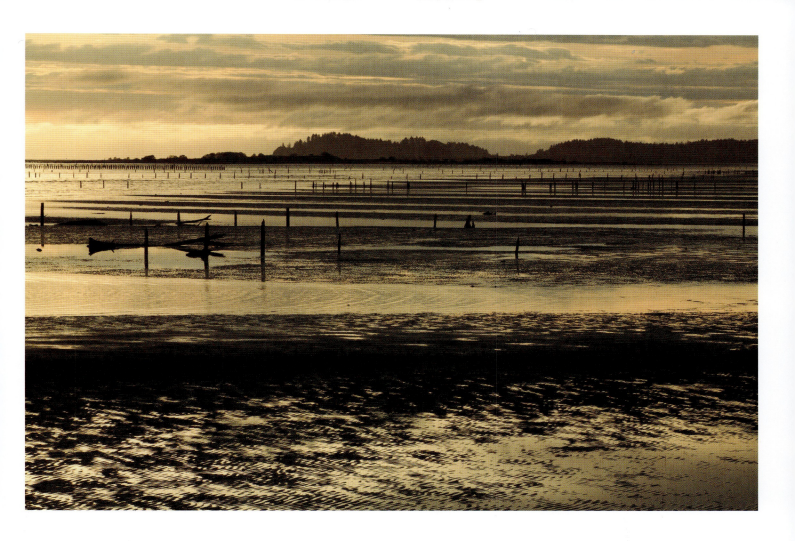

Hundreds of pier posts can still be
seen at low tide at Baker Bay along the
Columbia River; a faint silhouette of Cape
Disappointment Lighthouse can be seen
in the distance. •

RIGHT Gray's Harbor Lighthouse in Westport was built in 1898 and is the tallest lighthouse in the state. Here it bathes in the warm light of sunrise. ●

OPPOSITE Even in winter, the Columbia River Gorge is full of vibrant greens, as seen here along a creek in Skamania County surrounded by a fern- and moss-filled forest. ●

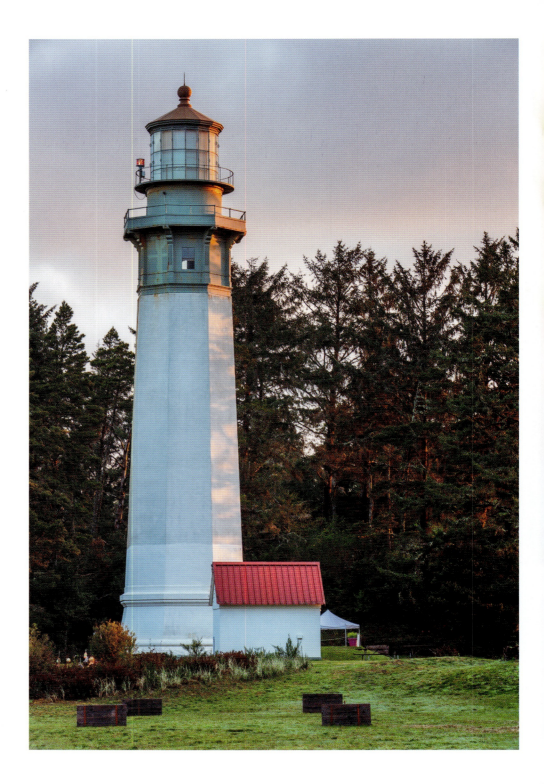

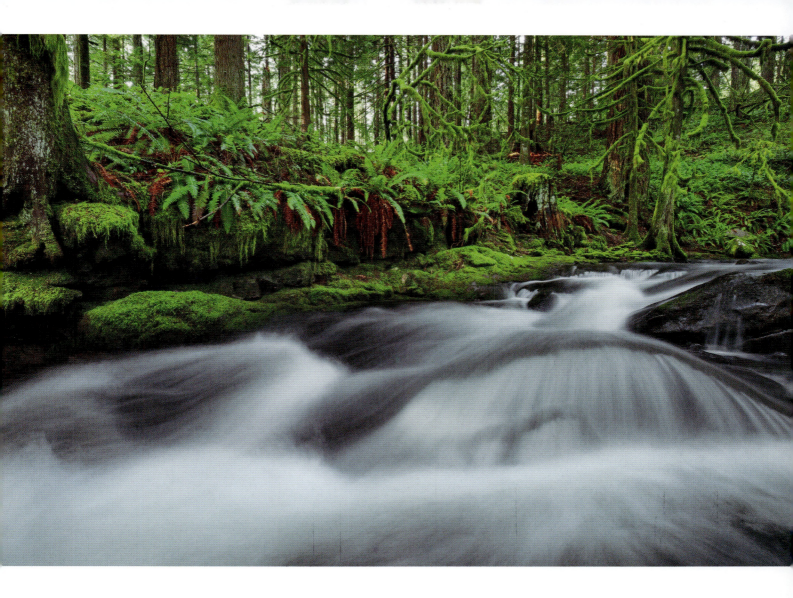

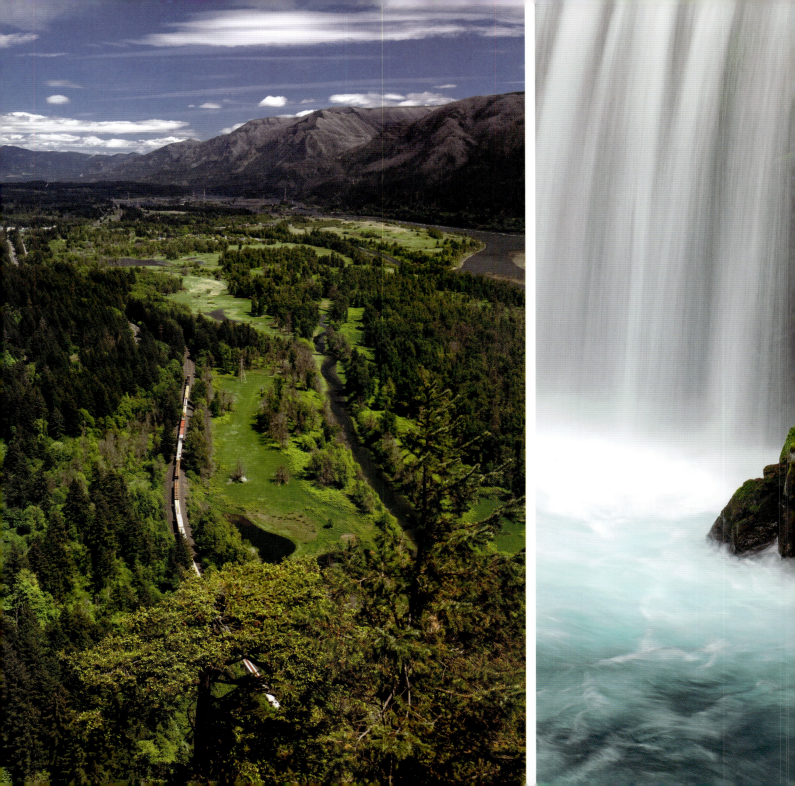

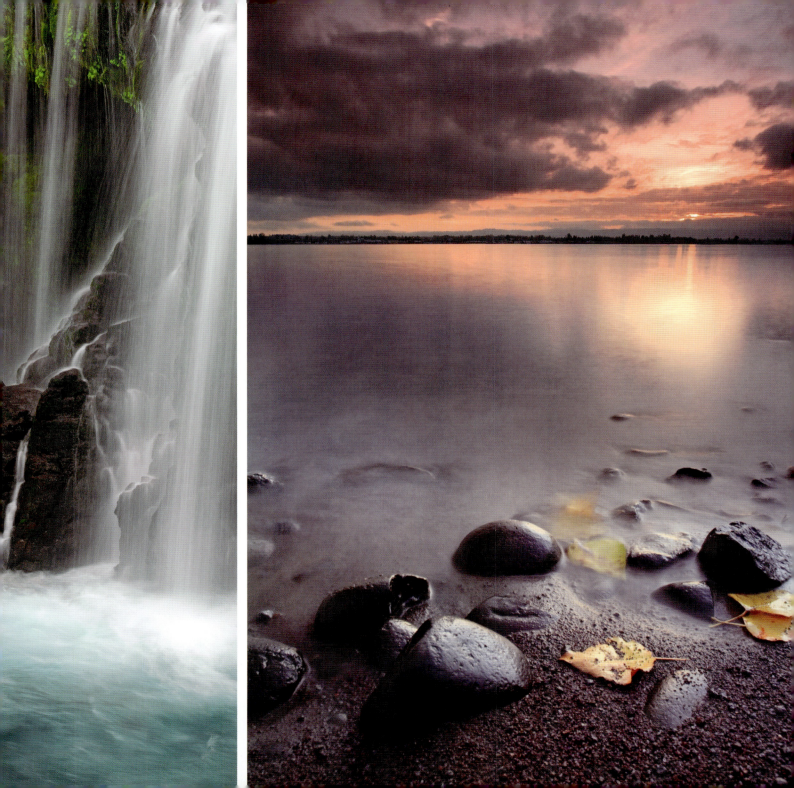

PREVIOUS PAGES, LEFT TO RIGHT
Viewed from the summit of Beacon
Rock, a freight train more than 800 feet
below makes its way west along the
Columbia River toward Bonneville Dam in
the distance. • Spring runoff cascades
down a mossy and rocky Spirit Falls into
a pool of emerald-colored water. •
Remnants of fall colors wash ashore
at sunset along the Columbia River in
Vancouver. •

RIGHT The emerald waters of Spirit Falls
near the Columbia River Gorge make for a
beautiful sight. •

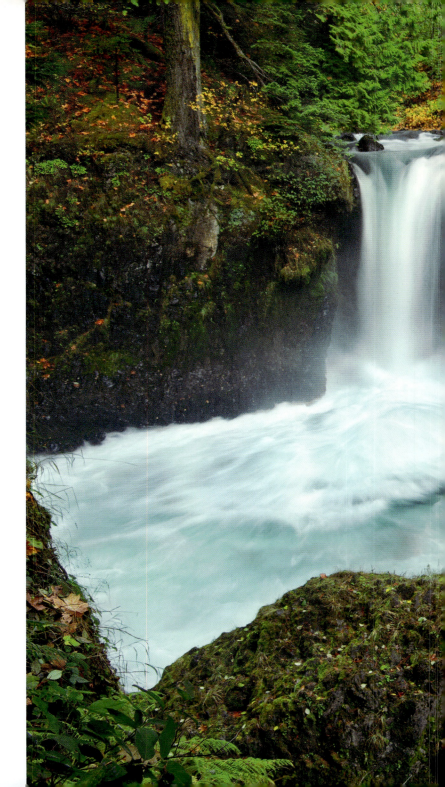

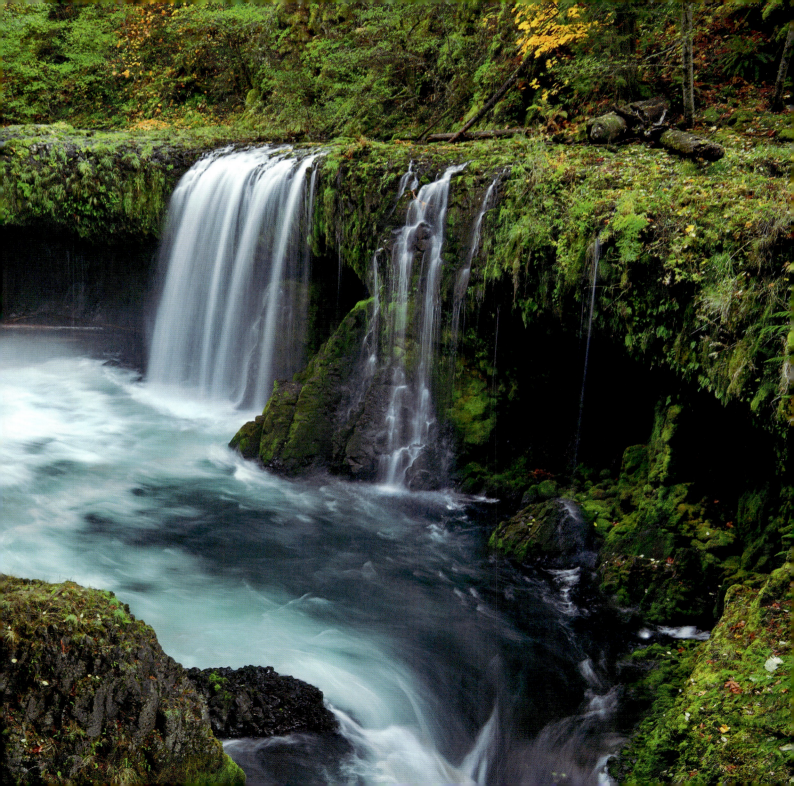

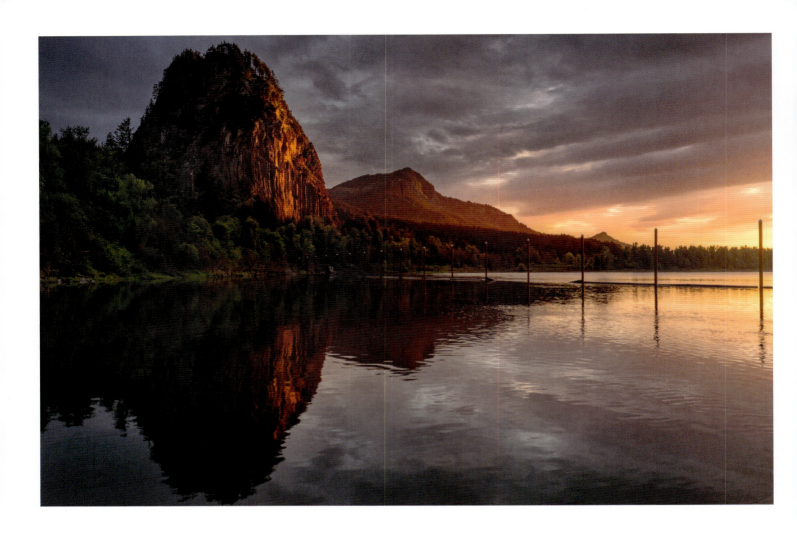

The first rays of sun shine down the Columbia River Gorge and light up the basalt columns of 848-foot-tall Beacon Rock, the core of an ancient volcano. •

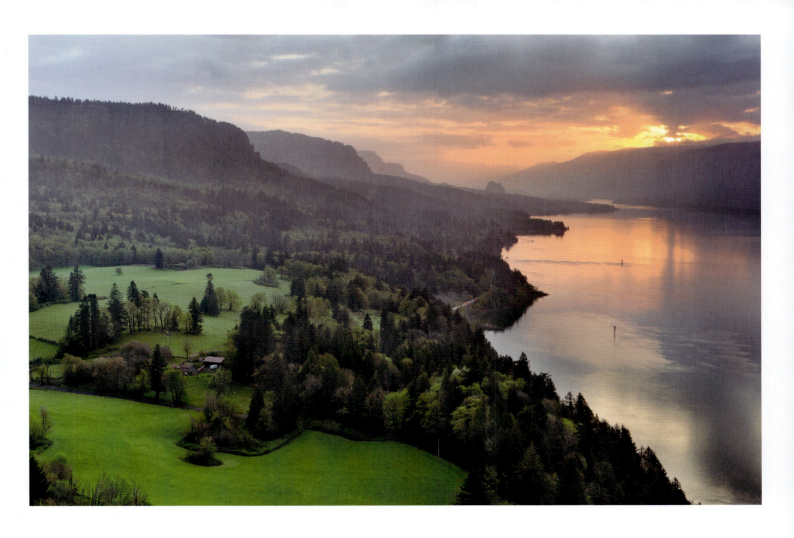

The view from Cape Horn with the sun glowing through morning clouds on the Columbia River as a train meanders through forest below. •

Copper Creek falls, among the countless waterfalls to be found in Gifford Pinchot National Forest, makes a delicate plunge through lush old-growth forest. •

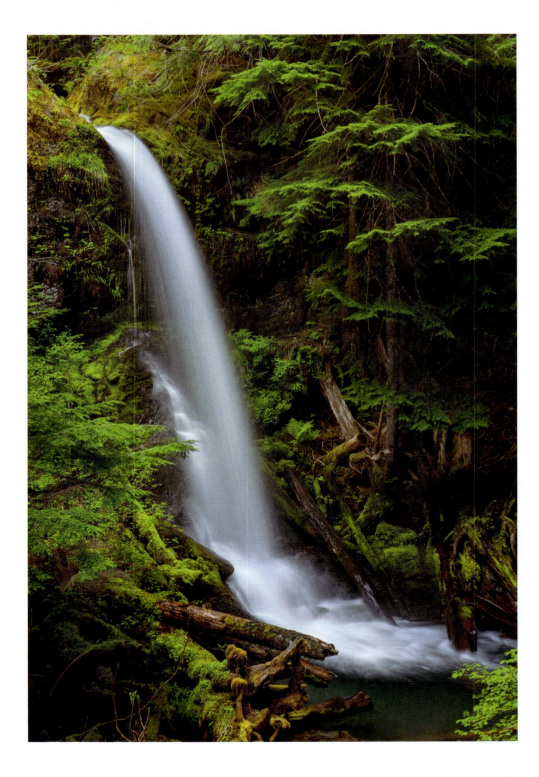

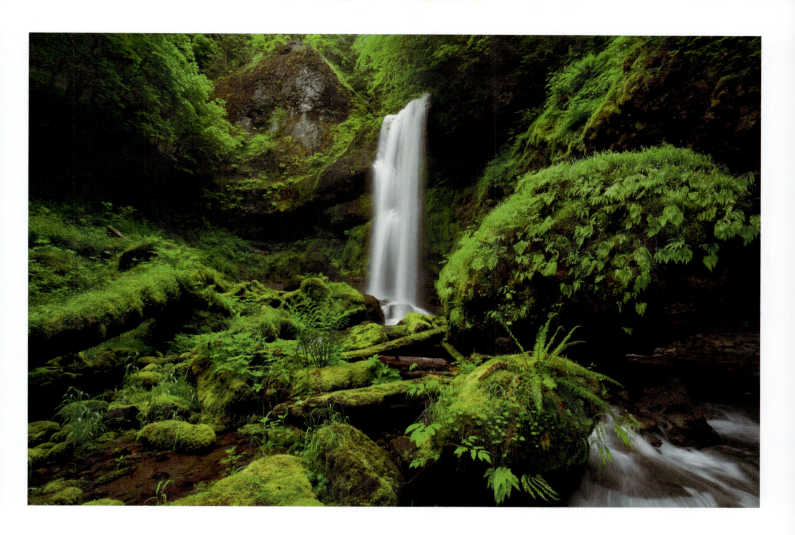

One of the many off-trail waterfalls
that can be found in the state's
Cascade Range. ●

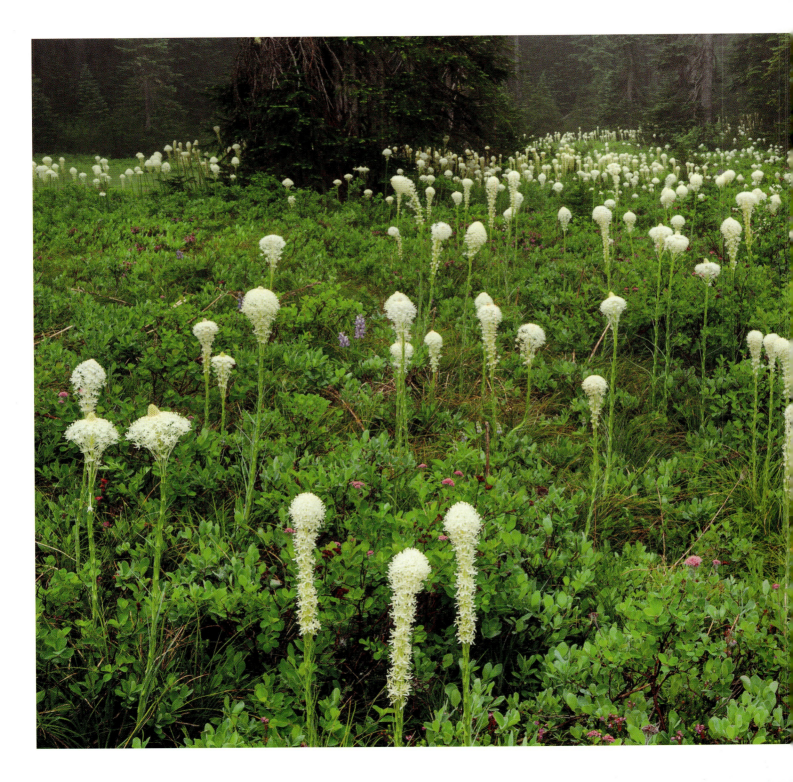

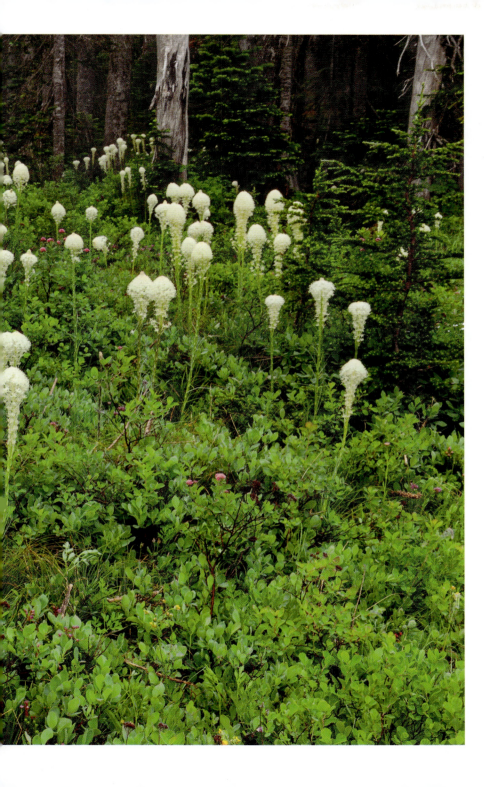

Beargrass (*Xerophyllum tenax*) covers a meadow on a foggy day in Indian Heaven Wilderness. ●

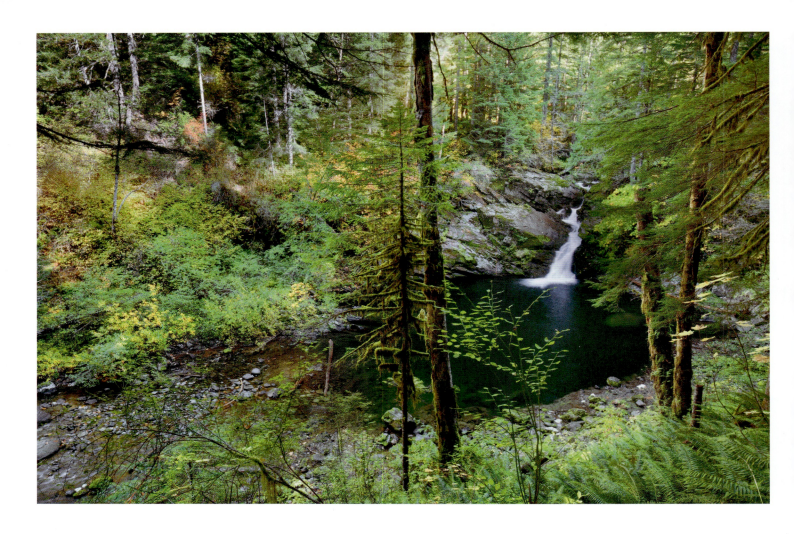

A small waterfall on Siouxon Creek with
fall colors beginning to fill the surrounding
landscape. ●

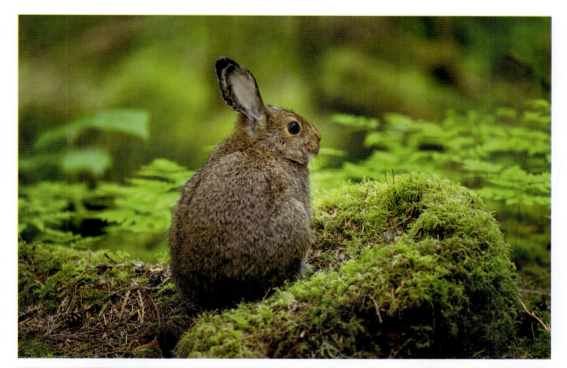

A small rabbit rests on a mossy stump in Gifford Pinchot National Forest near the Lewis River. •

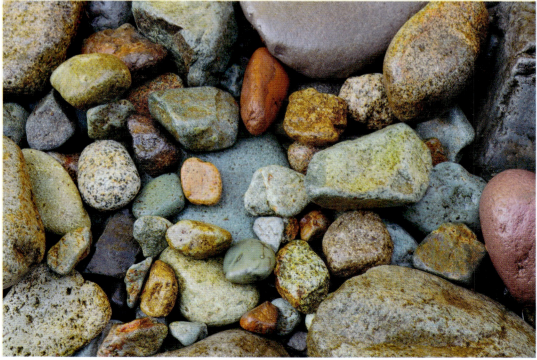

A sampling of the many colorful rocks that can be found in and along the banks of Siouxon Creek. •

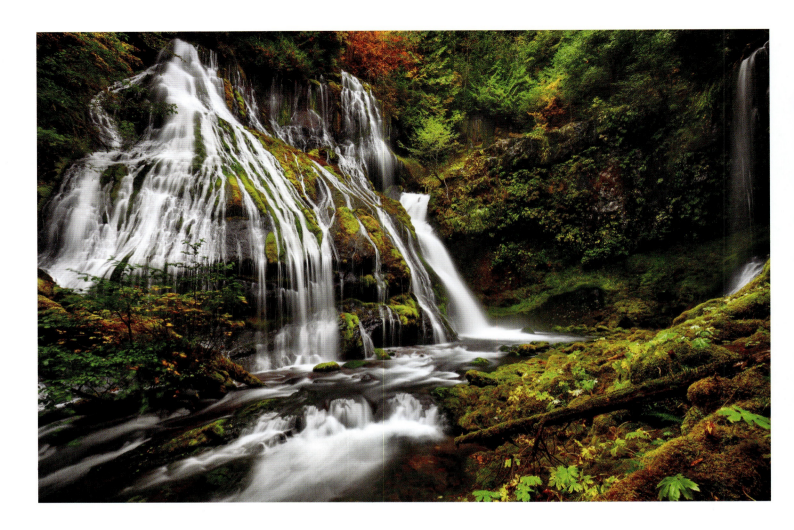

Panther Creek Falls, one of the most
intricate and impressive waterfalls in
Washington, is actually the confluence
of Panther Creek, which drops over the
cliffs in multiple places, and a series of
springs that send a veil of water down the
adjacent mossy rock face. •

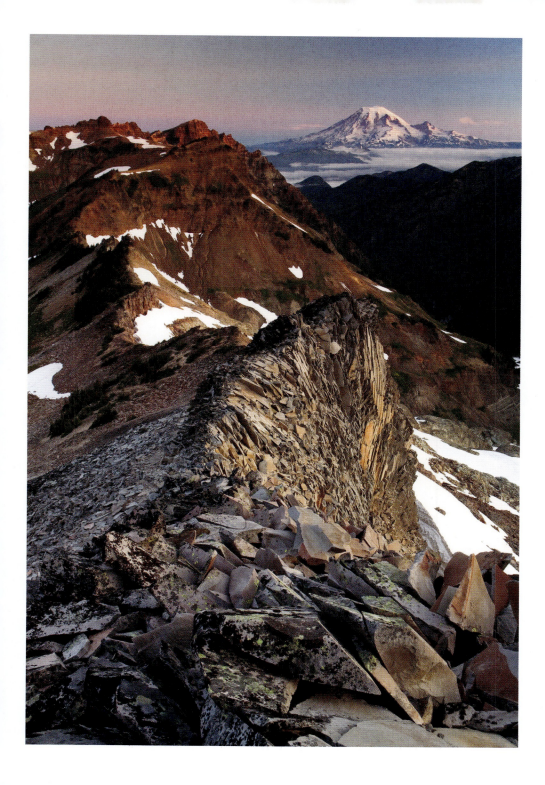

A ridgeline in Goat Rocks Wilderness points the way to distant Mount Rainier on a summer morning. ●

ABOVE Geological layers of time as seen from a large boulder in Goat Rocks Wilderness. •

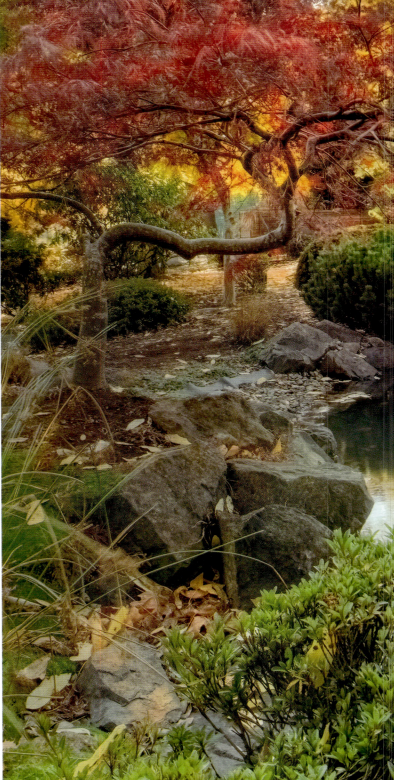

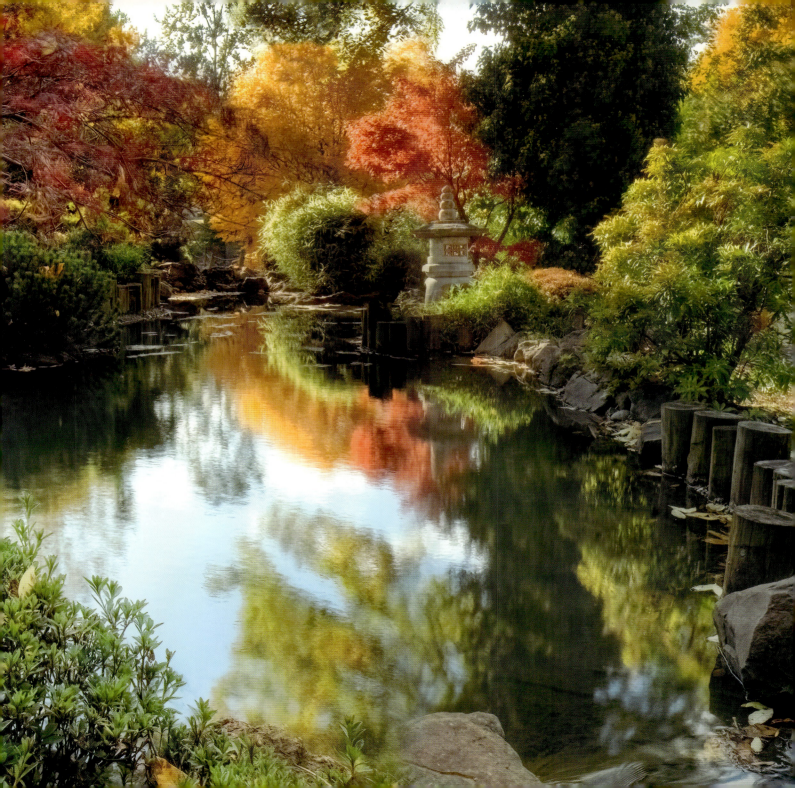

PREVIOUS PAGE Fall foliage reflects off a small pond in the Japanese Garden in Longview's Lake Sacajawea Park. •

RIGHT Lupine frames a small cascade in the Bird Creek Meadows area of Mount Adams. •

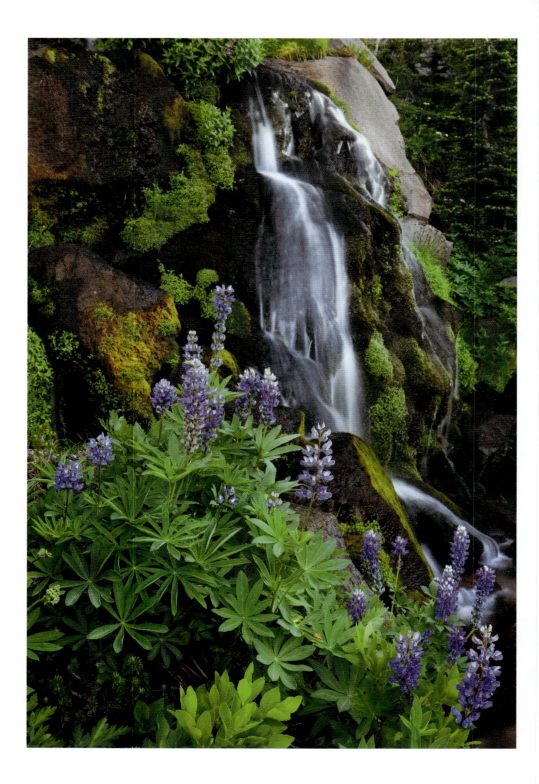

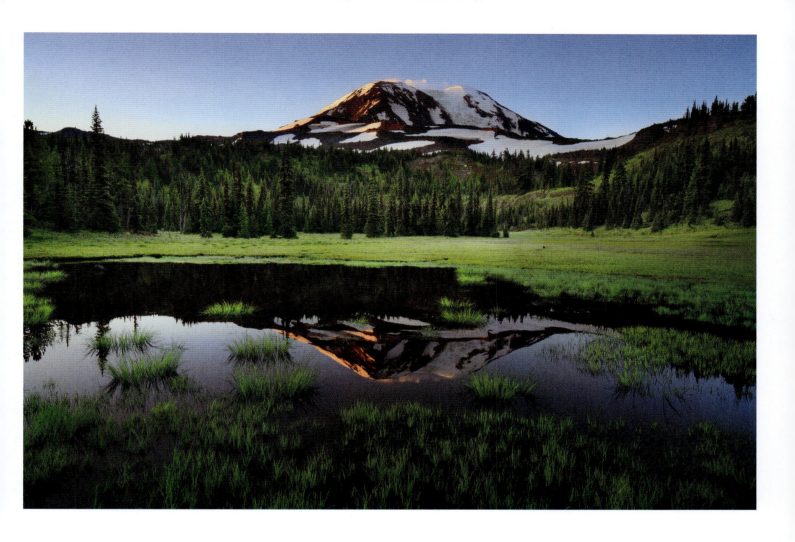

ABOVE Patchy snow fields and lush ever-green colors can be seen as the sun sets during the short alpine summer in Mount Adams Wilderness. •

OVERLEAF A sea of fog surrounds Mount Adams. •

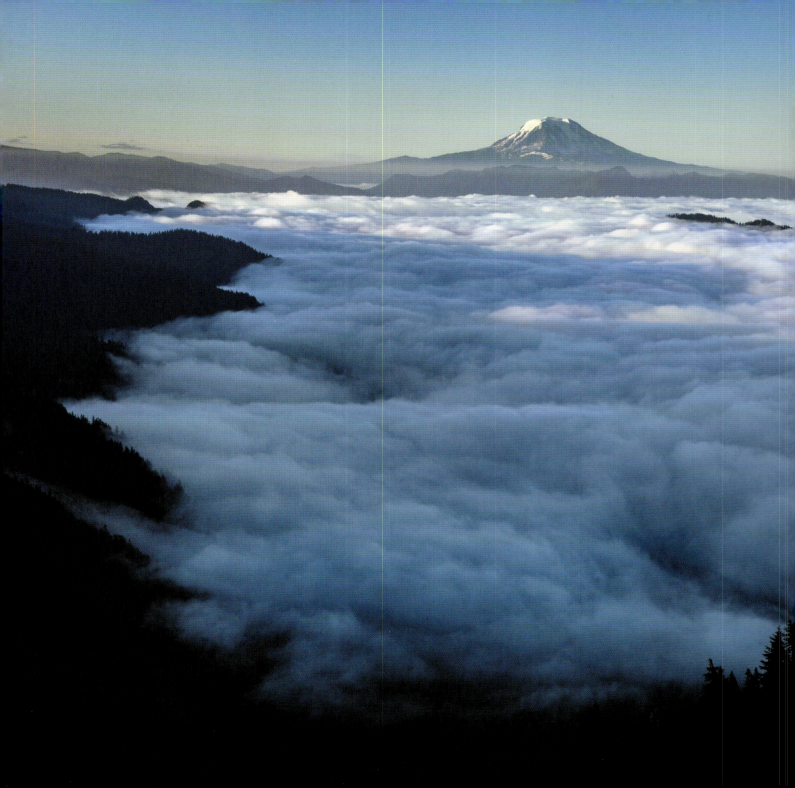

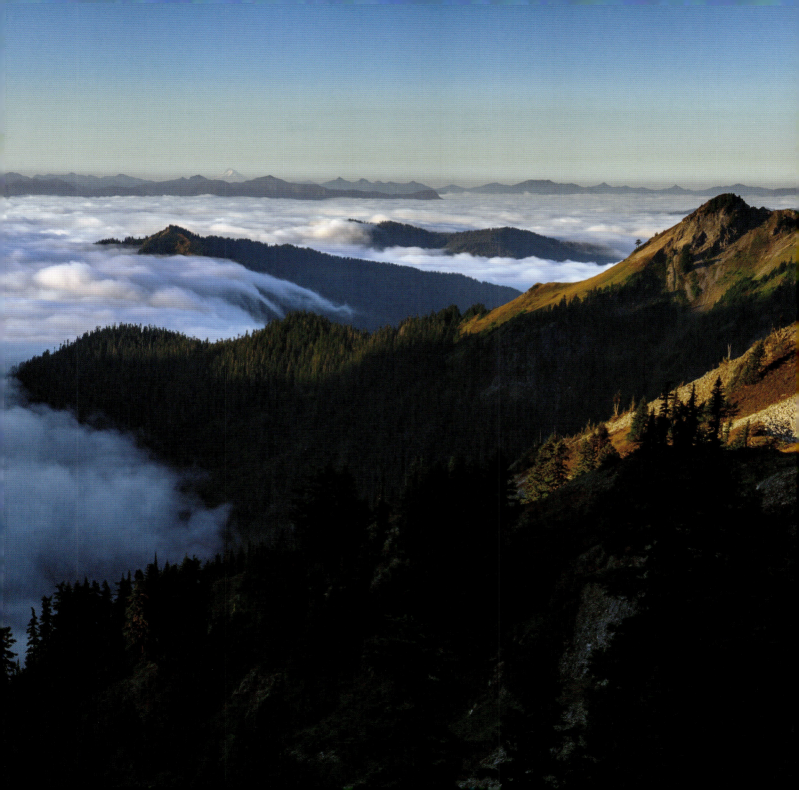

Mount Adams reflects in the waters during a fall sunrise near Trout Lake. •

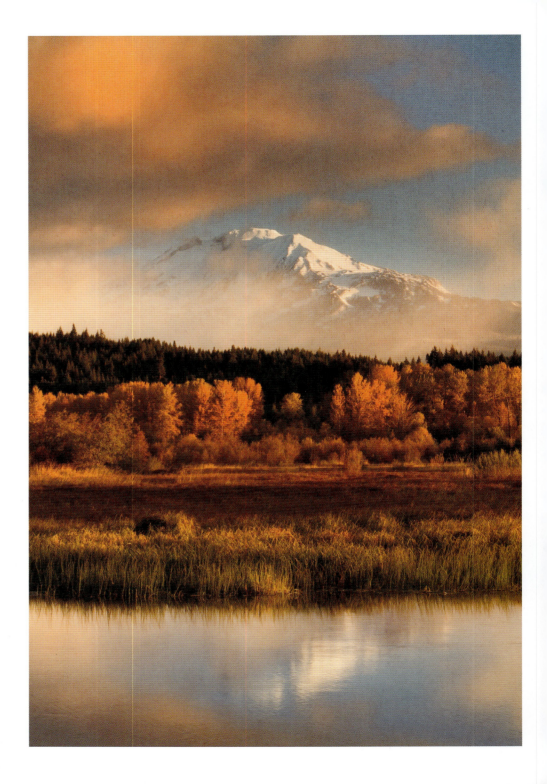

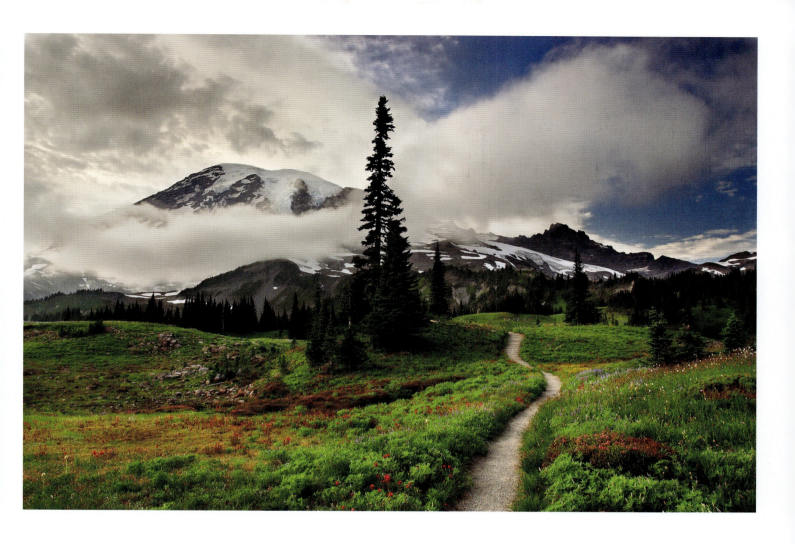

A trail winds up and along Mount
Rainier's Mazama Ridge. ●

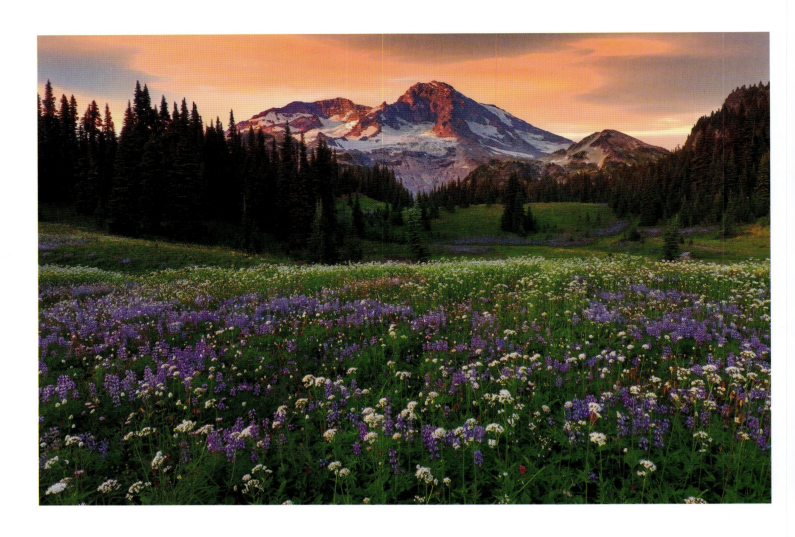

Summer wildflowers fill the meadows of Indian Henry Hunting Grounds in Mount Rainier National Park during a stunning sunset. Seen here are broadleaf lupine (*Lupinus latifolius*), Sitka valerian (*Valeriana sitchensis*), and paintbrush (*Castilleja* sp.). •

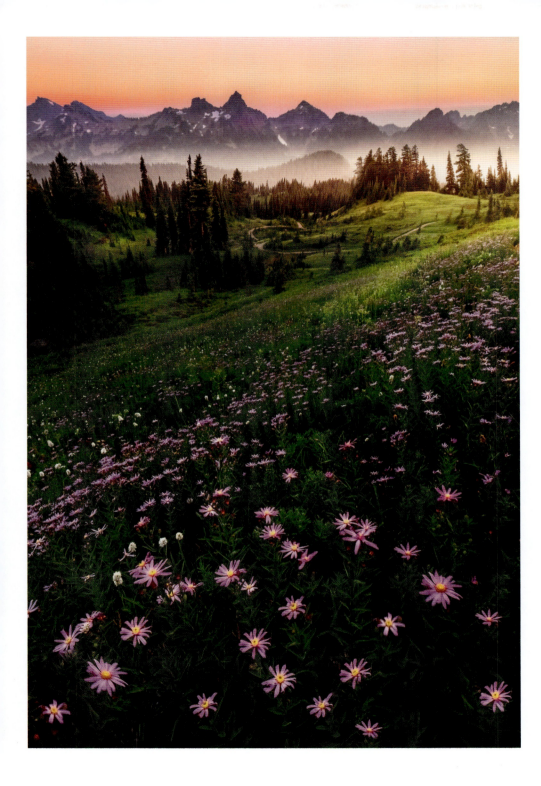

Cascade asters (*Eucephalus ledophyllus*) fill the meadow hillsides of Mount Rainier's Paradise region during a summer sunset. The Tatoosh Range can be seen in the background. ●

OVERLEAF A lenticular cloud formation surrounds the peak of Mount Rainier. ●

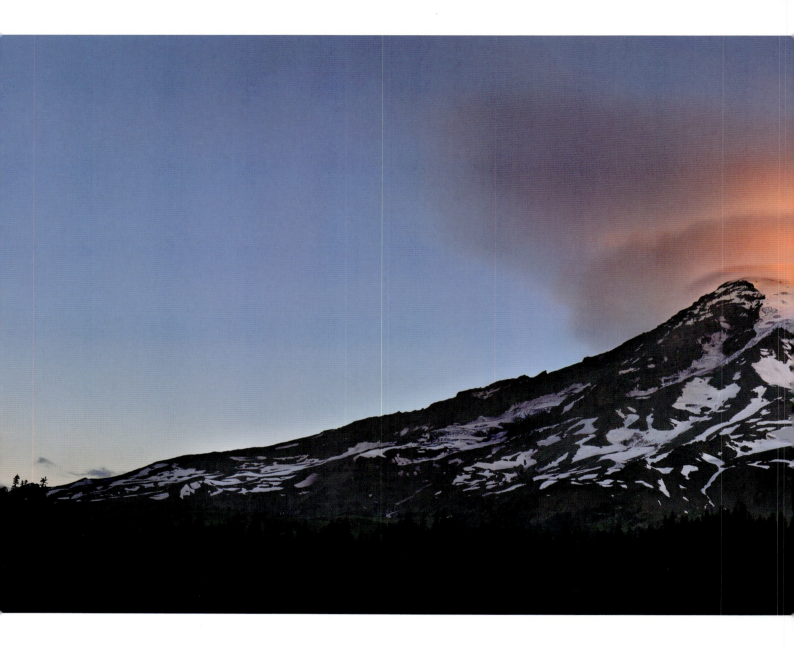

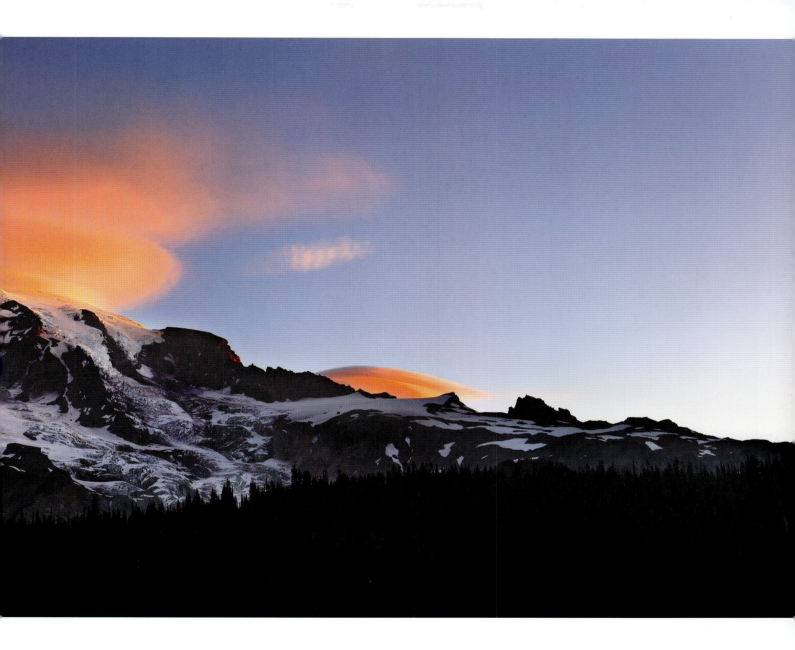

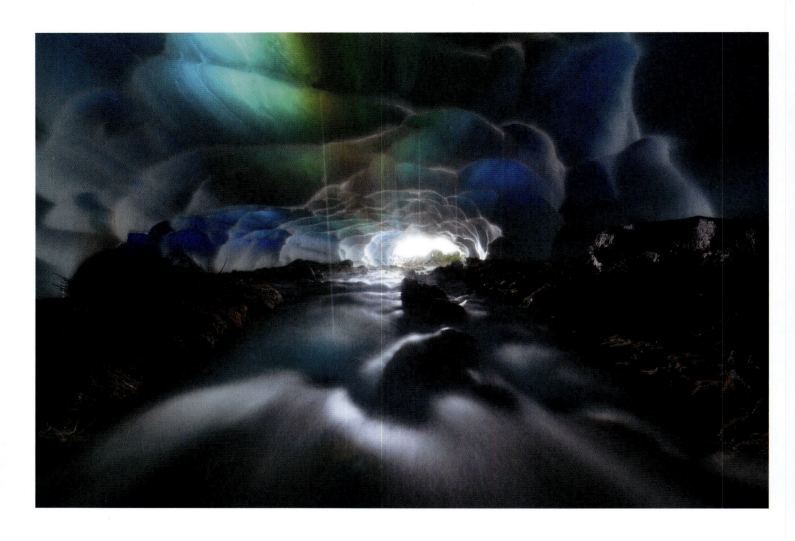

An ice cave on the Paradise side of
Mount Rainier as winter turns into spring.
The vibrant cool colors offer a nice
contrast to the warm glow at the end
of the tunnel. •

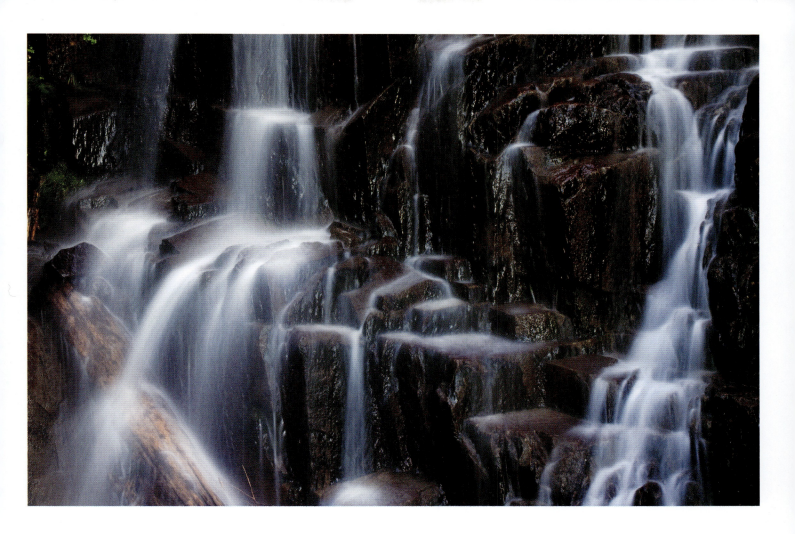

Waters cascade over the basalt steps
of Stevens Creek Falls in Mount Rainier
National Park. •

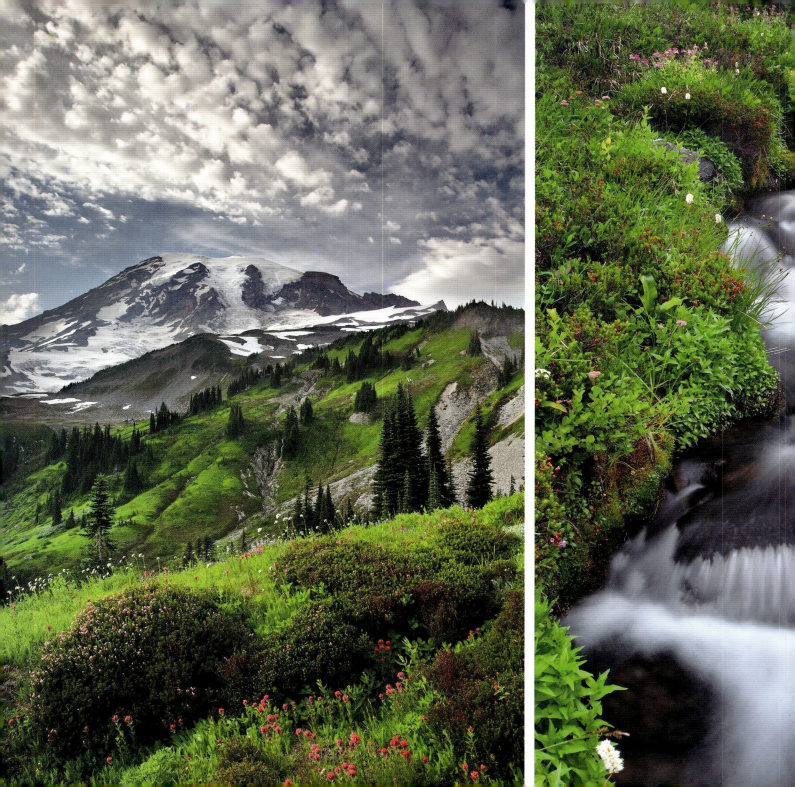

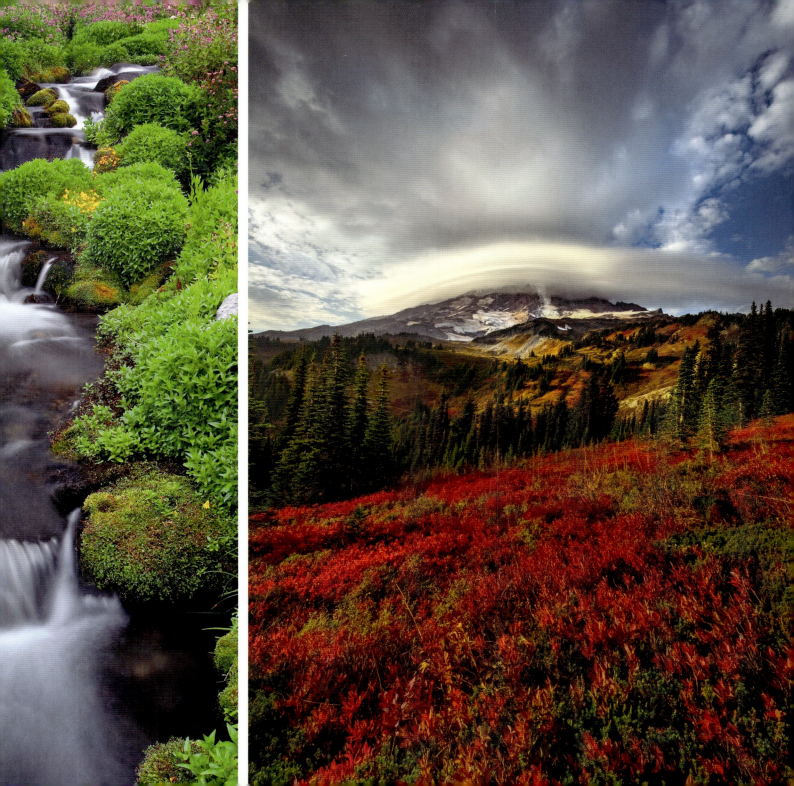

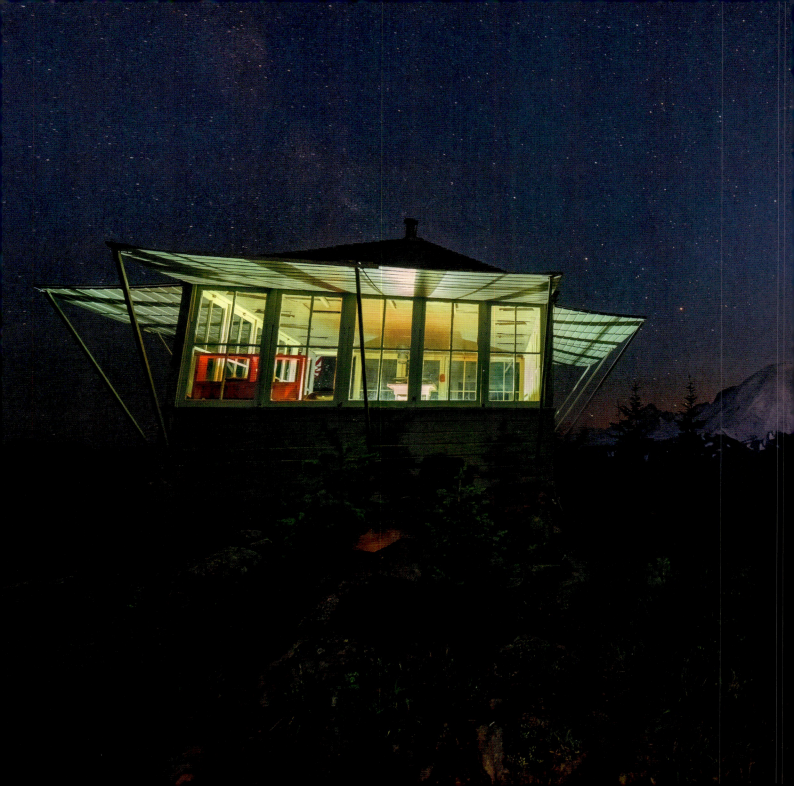

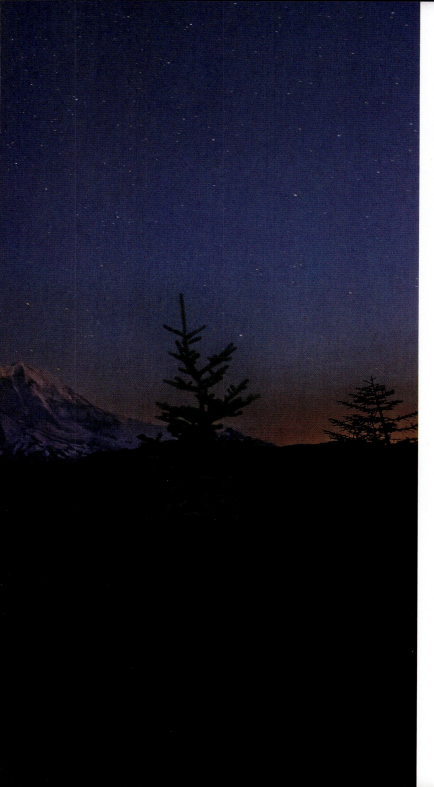

PREVIOUS PAGES, LEFT TO RIGHT
A beautiful view of Mount Rainier from the Paradise Trail is made all the better by the surrounding wildflowers. • A pristine mountain stream in Mount Rainier's Paradise region. • An updraft and lenticular cloud wave builds up above Mount Rainier from the Mazama Ridge area during the peak of autumn. •

LEFT A nighttime visit to Sun Top Lookout in Mt. Baker-Snoqualmie National Forest provides a stunning view of the Milky Way and Mount Rainier. •

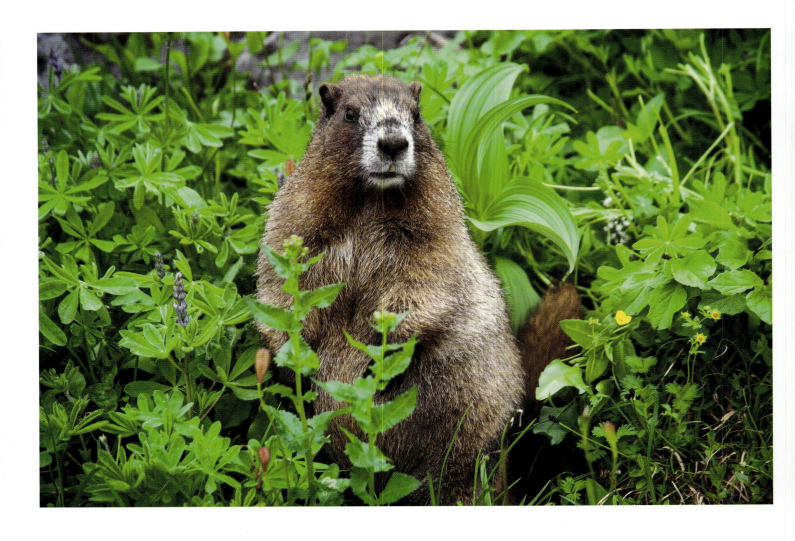

ABOVE Hoary marmots (*Marmota caligata*) are a common sight in the subalpine meadows around Mount Rainier. In summer, they consume vast quantities of meadow vegetation to put on a thick layer of fat that will allow them to survive eight to nine months of winter hibernation. •

OPPOSITE A small summer tarn reflects the backside of Mount Rainier from Indian Henry Hunting Grounds during a memorable sunset. •

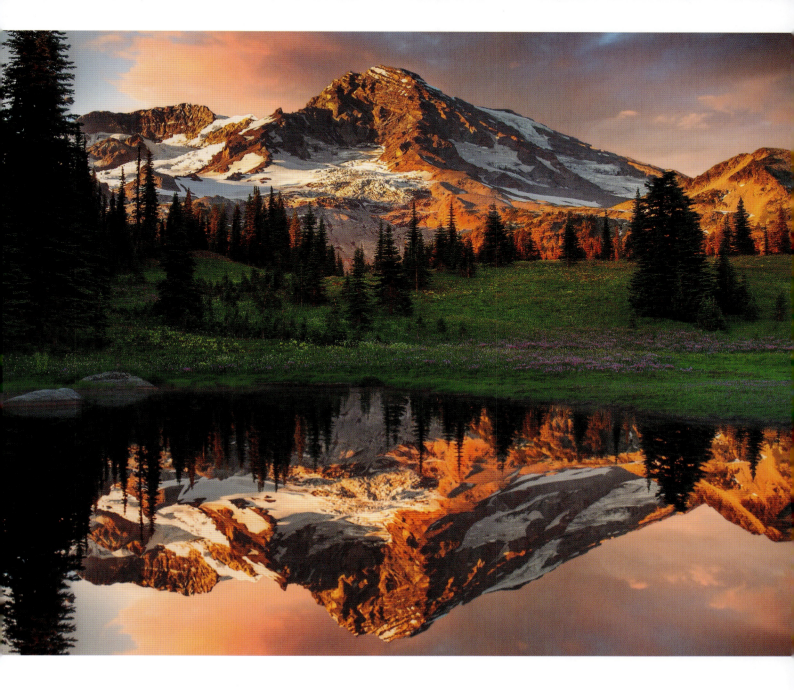

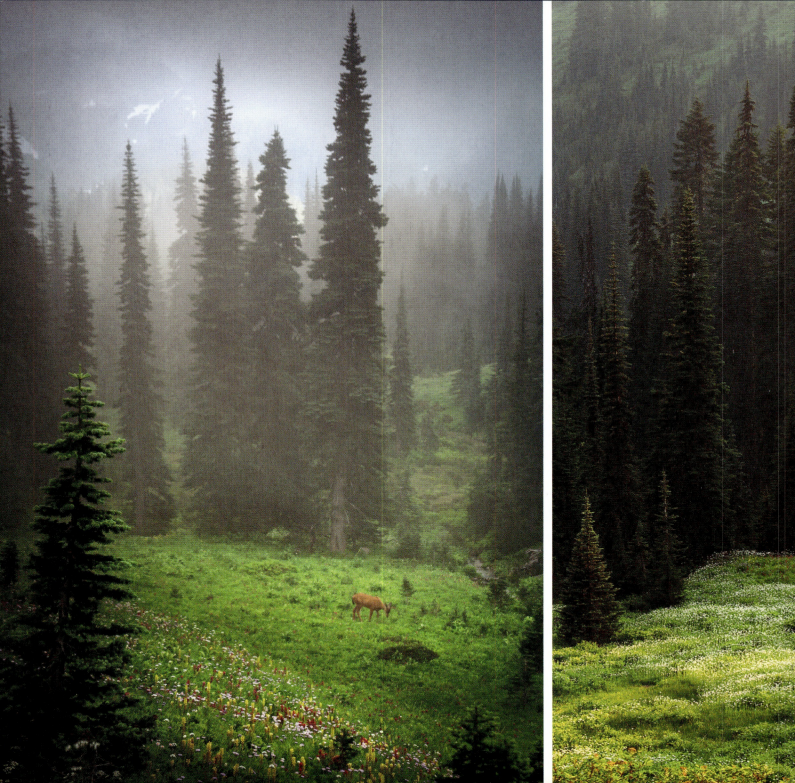

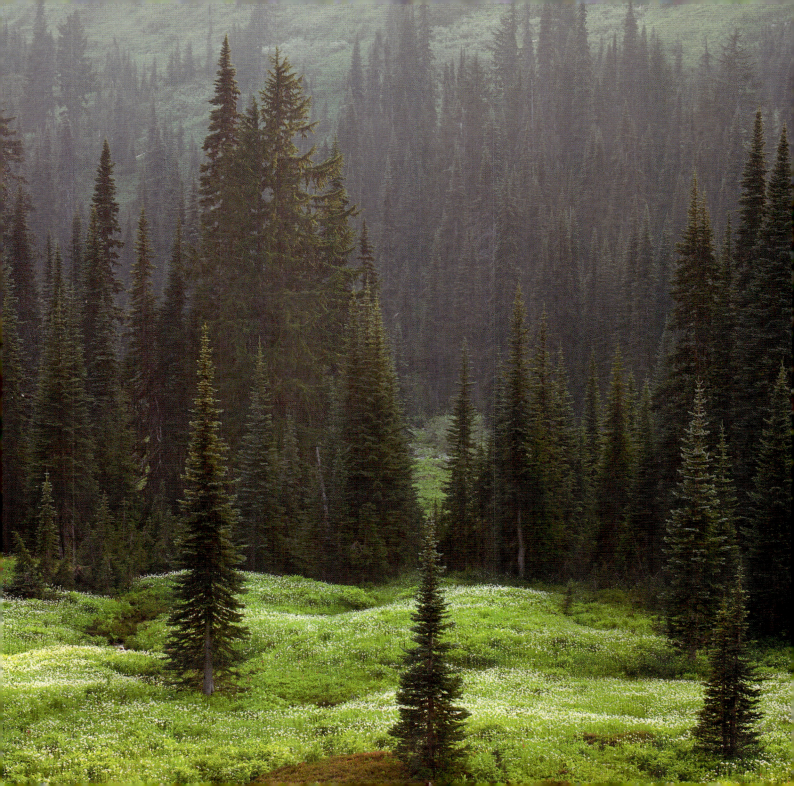

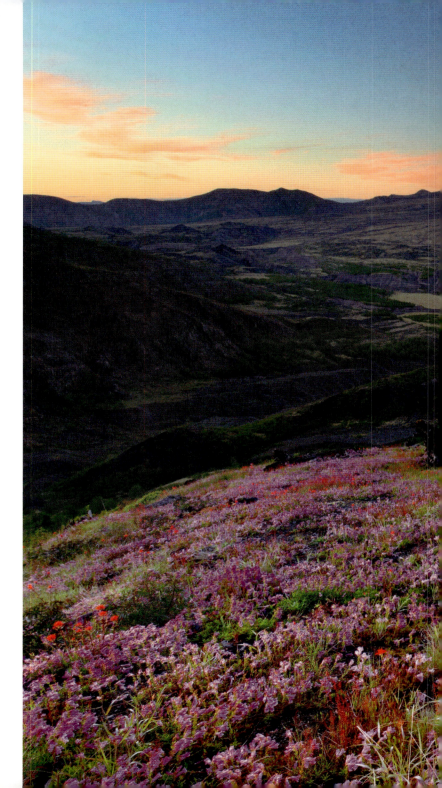

PREVIOUS PAGES, LEFT TO RIGHT
A hike along the Nisqually Vista Trail in Mount Rainier National Park reveals a visual feast including fog-shrouded peaks, fields of wildflowers, subalpine fir trees, and a grazing blacktail deer. •
A summer haze sits in the valley of a wildflower-carpeted, subalpine forest in Mount Rainier National Park. •

RIGHT Purple penstemon blankets the volcanic ash hills approaching Mount Saint Helens. •

OVERLEAF Moulton Falls Bridge sits high above the East Fork Lewis River; a long exposure shows the leaves flowing downstream. •

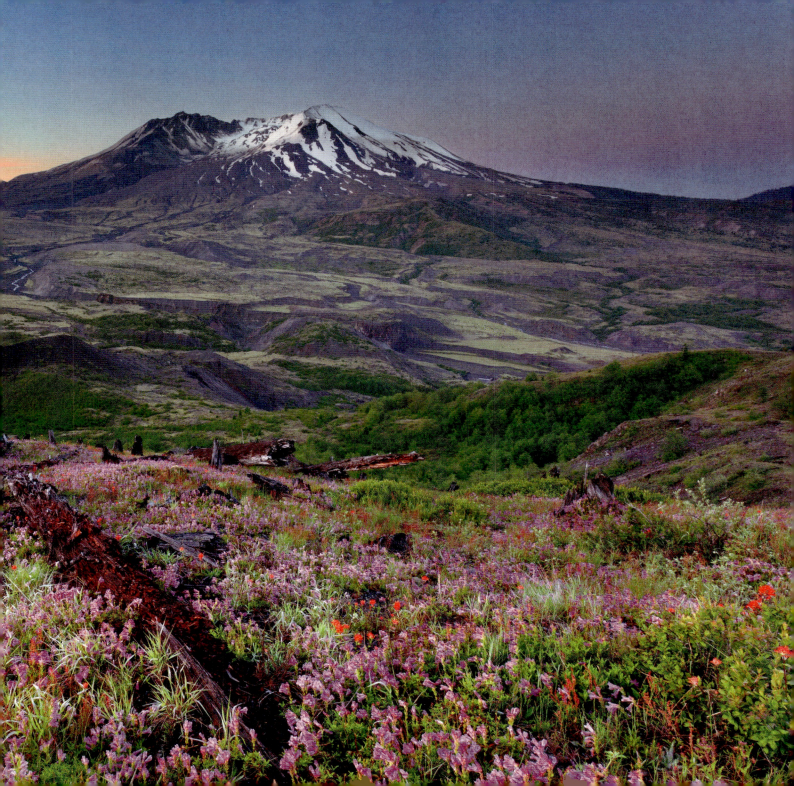

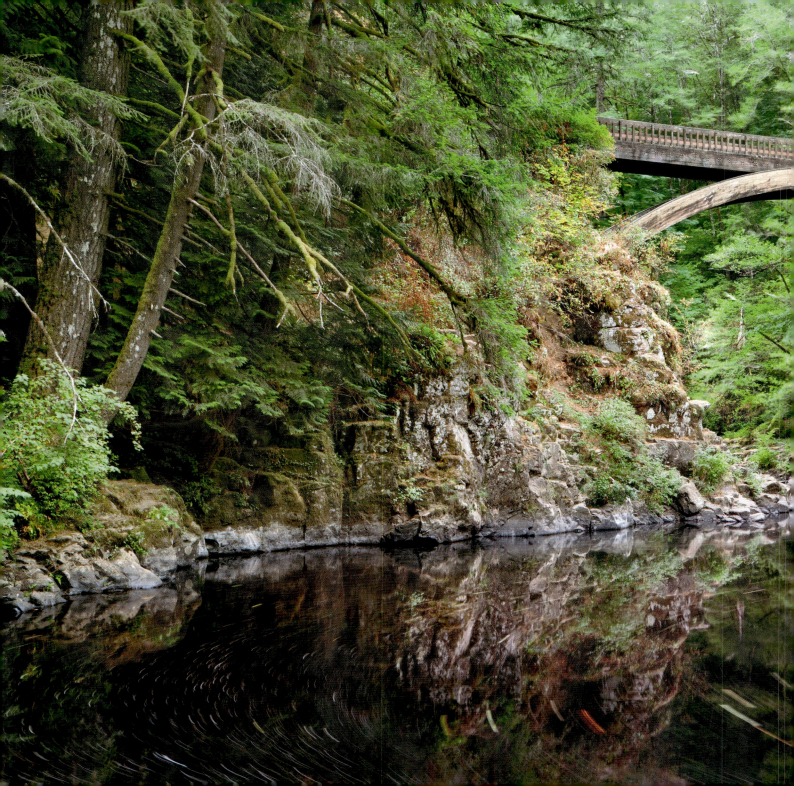

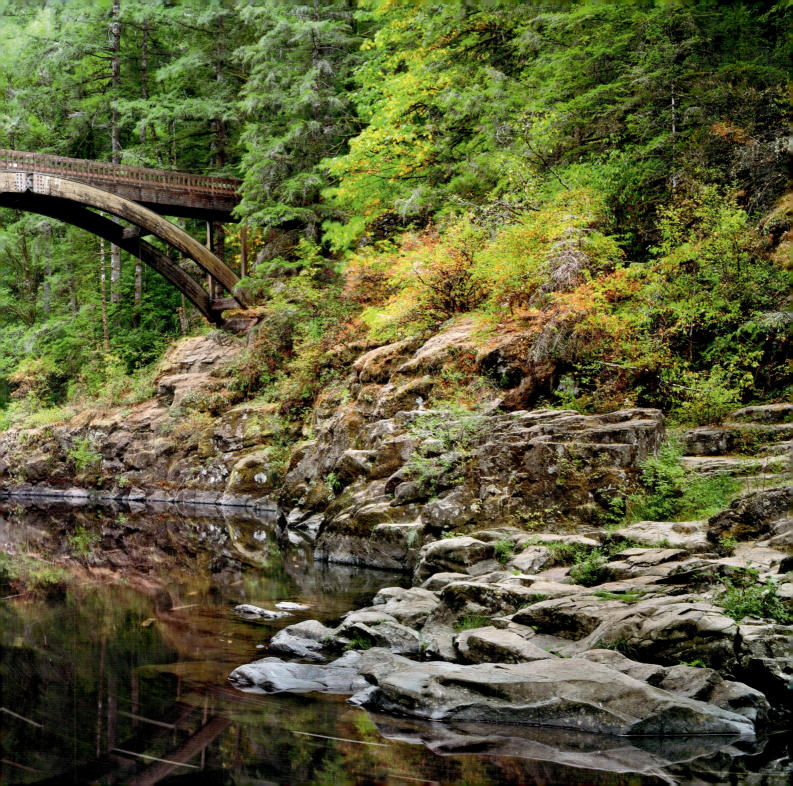

A crop of orchard pears ripening
in summertime. ●

Pinot noir grapes growing on the vine
during the summer season. ●

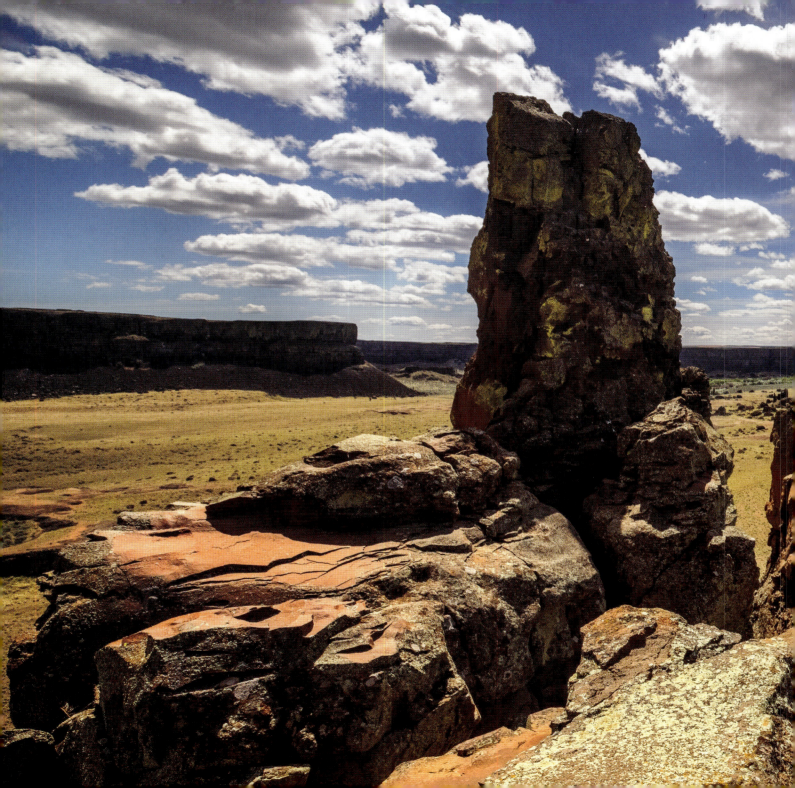

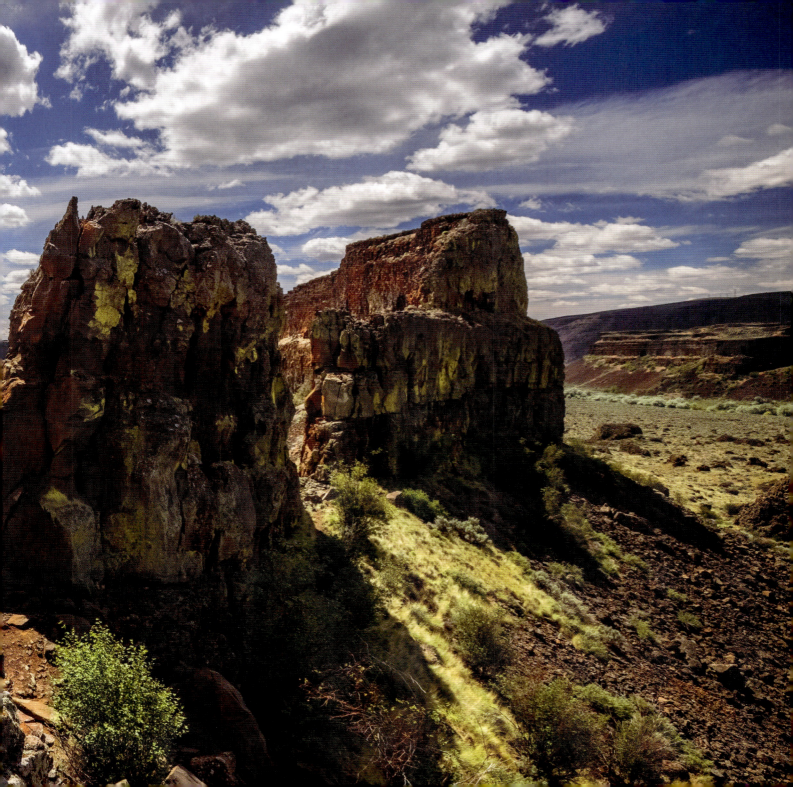

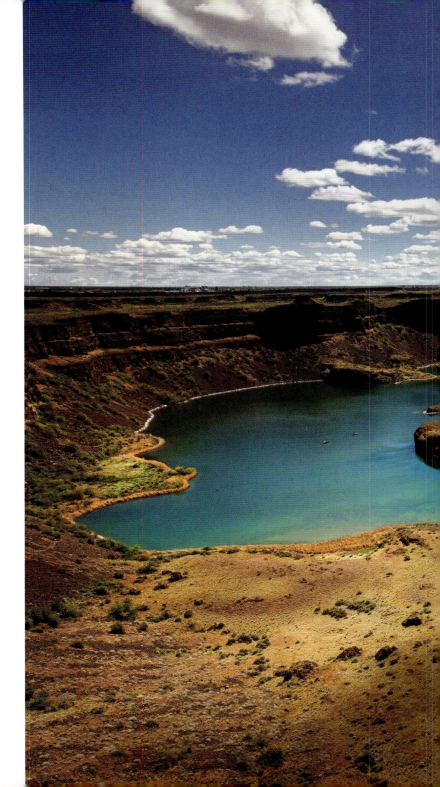

PREVIOUS PAGES These basalt towers at Sun Lakes-Dry Falls State Park were left standing after ice age floods scoured the land and carved out the now dry riverbed, or coulee, tens of thousands of years ago. •

RIGHT The 400-foot-tall cliffs of what we now call Dry Falls were the site of an enormous waterfall during the end of the last ice age. •

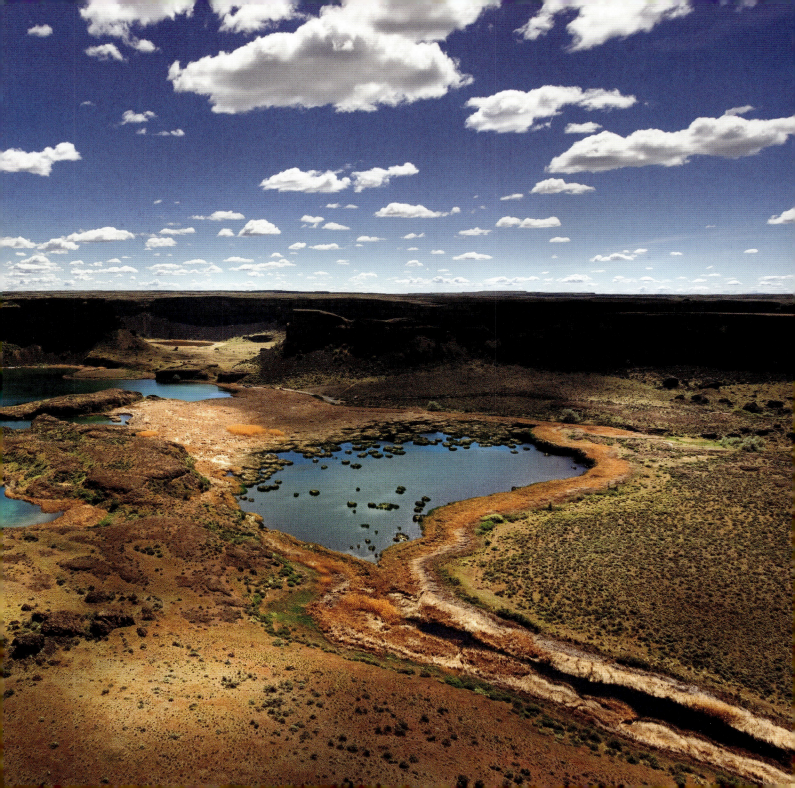

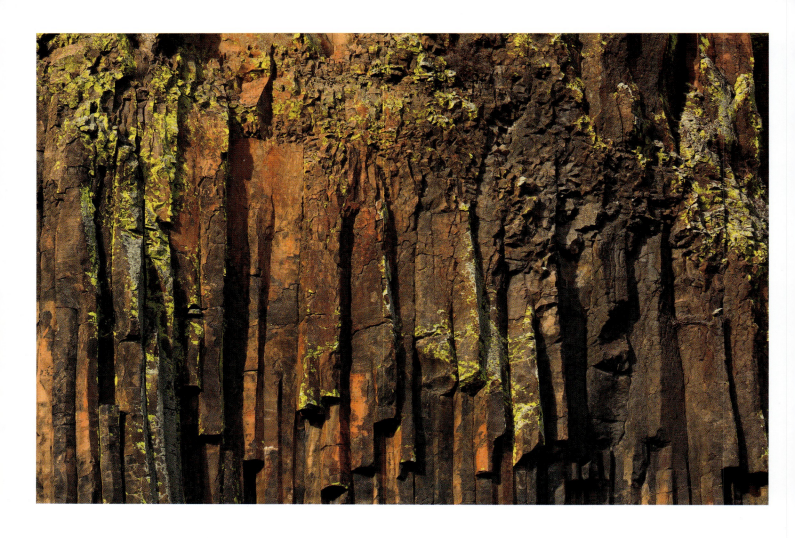

Lichen-covered columnar basalt at
Steamboat Rock State Park. •

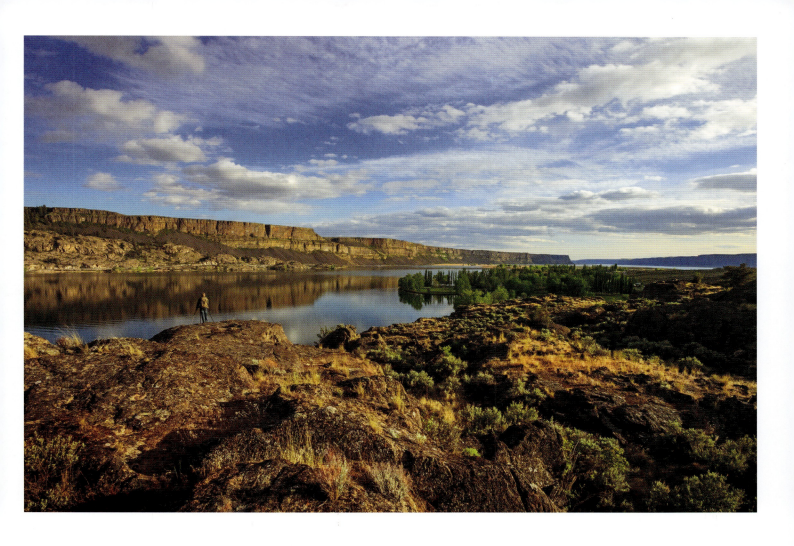

A well-placed photographer shows the massive scale of Devils Punch Bowl, an arm of the larger Banks Lake in Steamboat Rock State Park. •

Deep Lake in Sun Lakes-Dry Falls State Park is one of many lakes in the area that was carved by massive ice age floods over 13,000 years ago. This one stands out for its vertical basalt cliffs and turquoise-blue water. •

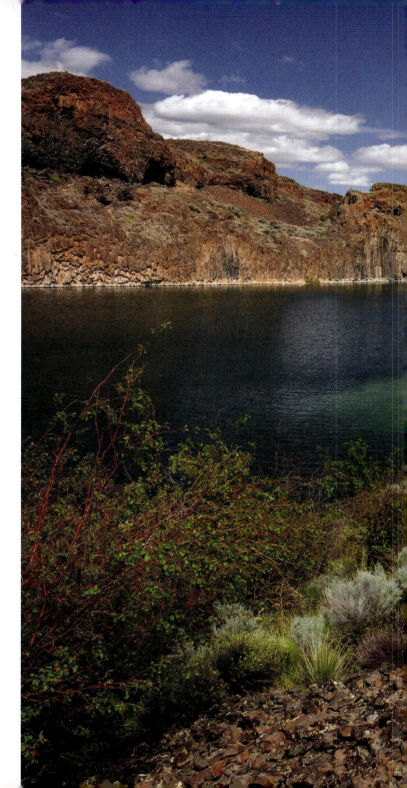

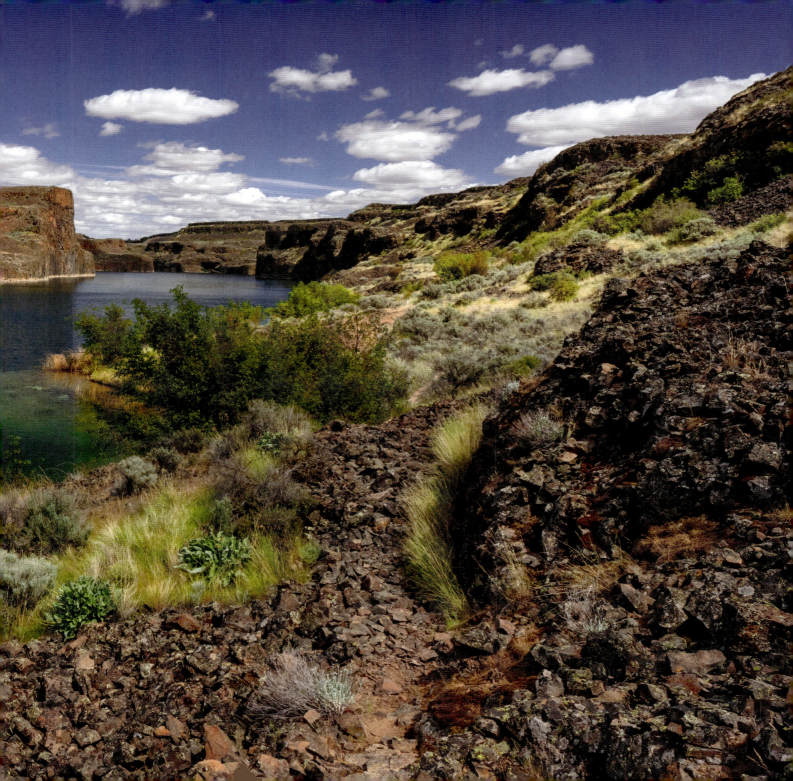

Mountain lady's slipper (*Cypripedium montanum*) grows in spring along the trails of Brooks Memorial State Park. ●

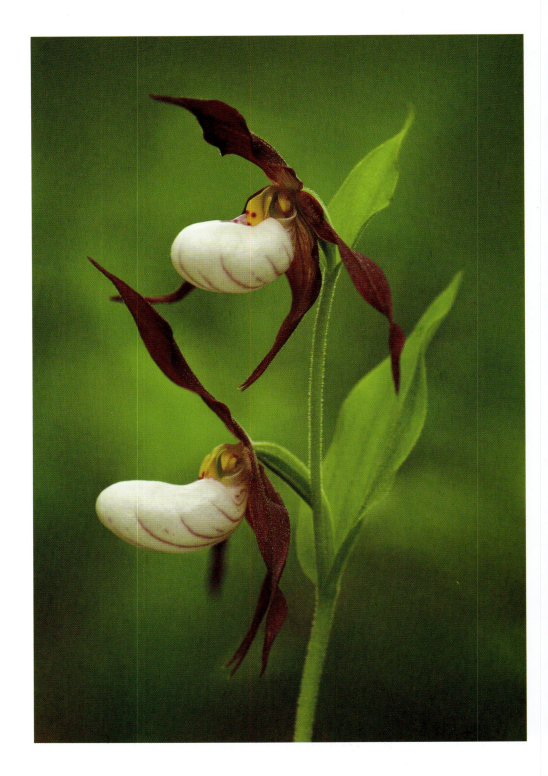

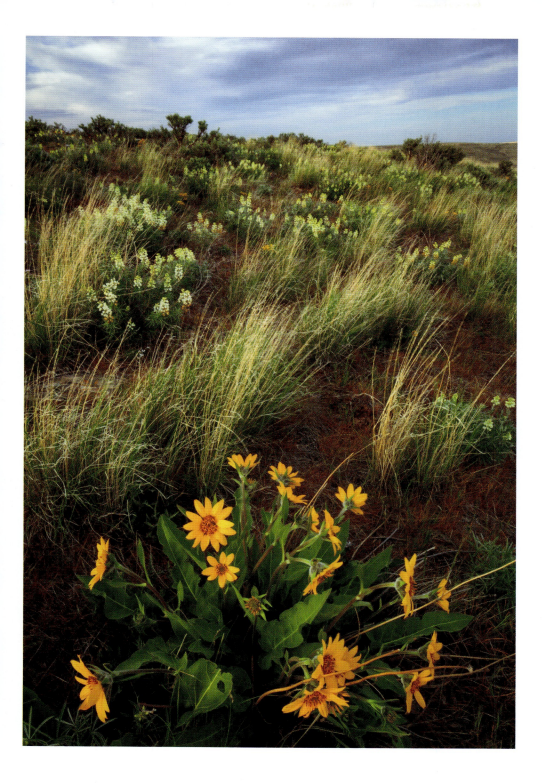

The Beezely Hills form a preserved shrub-steppe ecosystem and are famous for their spring wildflower show. White sulphur lupine (*Lupinus sulphureus*) and arrowleaf balsamroot (*Balsamorhiza sagittata*) make up this display. •

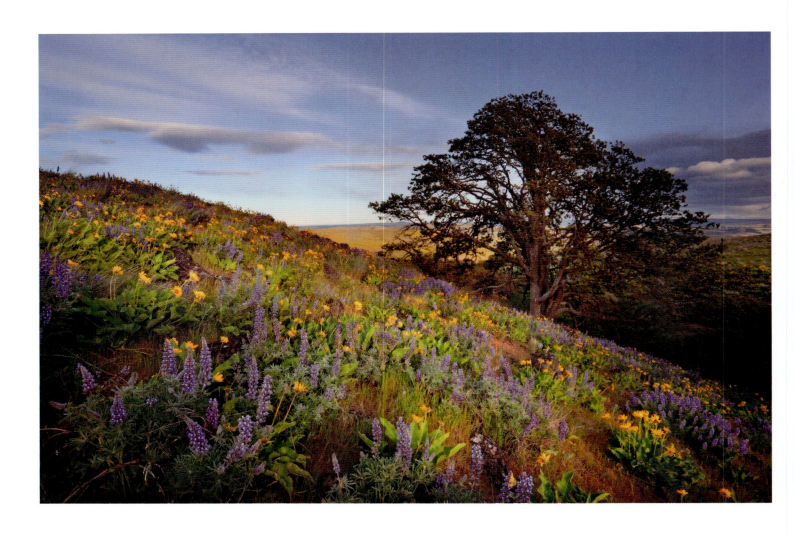

A large oak tree stands on a hillside
springing to life with lupine and balsam-
root flowers in Columbia Hills Historical
State Park. •

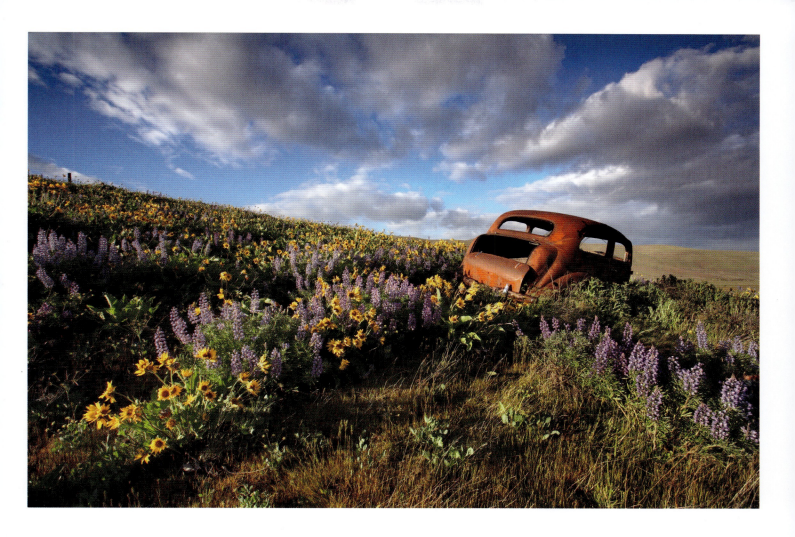

The shell of an old rusty car sits in a field of wildflowers inside Dalles Mountain Ranch. •

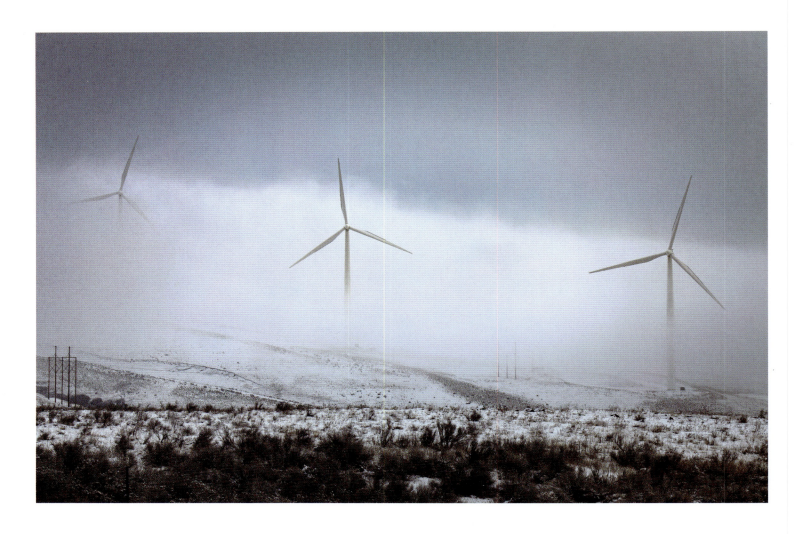

Giant wind turbines up to 400 feet tall
rise mysteriously out of a winter fog layer
along the Columbia River near Maryhill. •

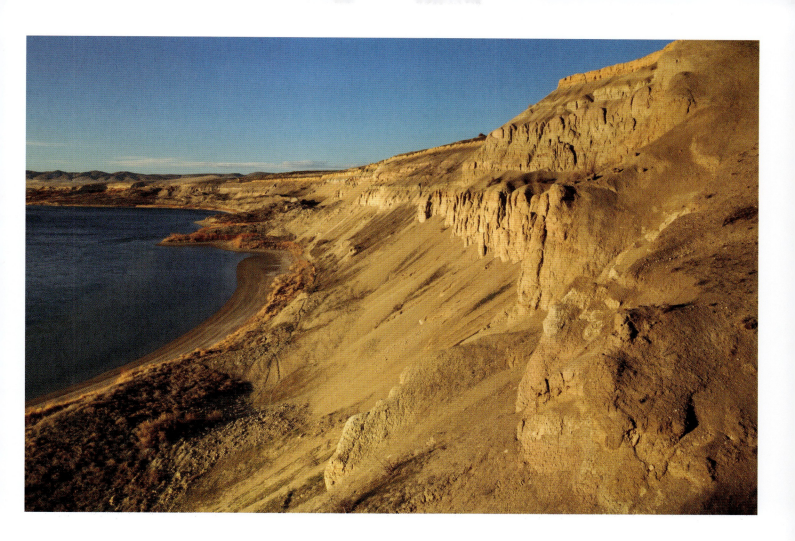

The White Bluffs in Hanford Reach
National Monument radiate the low rays
of the sun along one of the last remaining
wild stretches of the Columbia River. •

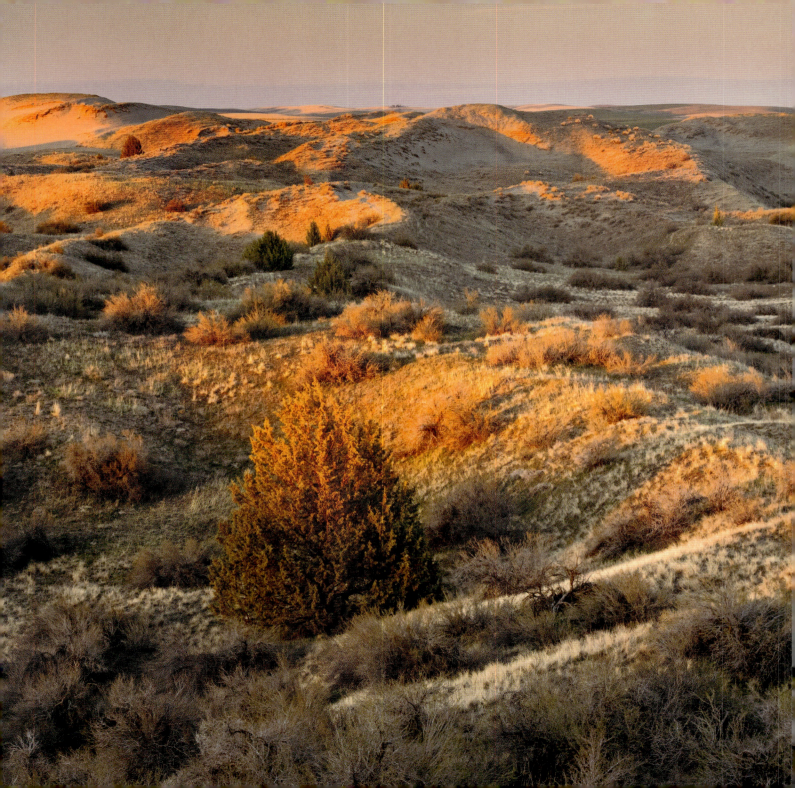

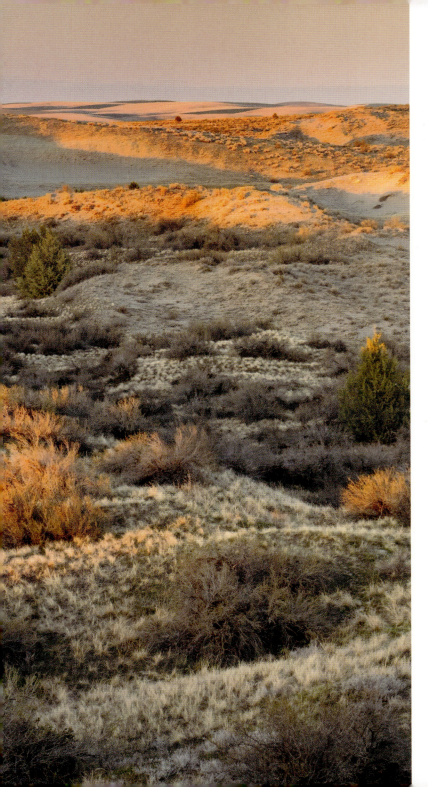

Juniper Dunes Wilderness, here basking in the evening light, is home to the northern-most growth of western juniper. •

203

The many colors of petrified wood can be seen in this close-up from Ginkgo Petrified Forest State Park. •

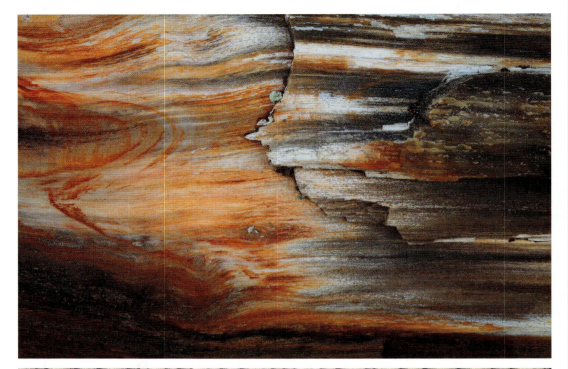

A close-up view of the scalloped layers, texture, and patterns of the sand in Juniper Dunes Wilderness. •

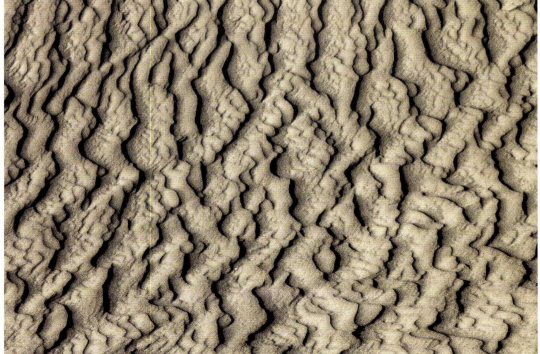

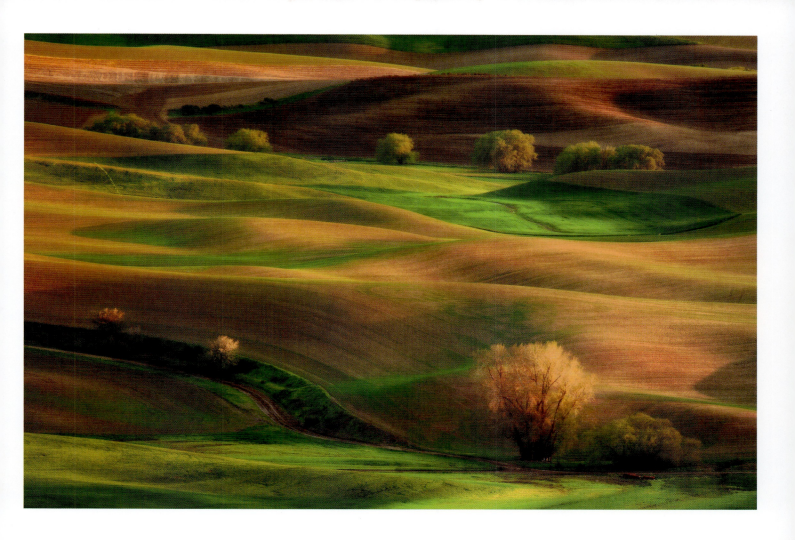

The bright spring colors of
cottonwood trees and rolling hills
in the Palouse region. •

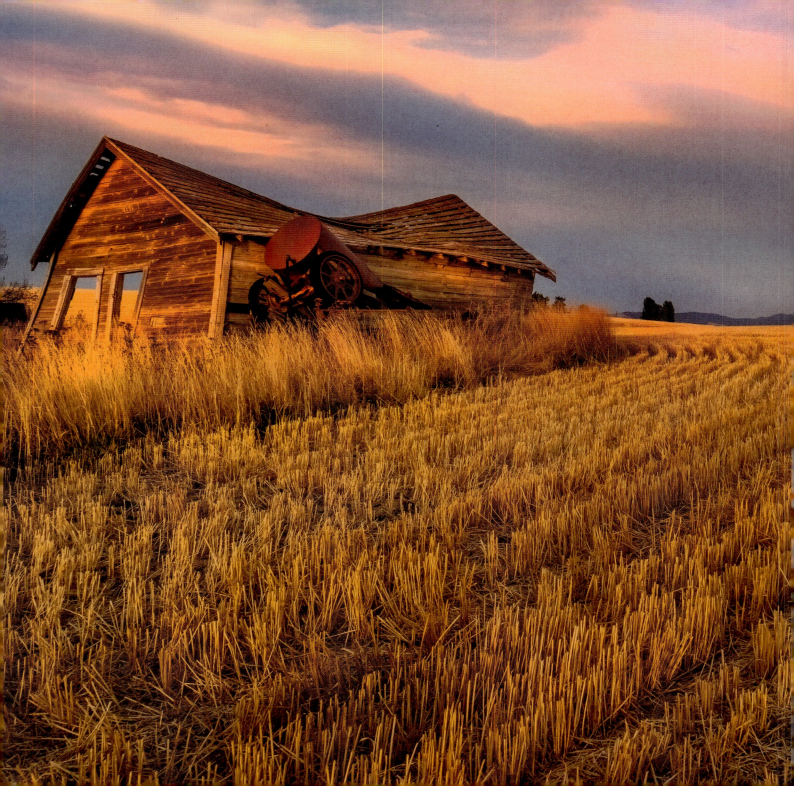

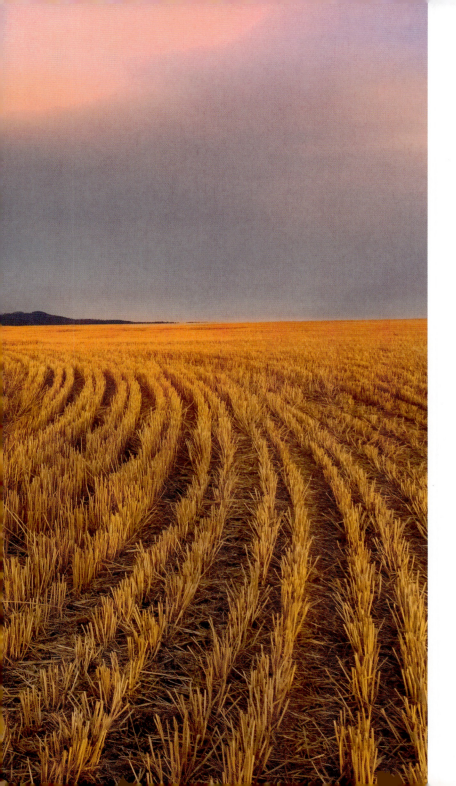

An old bar sits on a Palouse field during a pink sunset in harvest season. ●

This grass and tree in the Palouse region are beautifully illuminated by side lighting from the sun. •

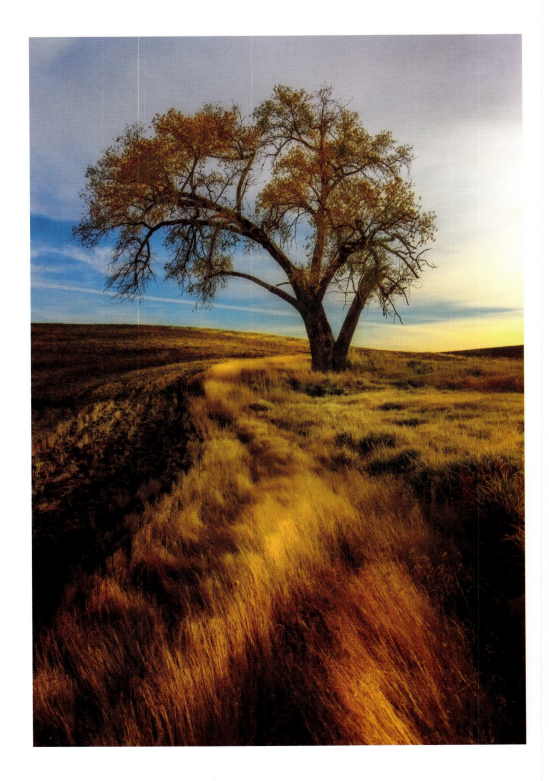

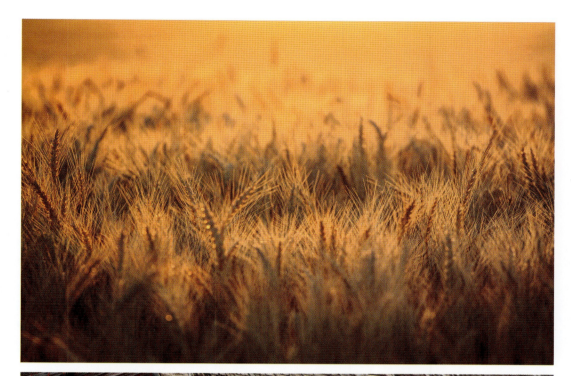

Amber waves of wheat, set alight by the setting sun during the summer harvest season in the Palouse. Washington is the nation's fourth largest wheat producer, harvesting over 2 million acres each year. •

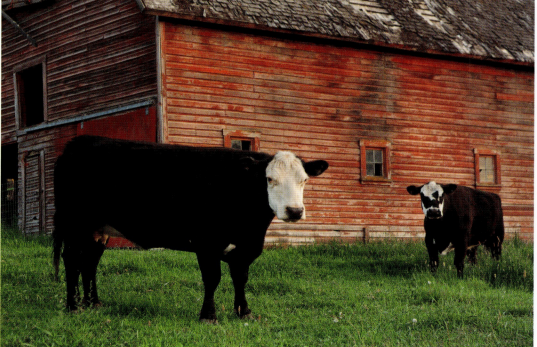

Two cows stand by a red barn in the Palouse. •

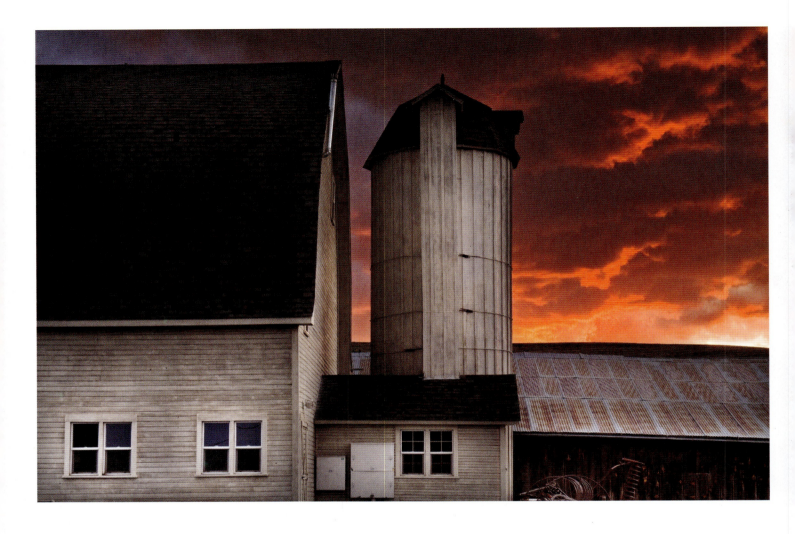

ABOVE The Dahmen Barn in Uniontown was built in 1935 and housed a commercial dairy until 1953. After sitting vacant for 50 years, the barn was renovated by the community and is now home to an artisans co-op (and its famous fence constructed of over 1000 vintage wheels). •

OPPOSITE Palouse Falls seen from below on a very cold winter day. •

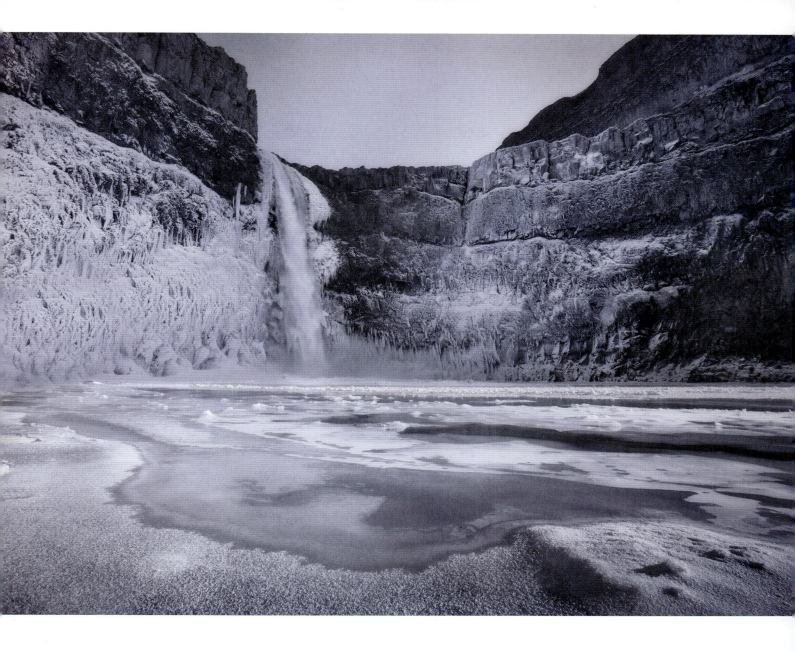

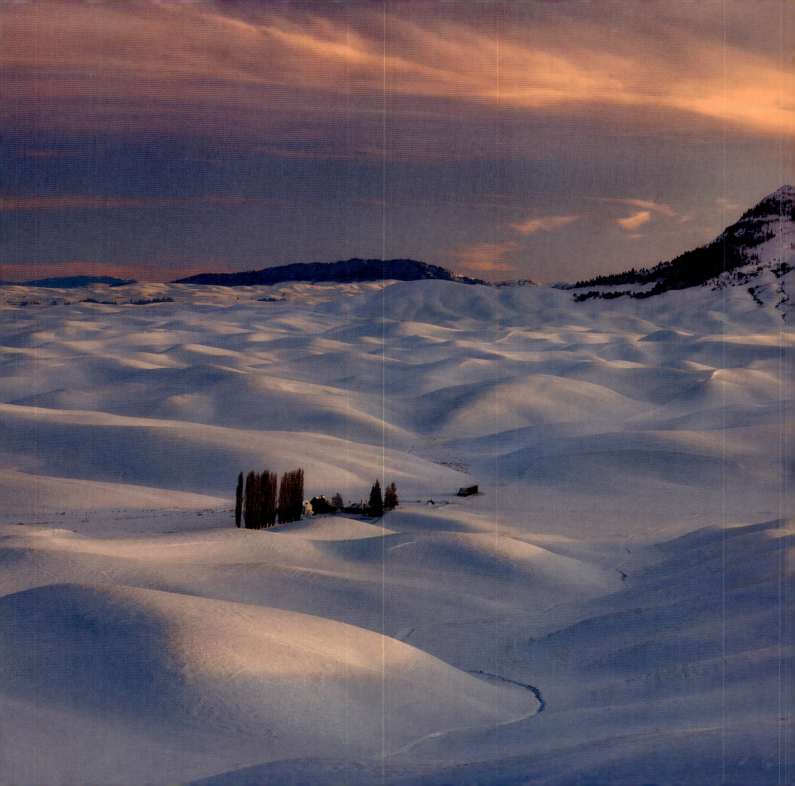

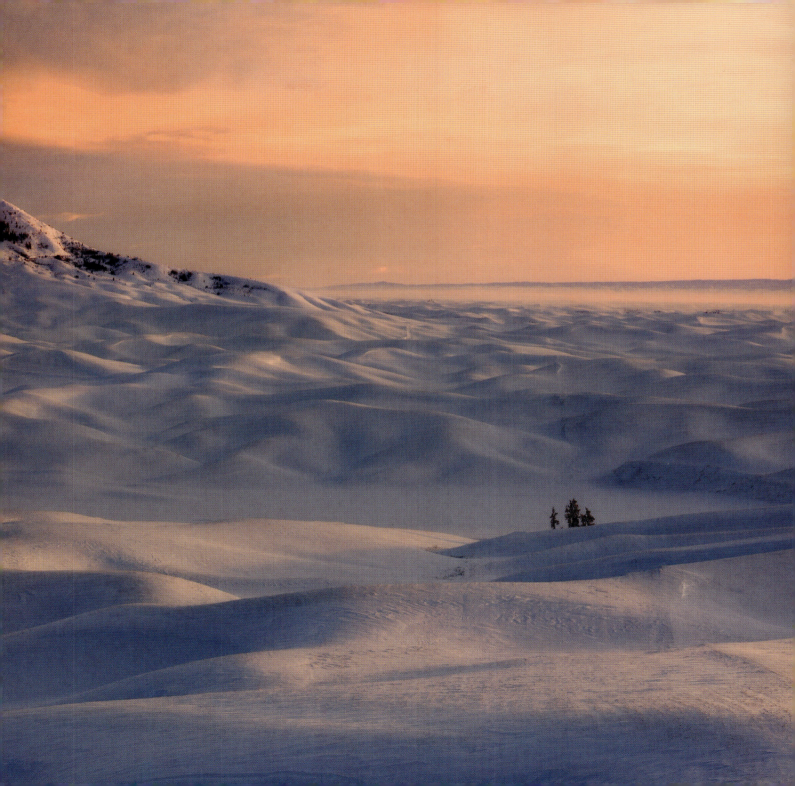

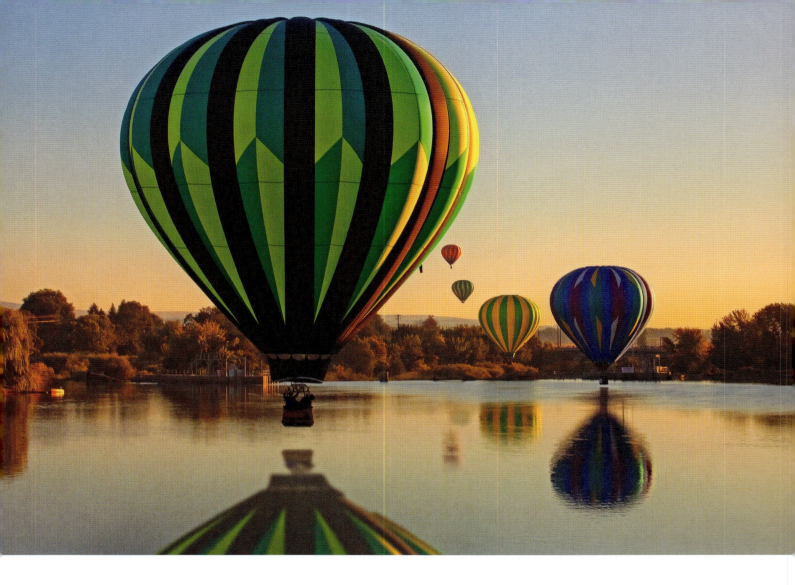

PREVIOUS PAGES Snow covers the rolling hills of the Palouse with Steptoe Butte in the background. •

ABOVE Hot air balloons reflected in the Yakima River at sunrise. Every September, the city of Prosser hosts the Great Prosser Balloon Rally. •

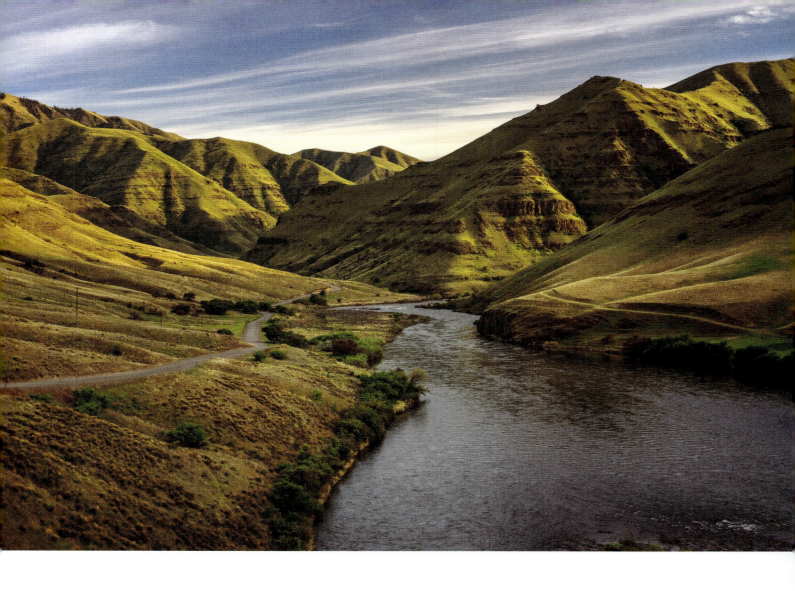

In the extreme southeast corner of Washington, the Grande Ronde River cuts its way up from Oregon and meets the Snake River at the exit of Hell's Canyon. The surrounding hills turn yellow-green with new grass for a few short weeks in spring. •

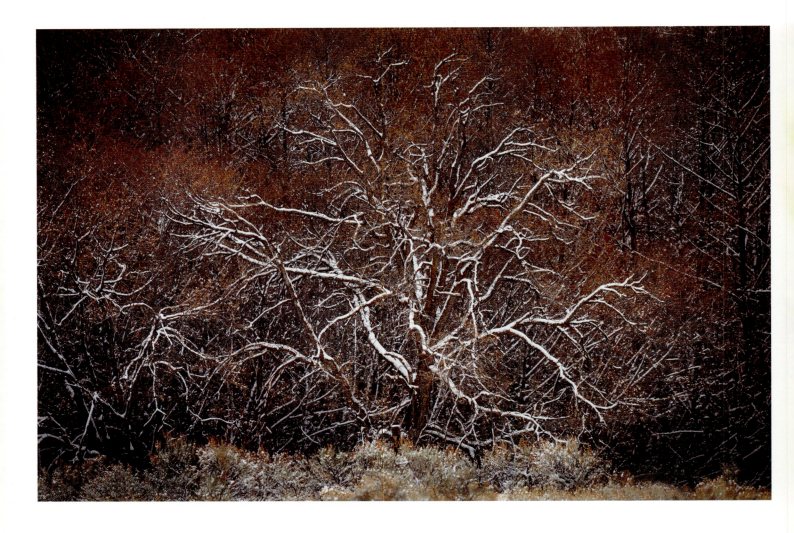

ABOVE An oak tree on the Yakima
Reservation is outlined in white during
a winter snowfall. White oak (*Quercus
garryana*) is usually only found west of the
Cascade Range, but can also be found
east of the mountains where the foothills
meet the plains in Yakima and Klickitat
counties. •

OPPOSITE Fall reflections in Spokane's
Japanese Garden. •

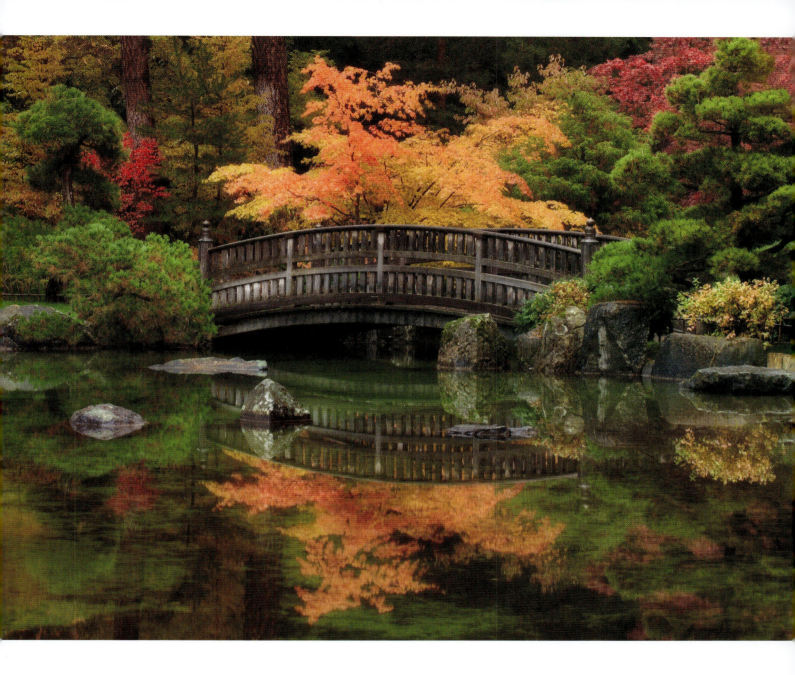

CREDITS

1	2	3	4
5	6	7	8
9	10	11	12

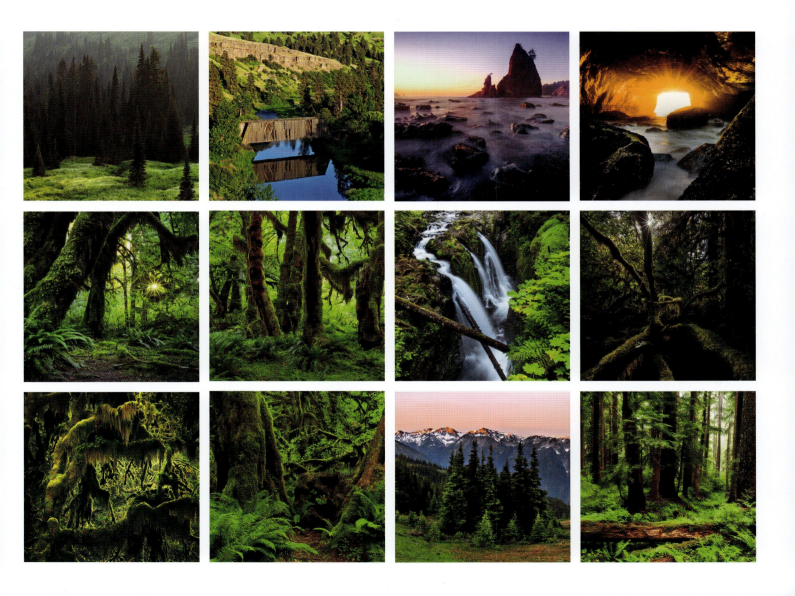

1
Page: 25
Adrian Klein
Camera: Canon EOS 5D Mark II
Aperture: $f/14$
Focal Length: 17mm
Shutter Speed: 1.6 sec.
ISO: 100

2
Page: 26
Adrian Klein
Camera: Canon EOS 5D Mark II
Aperture: $f/16$
Focal Length: 40mm
Shutter Speed: 1.6 sec.
ISO: 200

3
Page: 28
Kevin McNeal
Camera: Nikon D810
Aperture: $f/22$
Focal Length: 24mm
Shutter Speed: 0.4 sec.
ISO: 400

4
Page: 29
Kevin McNeal
Camera: Nikon D810
Aperture: $f/16$
Focal Length: 24mm
Shutter Speed: 1 sec.
ISO: 640

5
Page: 30
Zack Schnepf
Camera: Canon EOS 5D Mark I
Aperture: $f/20$
Focal Length: 73mm
Shutter Speed: 1/6 sec.
ISO: 100

6
Page: 31
David Cobb
Camera: Canon EOS 5D Mark I
Aperture: $f/16$
Focal Length: 17mm
Shutter Speed: 1/40 sec.
ISO: 100

7
Page: 33
Kevin McNeal
Camera: Nikon D810
Aperture: $f/16$
Focal Length: 28mm
Shutter Speed: 1/20 sec.
ISO: 640

8
Page: 34
Kevin McNeal
Camera: Nikon D850
Aperture: $f/13$
Focal Length: 11mm
Shutter Speed: 1/1600 sec.
ISO: 6400

9
Page: 35
Kevin McNeal
Camera: Canon EOS 5D Mark II
Aperture: $f/22$
Focal Length: 17mm
Shutter Speed: 1/25 sec.
ISO: 100

10
Page: 36
David Cobb
Camera: Canon EOS 5D Mark III
Aperture: $f/16$
Focal Length: 25mm
Shutter Speed: 3.2 sec.
ISO: 100

11
Page 37
David Cobb
Camera: Canon EOS 5D Mark I
Aperture: $f/22$
Focal Length: 31mm
Shutter Speed: 1/6 sec.
ISO: 100

12
Page: 38 left
Chip Phillips
Camera: Canon EOS 5D Mark I
Aperture: $f/22$
Focal Length: 16mm
Shutter Speed: 3.2 sec.
ISO: 50

13
Pages: 38–39 middle
Chip Phillips
Camera: Canon EOS 5D Mark I
Aperture: $f/16$
Focal Length: 16mm
Shutter Speed: 13 sec.
ISO: 100

14
Page: 39
Chip Phillips
Camera: Canon 5D Mark III
Aperture: $f/16$
Focal Length: 11mm
Shutter Speed: 1/25 sec.
ISO: 100

15
Page: 40
Erin Babnik
Camera: Canon EOS 5D Mark III
Aperture: $f/16$
Focal Length: 21mm
Shutter Speed: 0.5 sec.
ISO: 100

16
Page: 41
Adrian Klein
Camera: Canon EOS 5D Mark II
Aperture: $f/22$
Focal Length: 35mm
Shutter Speed: 0.3 sec.
ISO: 200

1	2	3	4
5	6	7	8
9	10	11	12
13	14	15	16

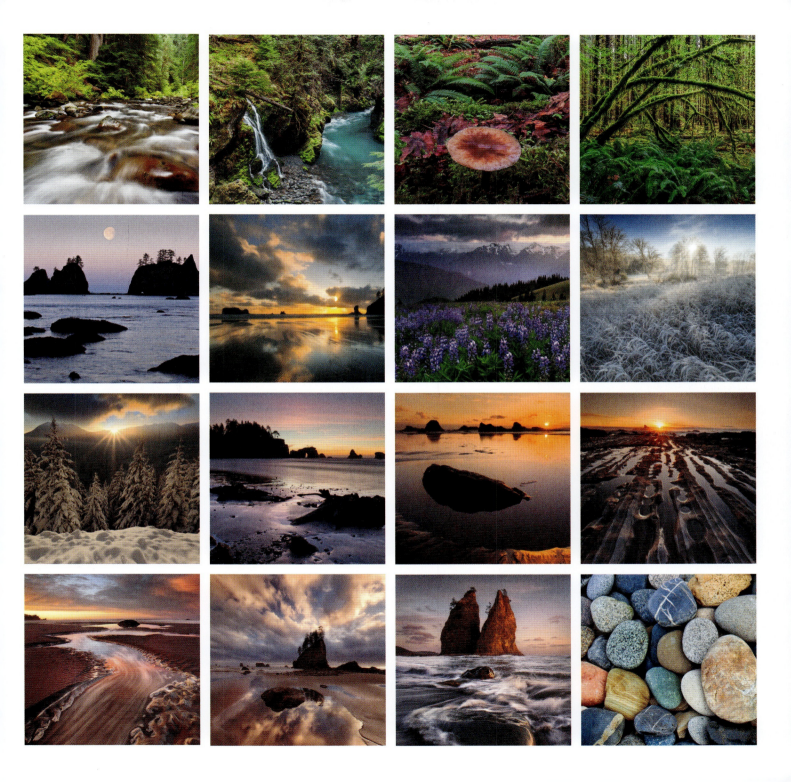

1
Page: 42
Chip Phillips
Camera: Canon EOS 5D Mark III
Aperture: ƒ/18
Focal Length: 11mm
Shutter Speed: 1 sec.
ISO: 100

———

2
Page: 44
Zack Schnepf
Camera: Canon EOS 5D Mark II
Aperture: ƒ/18
Focal Length: 17mm
Shutter Speed: 0.6 sec.
ISO: 160

———

3
Page: 45
Zack Schnepf
Camera: Canon EOS 5D Mark I
Aperture: ƒ/16
Focal Length: 17mm
Shutter Speed: 0.6 sec.
ISO: 100

———

4
Page: 46
Kevin McNeal
Camera: Canon EOS 5D Mark I
Aperture: ƒ/22
Focal Length: 17mm
Shutter Speed: 2.5 sec.
ISO: 50

———

5
Page: 48
David Cobb
Camera: Canon EOS 5D Mark I
Aperture: ƒ/22
Focal Length: 27mm
Shutter Speed: 25 sec.
ISO: 100

———

6
Page: 49
David Cobb
Camera: Canon EOS 5D Mark III
Aperture: ƒ/22
Focal Length: 54mm
Shutter Speed: 1 sec.
ISO: 200

———

7
Page: 50
David Cobb
Camera: Canon EOS 5D Mark III
Aperture: ƒ/16
Focal Length: 27mm
Shutter Speed: 15 sec.
ISO: 320

———

8
Page: 52
Kevin McNeal
Camera: Canon EOS 5D Mark II
Aperture: ƒ/22
Focal Length: 17mm
Shutter Speed: 1/25 sec.
ISO: 100

———

9
Page: 53
Sean Bagshaw
Camera: Canon EOS R5
Aperture: ƒ/13
Focal Length: 100mm
Shutter Speed: 1/100 sec.
ISO: 400

———

10
Page: 54
David Cobb
Camera: Canon EOS 5D Mark III
Aperture: ƒ/16
Focal Length: 85mm
Shutter Speed: 1.3 sec.
ISO: 400

———

11
Page: 55
Kevin McNeal
Camera: Canon EOS 5D Mark II
Aperture: ƒ/16
Focal Length: 280mm
Shutter Speed: 1/20 sec.
ISO: 200

———

12
Page: 56
Kevin McNeal
Camera: DJI Mavic 2 Pro
Aperture: ƒ/7.1
Focal Length: 10.3mm
Shutter Speed: 1/640 sec.
ISO: 100

———

13
Page: 58
Kevin McNeal
Camera: Nikon D800
Aperture: ƒ/9
Focal Length: 15mm
Shutter Speed: 1/20 sec.
ISO: 800

———

14
Page: 59
Kevin McNeal
Camera: Nikon D800
Aperture: ƒ/9
Focal Length: 14mm
Shutter Speed: 5 sec.
ISO: 1600

———

15
Page: 60
Sean Bagshaw
Camera: Canon EOS R5
Aperture: ƒ/8
Focal Length: 35mm
Shutter Speed: 1/1000 sec.
ISO: 200

———

16
Page: 62
Adrian Klein
Camera: Canon EOS R5
Aperture: ƒ/13
Focal Length: 40mm
Shutter Speed: 1/6 sec.
ISO: 250

———

PHOTO CREDITS

1	2	3	4
5	6	7	8
9	10	11	12
13	14	15	16

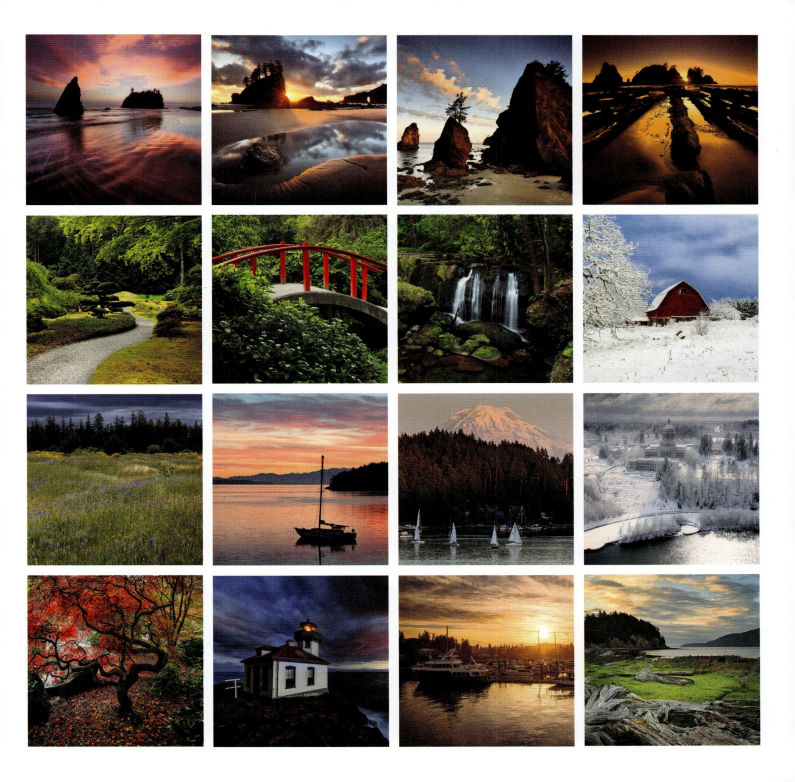

1
Page: 63 top
Adrian Klein
Camera: Canon EOS R5
Aperture: $f/13$
Focal Length: 28mm
Shutter Speed: 0.3 sec.
ISO: 250

2
Page: 63 bottom
Adrian Klein
Camera: Canon EOS R5
Aperture: $f/22$
Focal Length: 73mm
Shutter Speed: 0.6 sec.
ISO: 200

3
Page: 64
Kevin McNeal
Camera: Nikon D800
Aperture: $f/9$
Focal Length: 18mm
Shutter Speed: 2 sec.
ISO: 200

4
Page: 66
David Cobb
Camera: Canon EOS 5D Mark I
Aperture: $f/16$
Focal Length: 68mm
Shutter Speed: 2 sec.
ISO: 100

5
Page: 67 top
Kevin McNeal
Camera: Nikon D800
Aperture: $f/9$
Focal Length: 25mm
Shutter Speed: 1/50 sec.
ISO: 800

6
Page: 67 bottom
Kevin McNeal
Camera: Nikon D800
Aperture: $f/9$
Focal Length: 28mm
Shutter Speed: 1/60 sec.
ISO: 800

7
Page: 68
Kevin McNeal
Camera: Canon EOS 20D
Aperture: $f/7.1$
Focal Length: 17mm
Shutter Speed: 1/100 sec.
ISO: 400

8
Page: 69
Kevin McNeal
Camera: Nikon D800
Aperture: $f/9$
Focal Length: 25mm
Shutter Speed: 1/100 sec.
ISO: 400

9
Page: 70
Kevin McNeal
Camera: Canon EOS 5D Mark I
Aperture: $f/22$
Focal Length: 105mm
Shutter Speed: 8 sec.
ISO: 50

10
Page: 72
Kevin McNeal
Camera: Nikon D800
Aperture: $f/16$
Focal Length: 125mm
Shutter Speed: 1/6 sec.
ISO: 200

11
Page: 73
Kevin McNeal
Camera: Canon EOS 5D Mark II
Aperture: $f/16$
Focal Length: 19mm
Shutter Speed: 1/25 sec.
ISO: 200

12
Page: 74
Kevin McNeal
Camera: Canon EOS 5D Mark II
Aperture: $f/16$
Focal Length: 113mm
Shutter Speed: 1/10 sec.
ISO: 100

13
Page: 75
Kevin McNeal
Camera: Canon EOS 5D Mark II
Aperture: $f/16$
Focal Length: 131mm
Shutter Speed: 1/25 sec.
ISO: 100

14
Page: 76
David Cobb
Camera: Canon EOS 5D Mark I
Aperture: $f/16$
Focal Length: 70mm
Shutter Speed: 5 sec.
ISO: 400

15
Page: 77
David Cobb
Camera: Canon EOS 5D Mark III
Aperture: $f/11$
Focal Length: 45mm
Shutter Speed: 1/13 sec.
ISO: 100

16
Page: 78
David Cobb
Camera: Canon EOS 5D Mark I
Aperture: $f/5.6$
Focal Length: 28mm
Shutter Speed: 1/8 sec.
ISO: 100

PHOTO CREDITS

1	2	3	4
5	6	7	8
9	10	11	12
13	14	15	16

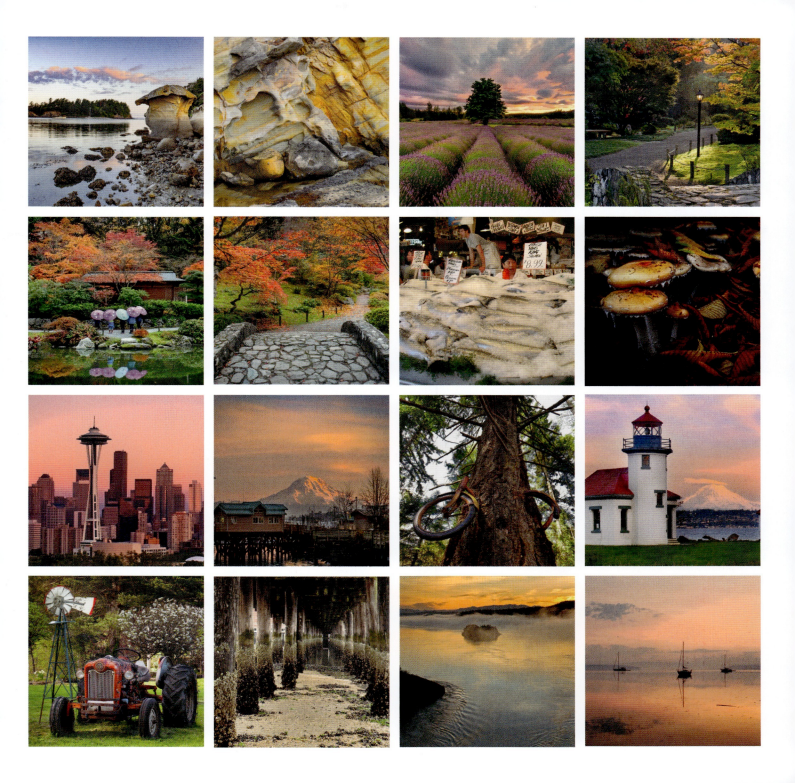

1
Page: 80
Zack Schnepf
Camera: Canon EOS 5D Mark I
Aperture: ƒ/16
Focal Length: 17mm
Shutter Speed: 0.6 sec.
ISO: 50

2
Page: 81
Zack Schnepf
Camera: Canon EOS 5D Mark I
Aperture: ƒ/16
Focal Length: 17mm
Shutter Speed: 3.2 sec.
ISO: 50

3
Page: 82 left
Sean Bagshaw
Camera: Canon EOS 5D Mark III
Aperture: ƒ/2.8
Focal Length: 16mm
Shutter Speed: 15 sec.
ISO: 3200

4
Page: 83
David Cobb
Camera: Canon EOS 5D Mark III
Aperture: ƒ/22
Focal Length: 24mm
Shutter Speed: 0.4 sec.
ISO: 100

5
Page: 84 left
Sean Bagshaw
Camera: Canon EOS 5D Mark III
Aperture: ƒ/16
Focal Length: 24mm
Shutter Speed: 1/30 sec.
ISO: 100

6
Pages: 84–85 middle
Adrian Klein
Camera: Canon EOS 5D Mark I
Aperture: ƒ/16
Focal Length: 17mm
Shutter Speed: 0.2 sec.
ISO: 160

7
Page: 85 right
Zack Schnepf
Camera: 5D Mark I
Aperture: ƒ/7.1
Focal Length:140mm
Shutter Speed: 1/200 sec.
ISO: 400

8
Page: 86
Chip Phillips
Camera: Canon EOS 5D Mark III
Aperture: ƒ/9
Focal Length: 176mm
Shutter Speed: 1/800 sec.
ISO: 100

9
Page: 87
David Cobb
Camera: Canon EOS 5D Mark III
Apertur: ƒ/16
Focal Length: 46mm
Shutter Speed: 1.3 sec.
ISO: 100

10
Page: 88
Sean Bagshaw
Camera: Canon EOS R5
Aperture: ƒ/22
Focal Length: 24mm
Shutter Speed: 1.6 sec.
ISO: 50

11
Page: 89
Sean Bagshaw
Camera: Canon EOS R5
Aperture: ƒ/11
Focal Length: 53mm
Shutter Speed: 1/100 sec.
ISO: 400

12
Page: 91
David Cobb
Camera: Canon EOS 5D Mark III
Aperture: ƒ/32
Focal Length: 260mm
Shutter Speed: 1.3 sec.
ISO: 100

13
Page: 92
Zack Schnepf
Camera: Nikon D850
Aperture: ƒ/11
Focal Length: 48mm
Shutter Speed: 1/25 sec.
ISO: 200

14
Page: 93
Chip Phillips
Camera: Canon EOS 5D Mark III
Aperture: ƒ/16
Focal Length: 47mm
Shutter Speed: 1 sec.
ISO: 100

15
Page: 94 left
Sean Bagshaw
Camera: Canon EOS 5D Mark III
Aperture: ƒ/18
Focal Length: 58mm
Shutter Speed: 1/13 sec.
ISO: 200

16
Page: 95
Kevin McNeal
Camera: Nikon D850
Aperture: ƒ/22
Focal Length: 42mm
Shutter Speed: 0.3 sec.
ISO: 31

PHOTO CREDITS

1	2	3	4
5	6	7	8
9	10	11	12
13	14	15	16

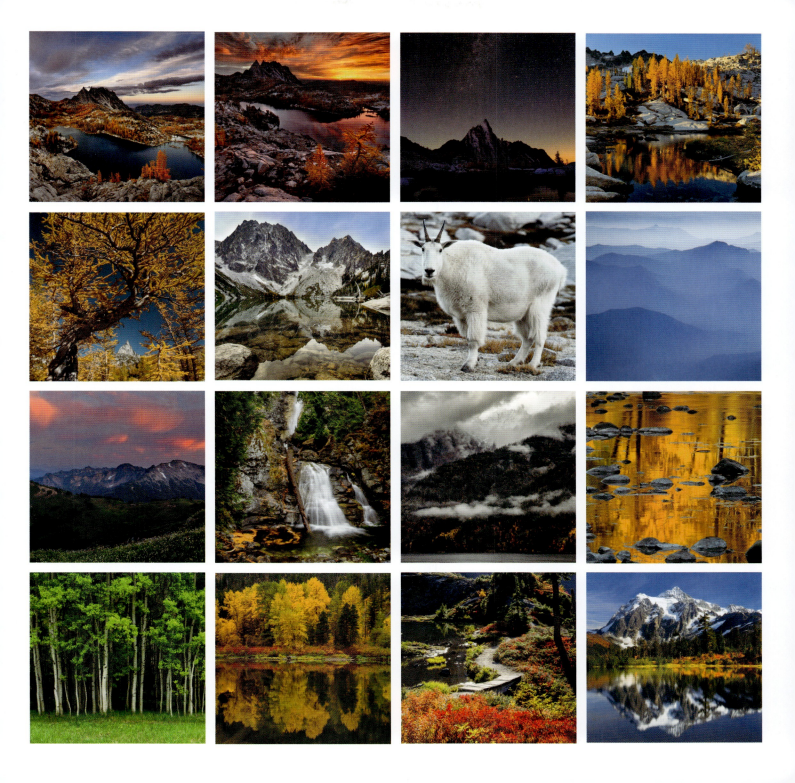

1
Page: 96
Kevin McNeal
Camera: Canon EOS 5D Mark II
Aperture: ƒ/16
Focal Length: 29mm
Shutter Speed: 1/13 sec.
ISO: 400

2
Page: 97
Kevin McNeal
Camera: Canon EOS 5D Mark II
Aperture: ƒ/16
Focal Length: 26mm
Shutter Speed: 1 sec.
ISO: 200

3
Page: 98
Sean Bagshaw
Camera: Canon EOS 5D Mark III
Aperture: ƒ/16
Focal Length: 24mm stitched panorama
Shutter Speed: 1.6 sec.
ISO: 100

4
Page: 100
Chip Phillips
Camera: Canon EOS 5D
Aperture: ƒ/22
Focal Length: 16mm
Shutter Speed: 1 sec.
ISO: 100

5
Page: 101
Kevin McNeal
Camera: Nikon D850
Aperture: ƒ/13
Focal Length: 28mm
Shutter Speed: 1/250 sec.
ISO: 1600

6
Page: 102
Sean Bagshaw
Camera: Canon EOS 5D Mark II
Aperture: ƒ/16
Focal Length: 32mm
Shutter Speed: 3.2 sec.
ISO: 200

7
Page: 104
Chip Phillips
Camera: Canon EOS 5D Mark II
Aperture: ƒ/14
Focal Length: 19mm
Shutter Speed: 4 sec.
ISO: 100

8
Page: 105
Sean Bagshaw
Camera: Canon EOS 5D Mark II
Aperture: ƒ/16
Focal Length: 24mm
Shutter Speed: 1/160 sec.
ISO: 200

9
Page: 106 left
David Cobb
Camera: Canon EOS 5D Mark III
Aperture: ƒ/11
Focal Length: 58mm
Shutter Speed: 1 sec.
ISO: 100

10
Page: 106–107 middle
David Cobb
Camera: Canon EOS 5D Mark III
Aperture: ƒ/22
Focal Length: 25mm
Shutter Speed: 1/8 sec.
ISO: 100

11
Page: 107 right
David Cobb
Camera: Canon EOS 5D Mark III
Aperture: ƒ/22
Focal Length: 100mm
Shutter Speed: 20 sec.
ISO: 200

12
Page: 109
David Cobb
Camera: Canon EOS 5D Mark III
Aperture: ƒ/16
Focal Length: 55mm
Shutter Speed: 1/30 sec.
ISO: 320

13
Page: 110
Sean Bagshaw
Camera: Canon EOS R5
Aperture: ƒ/13
Focal Length: 22mm
Shutter Speed: 1/60 sec.
ISO: 400

14
Page: 112
Kevin McNeal
Camera: Canon EOS 5D Mark II
Aperture: ƒ/16
Focal Length: 21mm
Shutter Speed: 1/30 sec.
ISO: 200

15
Page: 113
Kevin McNeal
Camera: Canon EOS 5D Mark II
Aperture: ƒ/8
Focal Length: 91mm
Shutter Speed: 1/1250 sec.
ISO: 800

16
Page 114
David Cobb
Camera: Canon EOS 5D Mark III
Aperture: ƒ/8
Focal Length: 28mm
Shutter Speed: 1/125 sec.
ISO: 200

PHOTO CREDITS

1	2	3	4
5	6	7	8
9	10	11	12
13	14	15	16

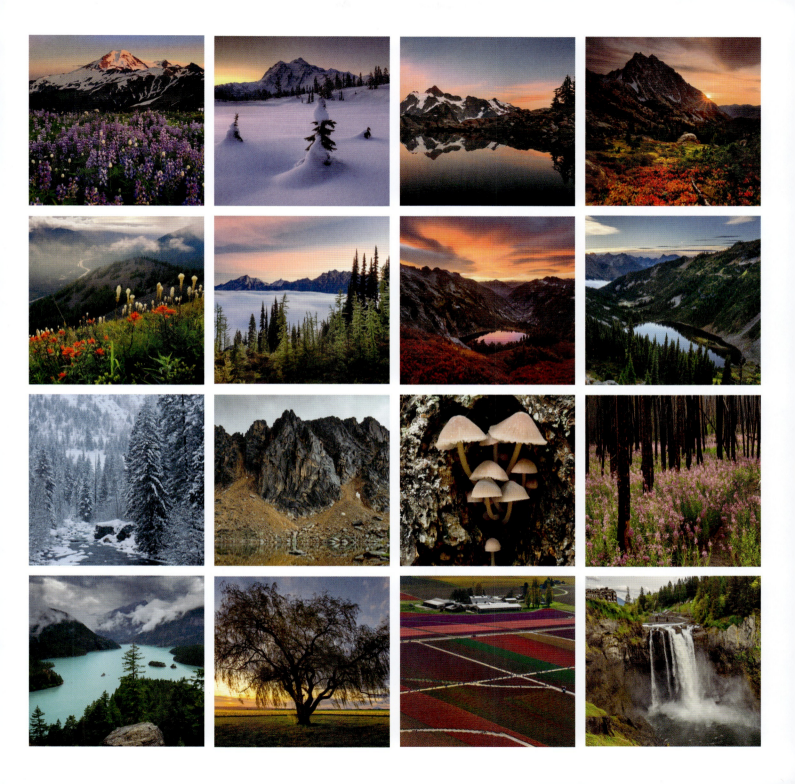

1
Page: 116
David Cobb
Camera: Canon EOS 5D Mark III
Aperture: ƒ/22
Focal Length: 35mm
Shutter Speed: 1/6 sec.
ISO: 400

2
Page: 117 top
Kevin McNeal
Camera: Nikon D850
Aperture: ƒ/16
Focal Length: 11mm
Shutter Speed: 1/8 sec.
ISO: 64

3
Page: 117 bottom
Sean Bagshaw
Camera: Canon EOS 5D Mark III
Aperture: ƒ/14
Focal Length: 104mm
Shutter Speed: 8 sec.
ISO: 100

4
Page: 118
David Cobb
Camera: Canon EOS 5D Mark III
Aperture: ƒ/22
Focal Length: 200mm
Shutter Speed: 1/13 sec.
ISO: 100

5
Page: 119
David Cobb
Camera: Canon EOS 5D Mark III
Aperture: ƒ/11
Focal Length: 230mm
Shutter Speed: 1/20 sec.
ISO: 100

6
Page: 121
Chip Phillips
Camera: Canon EOS 5D Mark II
Aperture: ƒ/16
Focal Length: 228mm
Shutter Speed: 0.25 sec.
ISO: 100

7
Page: 122
Sean Bagshaw
Camera: Canon EOS R
Aperture: ƒ/13
Focal Length: 15mm
Shutter Speed: 1/60 sec.
ISO: 400

8
Page: 123
Sean Bagshaw
Camera: Canon EOS R
Aperture: ƒ/13
Focal Length: 61mm
Shutter Speed: 1/100 sec.
ISO: 100

9
Page: 124
Zack Schnepf
Camera: Nikon D850
Aperture: ƒ/22
Focal Length: 24mm
Shutter Speed: 0.5 sec.
ISO: 200

10
Page: 125
Sean Bagshaw
Camera: Canon EOS R5
Aperture: ƒ/13
Focal Length: 24mm
Shutter Speed: 1/125 sec.
ISO: 125

11
Page: 126
David Cobb
Camera: Canon EOS 5D Mark III
Aperture: ƒ/16
Focal Length: 30mm
Shutter Speed: 2.5 sec.
ISO: 125

12
Page: 127
David Cobb
Camera: Canon EOS 5D Mark III
Aperture: ƒ/11
Focal Length: 70mm
Shutter Speed: 1/320 sec.
ISO: 400

13
Page: 128 top
Chip Phillips
Camera: Canon EOS 5D Mark II
Aperture: ƒ/14
Focal Length: 17mm
Shutter Speed: 0.3 sec.
ISO: 100

14
Page: 128 bottom
Chip Phillips
Camera: Canon EOS 5D Mark II
Aperture: ƒ/16
Focal Length: 16mm
Shutter Speed: 1.3 sec.
ISO: 100

15
Page: 129
Chip Phillips
Camera: Canon EOS 5D
Aperture: ƒ/18
Focal Length: 23mm
Shutter Speed: 1/10 sec.
ISO: 100

16
Page: 130
Zack Schnepf
Camera: Nikon D850
Aperture: ƒ/11
Focal Length: 200mm
Shutter Speed: 1/50 sec.
ISO: 100

PHOTO CREDITS

1	2	3	4
5	6	7	8
9	10	11	12
13	14	15	16

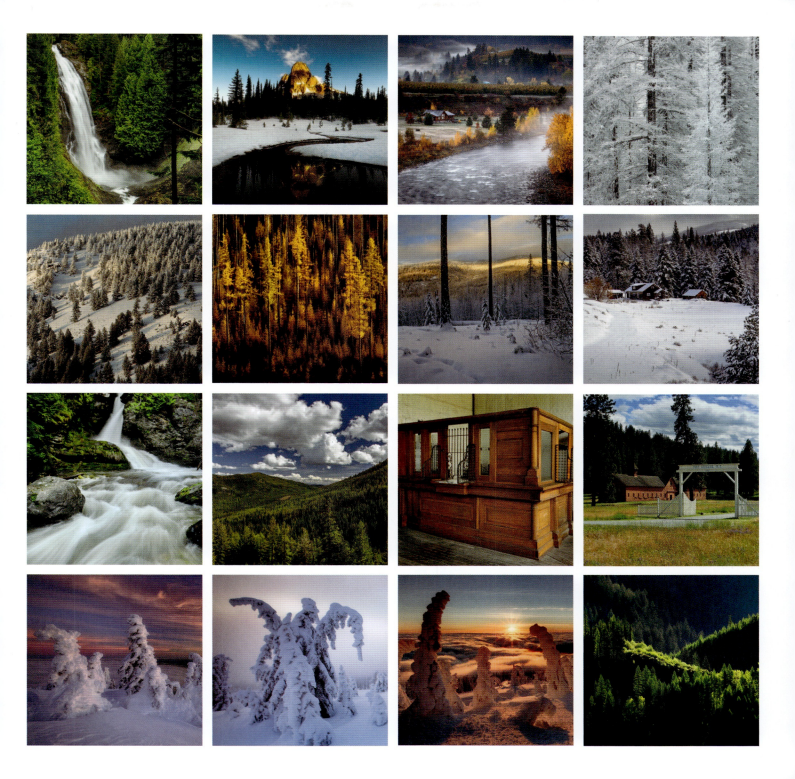

1
Page: 131
Sean Bagshaw
Camera: Canon EOS R5
Aperture: ƒ/16
Focal Length: 17mm
Shutter Speed: 0.2 sec.
ISO: 125

2
Page: 133
Sean Bagshaw
Camera: Canon EOS R5
Aperture: ƒ/13
Focal Length: 42mm
Shutter Speed: 1/25 sec.
ISO: 100

3
Page: 134
David Cobb
Camera: Canon EOS 5D Mark III
Aperture: ƒ/22
Focal Length: 100mm
Shutter Speed: 2 sec.
ISO: 100

4
Page: 135 top
David Cobb
Camera: Canon EOS 5D Mark I
Aperture: ƒ/22
Focal Length: 25mm
Shutter Speed: 0.8 sec.
ISO: 100

5
Page: 135 bottom
Kevin McNeal
Camera: Nikon D810
Aperture: ƒ/16
Focal Length: 70mm
Shutter Speed: 0.5 sec.
ISO: 100

6
Page: 136
David Cobb
Camera: Canon EOS 5D Mark III
Aperture: ƒ/22
Focal Length: 54mm
Shutter Speed: 1 sec.
ISO: 400

7
Page: 138
David Cobb
Camera: Canon EOS 5D Mark III
Aperture: ƒ/22
Focal Length: 42mm
Shutter Speed: 1 sec.
ISO: 400

8
Page: 139
David Cobb
Camera: Canon EOS 5D Mark III
Aperture: ƒ/22
Focal Length: 28mm
Shutter Speed: 2.5 sec.
ISO: 400

9
Page: 140
David Cobb
Camera: Canon EOS 5D Mark III
Aperture: ƒ/11
Focal Length: 98mm
Shutter Speed: 1/30 sec.
ISO: 320

10
Page: 141 top
David Cobb
Camera: Canon EOS 5D Mark III
Aperture: ƒ/22
Focal Length: 70mm
Shutter Speed: 1/13 sec.
ISO: 100

11
Page: 141 bottom
Adrian Klein
Camera: Canon EOS 5D Mark III
Aperture: ƒ/16
Focal Length: 25mm
Shutter Speed: 2.5 sec.
ISO: 400

12
Page: 142
David Cobb
Camera: Canon EOS 5D Mark III
Aperture: ƒ/22
Focal Length: 58mm
Shutter Speed: 0.3 sec.
ISO: 100

13
Page: 143
David Cobb
Camera: Canon EOS 5D Mark III
Aperture: ƒ/32
Focal Length: 140mm
Shutter Speed: 1/6 sec.
ISO: 100

14
Page: 144
David Cobb
Camera: Canon EOS 5D Mark III
Aperture: ƒ/11
Focal Length: 125mm
Shutter Speed: 0.3 sec.
ISO: 100

15
Page: 145
Adrian Klein
Camera: Canon EOS 5D Mark III
Aperture: ƒ/16
Focal Length: 16mm
Shutter Speed: 1.6 sec.
ISO: 400

16
Page: 146 left
Sean Bagshaw
Camera: Canon EOS R5
Aperture: ƒ/10
Focal Length: 24mm
Shutter Speed: 1/10 sec.
ISO: 100

PHOTO CREDITS

1	2	3	4
5	6	7	8
9	10	11	12
13	14	15	16

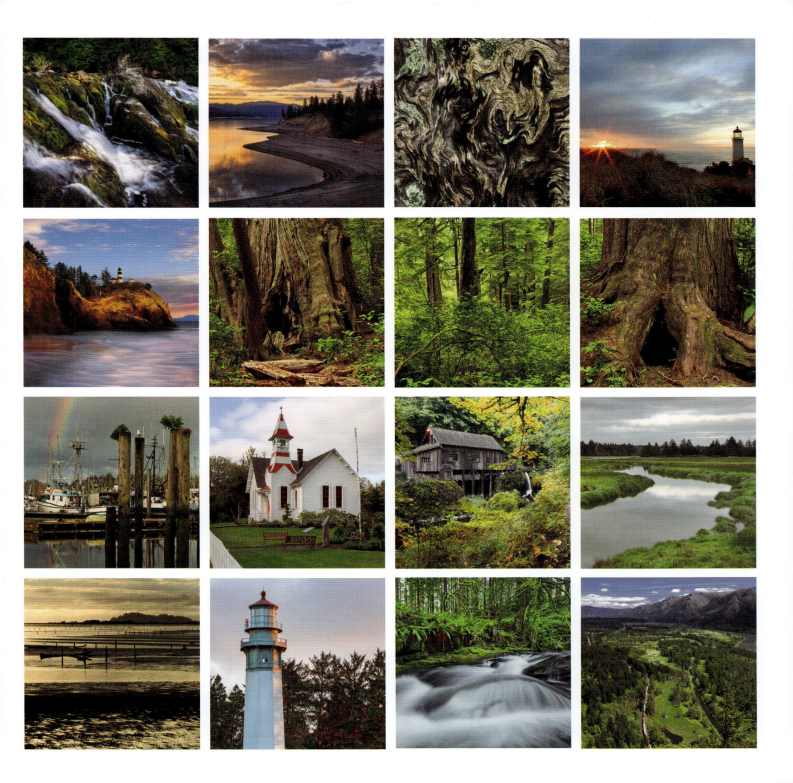

1
Pages: 146–147 middle
Adrian Klein
Camera: Canon EOS 5D Mark III
Aperture: ƒ/14
Focal Length: 94mm
Shutter Speed: 0.4 sec.
ISO: 200

2
Page: 147 right
Adrian Klein
Camera: Canon EOS 5D Mark I
Aperture: ƒ/18
Focal Length: 22mm
Shutter Speed: 4 sec.
ISO: 100

3
Page: 149
David Cobb
Camera: Canon EOS 5D Mark III
Aperture: ƒ/14
Focal Length: 27mm
Shutter Speed: 0.25 sec.
ISO: 400

4
Page: 150
Sean Bagshaw
Camera: Canon EOS R5
Aperture: ƒ/13
Focal Length: 35mm
Shutter Speed: 1/60 sec.
ISO: 100

5
Page: 151
Adrian Klein
Camera: Canon EOS 5D Mark II
Aperture: ƒ/16
Focal Length: 55mm
Shutter Speed: 1/13 sec.
ISO: 100

6
Page: 152
Sean Bagshaw
Camera: Canon EOS R5
Aperture: ƒ/11
Focal Length: 57mm
Shutter Speed: 0.4 sec.
ISO: 400

7
Page: 153
David Cobb
Camera: Canon EOS 5D Mark III
Aperture: ƒ/14
Focal Length: 17mm
Shutter Speed: 0.3 sec.
ISO: 640

8
Page: 154
David Cobb
Camera: Canon EOS 5D Mark III
Aperture: ƒ/22
Focal Length: 38mm
Shutter Speed: 0.4 sec.
ISO: 160

9
Page: 156
Adrian Klein
Camera: Canon EOS 5D Mark III
Aperture: ƒ/16
Focal Length: 25mm
Shutter Speed: 1/40 sec.
ISO: 400

10
Page: 157 top
Sean Bagshaw
Camera: Canon EOS R5
Aperture: ƒ/4
Focal Length: 200mm
Shutter Speed: 1/20 sec.
ISO: 400

11
Page: 157 bottom
Adrian Klein
Camera: Canon EOS 5D Mark III
Aperture: ƒ/22
Focal Length: 67mm
Shutter Speed: 2 sec.
ISO: 200

12
Page: 158
Sean Bagshaw
Camera: Canon EOS 5D Mark III
Aperture: ƒ/16
Focal Length: 16mm
Shutter Speed: 4 sec.
ISO: 100

13
Page: 159
David Cobb
Camera: Canon EOS 5D Mark I
Aperture: ƒ/16
Focal Length: 30mm
Shutter Speed: 2.5 sec.
ISO: 200

14
Page: 160
Adrian Klein
Camera: Canon EOS 5D Mark II
Aperture: ƒ/22
Focal Length: 40mm
Shutter Speed: 1/40 sec.
ISO: 200

15
Page: 161
Kevin McNeal
Camera: Nikon D2X
Aperture: ƒ/16
Focal Length: 17mm
Shutter Speed: 1 sec.
ISO: 100

16
Page: 162
David Cobb
Camera: Canon EOS 5D Mark I
Aperture: ƒ/22
Focal Length: 35mm
Shutter Speed: 1.6 sec.
ISO: 400

1	2	3	4
5	6	7	8
9	10	11	12
13	14	15	16

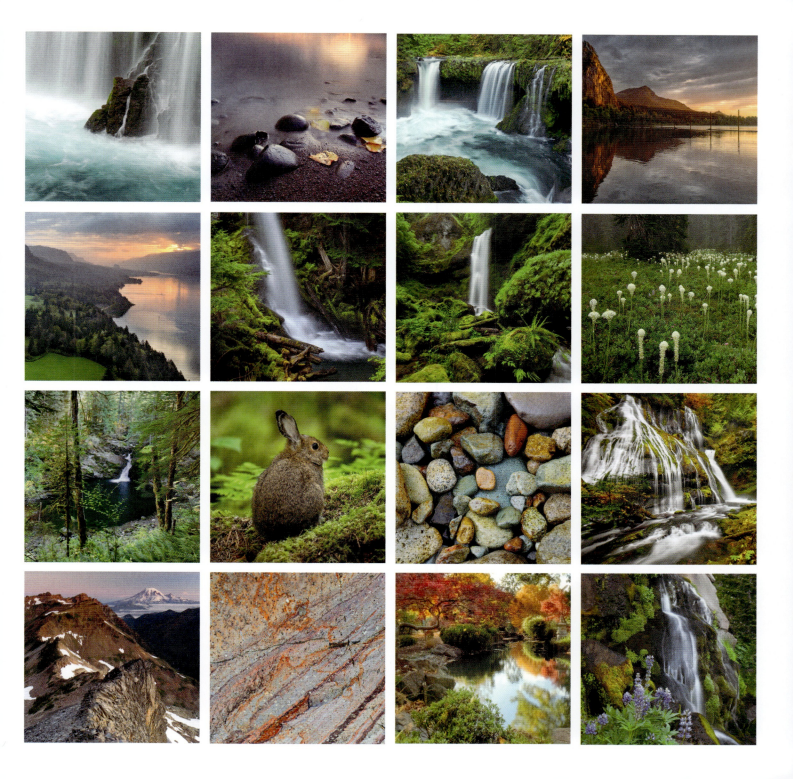

1
Page: 163
Adrian Klein
Camera: Sony a6000
Aperture: $f/16$
Focal Length: 22mm
Shutter Speed: 0.3 sec.
ISO: 100

2
Page: 164
Zack Schnepf
Camera: Sony A7r
Aperture: $f/18$
Focal Length: 70mm
Shutter Speed: 1/40 sec.
ISO: 200

3
Page: 166
David Cobb
Camera: Canon EOS 5D Mark I
Aperture: $f/22$
Focal Length: 78mm
Shutter Speed: 0.8 sec.
ISO: 100

4
Page: 167
Zack Schnepf
Camera: Canon EOS 10D
Aperture: $f/11$
Focal Length: 17mm
Shutter Speed: 1/10 sec.
ISO: 200

5
Page: 168
Kevin McNeal
Camera: Canon EOS 5D Mark II
Aperture: $f/16$
Focal Length: 17mm
Shutter Speed: 3.2 sec.
ISO: 100

6
Page: 169
Kevin McNeal
Camera: Nikon D810
Aperture: $f/16$
Focal Length: 17mm
Shutter Speed: 0.25 sec.
ISO: 400

7
Page: 170
Zack Schnepf
Camera: Canon EOS 10D
Aperture: $f/8$
Focal Length: 42mm
Shutter Speed: 1/20 sec.
ISO: 100

8
Page: 172
Kevin McNeal
Camera: Nikon D850
Aperture: $f/16$
Focal Length: 11mm
Shutter Speed: 15 sec.
ISO: 200

9
Page: 173
David Cobb
Camera: Canon EOS 5D Mark I
Aperture: $f/13$
Focal Length: 80mm
Shutter Speed: 2 sec.
ISO: 100

10
Page: 174 left
Zack Schnepf
Camera: Canon EOS 10D
Aperture: $f/11$
Focal Length: 17mm
Shutter Speed: 1/30 sec.
ISO: 200

11
Pages: 174–175 middle
Zack Schnepf
Camera: Canon EOS 10D
Aperture: $f/22$
Focal Length: 28mm
Shutter Speed: 1.3 sec.
ISO: 100

12
Page: 175 right
Kevin McNeal
Camera: Nikon D810
Aperture: $f/16$
Focal Length: 14mm
Shutter Speed: 1/13 sec.
ISO: 64

13
Page: 176
Kevin McNeal
Camera: Nikon D810
Aperture: $f/5.6$
Focal Length: 14mm
Shutter Speed: 30 sec.
ISO: 1600

14
Page: 178
Sean Bagshaw
Camera: Canon EOS 5D Mark I
Aperture: $f/5.6$
Focal Length: 135mm
Shutter Speed: 1/40 sec.
ISO: 250

15
Page: 179
Kevin McNeal
Camera: Canon EOS 5D Mark I
Aperture: $f/16$
Focal Length: 28mm
Shutter Speed: 0.8 sec.
ISO: 100

16
Page: 180
Sean Bagshaw
Camera: Canon EOS 5D Mark I
Aperture: $f/8$
Focal Length: 70mm
Shutter Speed: 1/40 sec.
ISO: 320

PHOTO CREDITS

1	2	3	4
5	6	7	8
9	10	11	12
13	14	15	16

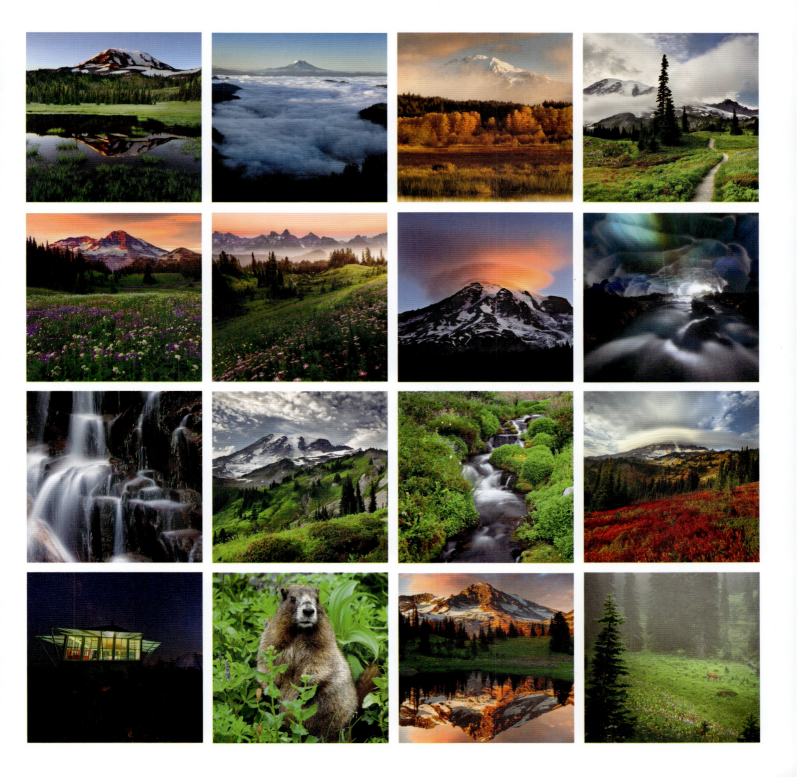

1
Page: 181
David Cobb
Camera: Canon EOS 5D Mark III
Aperture: *f*/16
Focal Length: 75mm
Shutter Speed: 1/8 sec.
ISO: 250

———

2
Page: 183
Adrian Klein
Camera: Canon EOS 5D Mark II
Aperture: *f*/16
Focal Length: 17mm
Shutter Speed: 13 sec.
ISO: 200

———

3
Page: 184
Adrian Klein
Camera: Canon EOS 5D Mark III
Aperture: *f*/16
Focal Length: 32mm
Shutter Speed: 30 sec.
ISO: 100

———

4
Page: 186
David Cobb
Camera: Canon EOS 5D Mark III
Aperture: *f*/14
Focal Length: 98mm
Shutter Speed: 1/13 sec.
ISO: 320

———

5
Page: 187
David Cobb
Camera: Canon EOS 5D Mark III
Aperture: *f*/11
Focal Length: 70mm
Shutter Speed: 1/6 sec.
ISO: 320

———

6
Page: 188
Sean Bagshaw
Camera: Canon EOS R5
Aperture: *f*/13
Focal Length: 15mm
Shutter Speed: 1/200 sec.
ISO: 100

———

7
Page: 191
Adrian Klein
Camera: Canon EOS R5
Aperture: *f*/14
Focal Length: 17mm
Shutter Speed: 1/50 sec.
ISO: 100

———

8
Page: 192
David Cobb
Camera: Canon EOS 5D Mark III
Aperture: *f*/22
Focal Length: 155mm
Shutter Speed: 1/10 sec.
ISO: 100

———

9
Page: 193
Adrian Klein
Camera: Canon EOS R5
Aperture: *f*/14
Focal Length: 17mm
Shutter Speed: 1/125 sec.
ISO: 250

———

10
Page: 194
Sean Bagshaw
Camera: Canon EOS R5
Aperture: *f*/13
Focal Length: 24mm
Shutter Speed: 1/80 sec.
ISO: 100

———

11
Page: 196
David Cobb
Camera: Canon EOS 5D Mark III
Aperture: *f*/5.6
Focal Length: 145mm
Shutter Speed: 1/50 sec.
ISO: 200

———

12
Page: 197
David Cobb
Camera: Canon EOS 5D Mark III
Aperture: *f*/22
Focal Length: 28mm
Shutter Speed: 1/100 sec.
ISO: 400

———

13
Page: 198
Adrian Klein
Camera: Canon EOS 5D Mark II
Aperture: *f*/16
Focal Length: 17mm
Shutter Speed: 1/60 sec.
ISO: 400

———

14
Page: 199
Zack Schnepf
Camera: Canon EOS 5D Mark I
Aperture: *f*/11
Focal Length: 17mm
Shutter Speed: 1/125 sec.
ISO: 250

———

15
Page: 200
Sean Bagshaw
Camera: Canon EOS R
Aperture: *f*/10
Focal Length: 100mm
Shutter Speed: 1/320 sec.
ISO: 100

———

16
Page: 201
David Cobb
Camera: Canon EOS 5D Mark III
Aperture: *f*/22
Focal Length: 24mm
Shutter Speed: 1/6 sec.
ISO: 100

———

PHOTO CREDITS

1	2	3	4
5	6	7	8
9	10	11	12
13	14	15	16

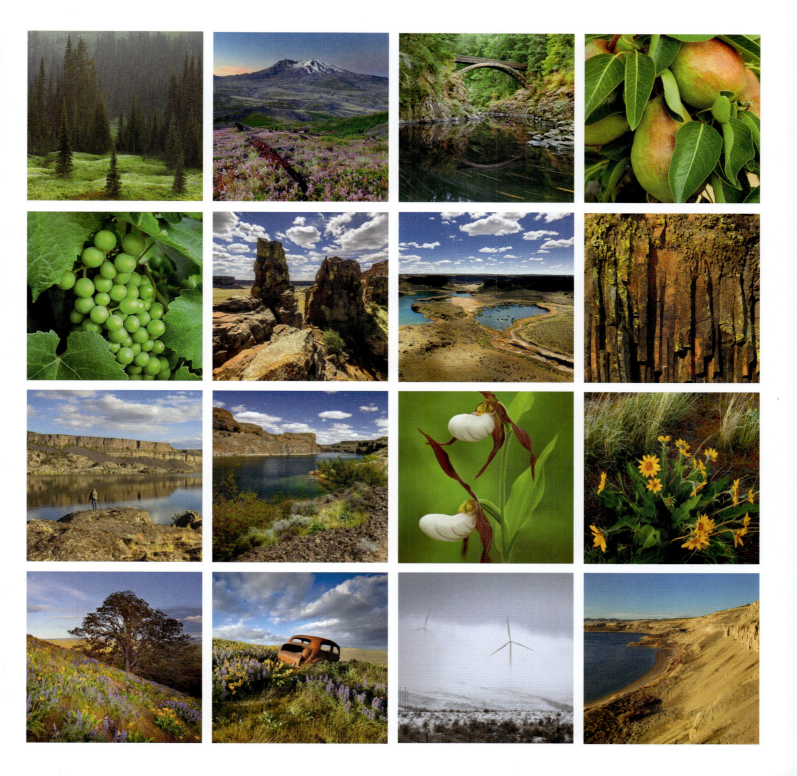

1
Page: 202
Adrian Klein
Camera: Canon EOS R5
Aperture: ƒ/16
Focal Length: 70mm
Shutter Speed: 1/10 sec.
ISO: 400

———

2
Page: 204 top
David Cobb
Camera: Canon EOS 5D Mark III
Aperture: ƒ/22
Focal Length: 100mm
Shutter Speed: 0.6 sec.
ISO: 100

———

3
Page: 204 bottom
Adrian Klein
Camera: Canon EOS R5
Aperture: ƒ/20
Focal Length: 200mm
Shutter Speed: 1/25 sec.
ISO: 400

———

4
Page: 205
Chip Phillips
Camera: Canon EOS 5D Mark II
Aperture: ƒ/16
Focal Length: 280mm
Shutter Speed: 1/6 sec.
ISO: 100

———

5
Page: 206
Kevin McNeal
Camera: Nikon D810
Aperture: ƒ/16
Focal Length: 28mm
Shutter Speed: 1/125 sec.
ISO: 400

———

6
Page: 208
Kevin McNeal
Camera: Nikon D810
Aperture: ƒ/9
Focal Length: 28mm
Shutter Speed: 1/8000 sec.
ISO: 1600

———

7
Page: 209 top
Sean Bagshaw
Camera: Canon EOS 5D Mark III
Aperture: ƒ/5
Focal Length: 200mm
Shutter Speed: 1/125 sec.
ISO: 100

———

8
Page: 209 bottom
David Cobb
Camera: Canon EOS 5D Mark III
Aperture: ƒ/5.6
Focal Length: 70mm
Shutter Speed: 1/13 sec.
ISO: 400

———

9
Page: 210
Sean Bagshaw
Camera: Canon EOS 5D Mark I
Aperture: ƒ/18
Focal Length: 65mm
Shutter Speed: 0.6 sec.
ISO: 100

———

10
Page: 211
Chip Phillips
Camera: Canon EOS 5D
Aperture: ƒ/16
Focal Length: 16mm
Shutter Speed: 0.3 sec.
ISO: 100

———

11
Page: 212
Chip Phillips
Camera: Canon EOS 5D Mark IV
Aperture: ƒ/11
Focal Length: 98mm
Shutter Speed: 1/13 sec.
ISO: 100

———

12
Page: 214
Kevin McNeal
Camera: Canon EOS 5D Mark II
Aperture: ƒ/25
Focal Length: 70mm
Shutter Speed: 1/100 sec.
ISO: 400

———

13
Page: 215
Sean Bagshaw
Camera: Canon EOS R5
Aperture: ƒ/10
Focal Length: 45mm
Shutter Speed: 1/40 sec.
ISO: 100

———

14
Page: 216
Sean Bagshaw
Camera: Canon EOS R
Aperture: ƒ/5.6
Focal Length: 241mm
Shutter Speed: 1/500 sec.
ISO: 400

———

15
Page: 217
Chip Phillips
Camera: Canon EOS 5D Mark II
Aperture: ƒ/14
Focal Length: 94mm
Shutter Speed: 1.3 sec.
ISO: 100

———

PHOTO CREDITS

1	2	3	4
5	6	7	8
9	10	11	12
13	14	15	

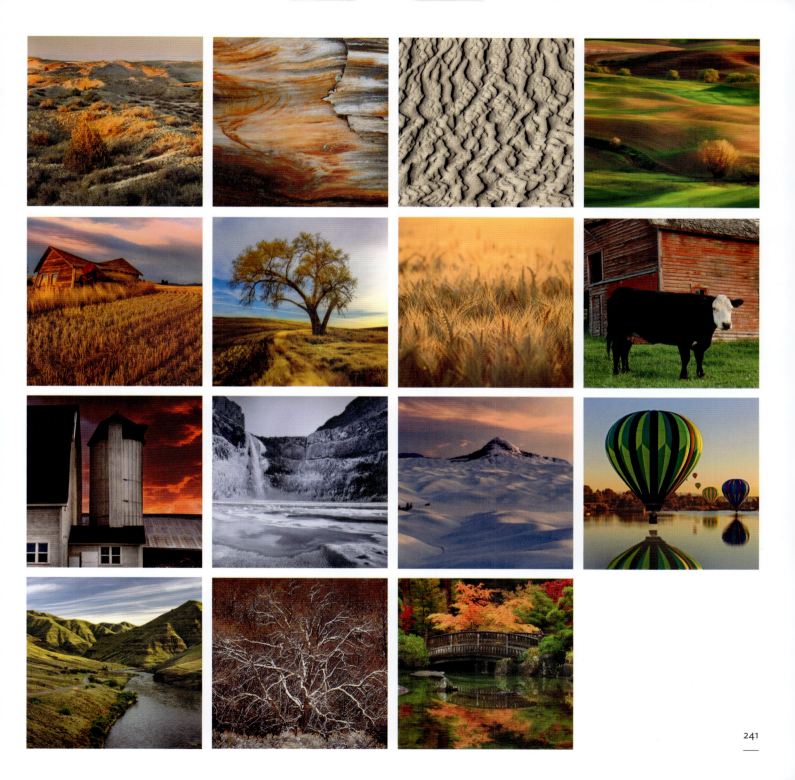

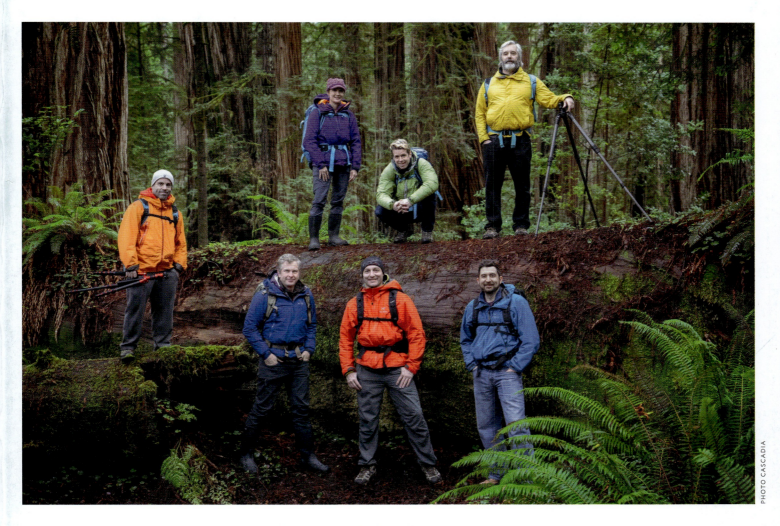

The seven photographers of the collective known as Photo Cascadia—Erin Babnik, Sean Bagshaw, David Cobb, Adrian Klein, Kevin McNeal, Chip Phillips, and Zach Schnepf—all live in the Pacific Northwest and have dedicated their careers to sharing its natural beauty while encouraging stewardship and conservation efforts. Active members of the photographic community, they regularly teach workshops and lead group photography tours throughout the region and beyond. Collectively they have mounted dozens of exhibitions and have received many industry and juried awards. Their images have been published in *Digital Photo Magazine, Digital Photographer, National Geographic, Nature's Best Photography, Northwest Magazine, OnLandscape, Outdoor Photographer, Outside, Popular Photography and Imaging,* and elsewhere. Erin Babnik is a Canon Explorer of Light.

See more of their work at photocascadia.com.

Noted lepidopterist and writer **ROBERT MICHAEL PYLE** is the founder of the Xerces Society for Invertebrate Conservation and an Honorary Fellow of the Royal Entomological Society. A Yale-trained ecologist and a Guggenheim fellow, he is a full-time biologist and the author of more than 20 books, including *Wintergreen,* which won the John Burroughs Medal, *Chasing Monarchs, Mariposa Road,* and two collections of poetry. His works on butterflies include *The Audubon Society Field Guide to North American Butterflies, Handbook for Butterfly Watchers,* and *The Butterflies of Cascadia.* He lives in Gray's River, Washington.

Frontispiece: A summer haze sits in the valley of
a wildflower-carpeted subalpine forest in Mount
Rainier National Park.

Copyright © 2022 by Photo Cascadia.
All rights reserved.
Photography credits begin on page 218.

Published in 2022 by Timber Press, Inc.

The Haseltine Building
133 S.W. Second Avenue, Suite 450
Portland, Oregon 97204-3527
timberpress.com

Printed in China on paper from responsible sources

Text and cover design by Adrianna Sutton

Text is set in Ideal Sans, a typeface designed by
Hoefler & Frere-Jones in 2011 and in Requiem,
a typeface designed by Jonathan Hoefler in 1992

ISBN 978-1-64326-140-9

A catalog record for this book is available from the
Library of Congress.